Addition
JOURNEY TO HE,

MW00332176

WHEN ONE OF THE WEST'S most interesting thinkers makes a pilgrimage to China's heart, the account becomes as rich with meaning as Thomas Mann's *The Magic Mountain.*

The book can be read on a dozen levels, and on all of them, enlightens. Dr. Martin brings news that Chinese Buddhist culture, widely thought to have perished under Mao, as Russian Jewish culture perished under Stalin, has resurfaced and thrives. Dozens of memorable characters populate Martin's pages saintly and wise, funny or quite villainous, like the fisherman who uses Martin's pilgrimage to maroon him for ransom on a water-less island in the China Sea. The worldly brilliance of the Abbot who teaches him unworldly Buddhism, the overwhelming beauty of the mortally-ill girl who leads Martin through the stream-filled caverns of a Sacred Island, combine to make a moving case for Chinese Buddhism as faith, and as culture.

—**George J. Leonard,** Editor in Chief,
The Asian Pacific American Heritage:
A Companion to Literature and Arts.

JOURNEY TO HEAVENLY MOUNTAIN demonstrates once again why Jay Martin is widely known as a superb teller of stories, both in print and through conversation. An account of a recent summer spent in different Chinese Buddhist monasteries seeking to "revisit his soul and expand his imagination," this book well could have been another earnest but excruciating moral tale. Instead, it is a wonderfully engaging description of numerous experiences, spiritual and otherwise, that invites the reader into the conversational text and, if so inclined, the realm of introspection. Everyone with an interest in any dimension of the subject matter—from tourists to philosophers—will find it highly entertaining.

—**Paul Hooper,** Professor of Asian-American Relations,
The University of Hawai'i, and editor, *Building*
a Pacific Community (East-West Center).

IN OUR MURDEROUS times we tend to think of bearing witness as a painful duty of those who have experienced and survived "unencompassable devastation." Jay Martin's moving and hopeful first person account of his quest for wholeness—his own and humanity's—reminds us that we have the power to make as well as see rainbows.

—**Ronald Gottesman,** Editor,
*The Norton Anthology of American
Literature* and *The Encyclopedia of Violence.*

JAY MARTIN TELLS an engaging tale, full of wit and humor, of how he became a Buddhist monk in China. The story, beautifully told, sparkles with epiphanies concerning the greatest and smallest things. Scene after scene is so charmingly depicted that they all linger vividly in the memory long after the last page has turned.

—**Graham Parkes,** author,
The Zen Dry Garden.

A PREEMINENT AUTHOR, scholar, professor, and psychoanalyst, Martin offers his readers a dazzling tapestry of sharp observations, penetrating insights, delightful wit and humor. . . It is about a spiritual journey of inquiry and self-inquiry, a quest for inner peace, wisdom, and empathy, mapped simultaneously on the Chinese landscape he traveled. . . Martin envision his book as a response to Thomas Mann's *The Magic Mountain,* to underscore his faith in the essential goodness and perfectibility of humankind, shared by both the Chinese and the Americans. . . This rich yet accessible book would be an important addition to the libraries of specialists in American studies, Chinese studies, religious studies, psychology, and East-West Cultural relations. General readers will also enjoy this unique book, and through its comparative perspective, come to a better understanding of contemporary China, the American national character, and their own "soul and psyche."

—**Sheng-Tai Chang,** author,
The Tears of Chinese Immigrants

JOURNEY
TO HEAVENLY
MOUNTAIN

Journey to Heavenly Mountain

An American's Pilgrimage to the
Heart of Buddhism in Modern China

Jay Martin

HOHM PRESS
Prescott, Arizona

Cover design: Kim Johansen
Layout and design: Bookworks, San Diego, California

Library of Congress Cataloging in Publication Data:

Martin, Jay.
 Journey to heavenly mountain: an American's Pilgrimage to the heart of Buddhism in modern China / by Jay Martin.
 p. cm.
 ISBN 1-890772-17-8 (alk. paper)
 1. Martin, Jay—Journeys—China. 2. Tiantai Mountains (China)—Description and travel. 3. Temples, Buddhist in modern China. II. Title.

DS793.C3 M37 2002
951'.242–dc21

 2002017248

 HOHM PRESS
 P.O. Box 2501
 Prescott, AZ 86302
 800-381-2700
 http://www.hohmpress.com

 This book was printed in the U.S.A. on acid-free
 paper using soy ink.

 05 04 03 02 01 5 4 3 2 1

TO MYRON SIMON

From Guo Qing temple
by stone bridge Xiling waterfall
to Flower Peak, precipitous,
I climbed sometimes, seeking red-streaked
 sunsets.
Nightbirds perched on my lamp,
fluttering incense.

I'd climb this Tiantai ridge again
and stop halfway at Master Zhi Yi's tomb
for more illumination.

Or breathe, instead, from Master
 Simon's lamp
a fragrant incense, wisdom-drenched.

Imitated and adapted by Jay Martin from the
verses of the ninth-century Buddhist monk
Zhi Zi, titled, "Thinking of a Monk of Flower
Peak on Mount Tiantai"

懷天台華頂僧

華頂危臨海丹霞裹石橋曾從國清寺上看月明潮好

鳥親香火狂泉噴沈寥欲歸師智者頭白路迢迢

How to Climb a Mountain

Given to Jay Martin in the forest solitude above Tiantong temple, August 10, 1998.

To climb a mountain, never begin at the bottom. Start at the summit and then climb past the rooftops of the world, to the heaven-beyond-heaven.

Contents

Author's Note

Concerning the transcriptions of Chinese names, my spellings are for the most part based on sound, for I seldom saw the names of those I met written in Chinese characters. I have maintained consistency in contemporary Pinyin spelling, except in a few instances, such as "Chiang Kai-shek," "Puto" (Pinyin, "Putuo"), or "Kuomintang," where I have retained the older, more familiar spellings.

Journey to Heavenly Mountain

❧ I AM SITTING in the waiting room of the main railway station in Shanghai, along with a thousand other people.

If I were writing a memoir of my travels, I would now have to tell why I am here and how I got here. But this book is about how I arrived at the base of Tiantai Mountain to become a Buddhist monk. This is a book of mystery and desire, a tour of the soul and psyche, not a travel book or a memoir.

So I am simply here, at the beginning of my journey, tired from a long flight.

The waiting room is as large as an aircraft hangar. The sun explodes through the dusty panes of the high windows. The odors of China flow like rivers through the room. The varied colors of the passengers' outfits are splashed like a Jackson Pollock painting. The noise is pitched as high as possible.

We sit on hard wooden benches. A Chinese husband and wife, rural people, farmers, who had probably come to shop in the city, squeeze in next to me, one on each side, so tightly I feel that they are trying to meet through me. They have

deposited an immense number of cloth and twine-wrapped bundles all about my feet. I think of getting up and inviting them to sit together, but if I were to get up, the space I had occupied would disappear as they slide together. Besides, I like sitting cozily between them, packed in together, wholly abandoning the larger bodily space cherished by Americans. We sit contentedly, we three, tucked into each other. I begin to absorb China from the warmth of their bodies.

There are so many ways of becoming a new person in China. Even simply sitting in a crowded waiting room confers a new life upon me, a special feeling of belonging by simply being there, folded into a little family. Soon, I notice that we three are breathing in unison. In fact, the husband drops into a restful sleep and snores in time with our breaths. His cautious wife keeps a wary eye on their packages.

This is the way it is in China. People like to be in rhythm together, like musicians or oarsmen on a great vessel, in waiting rooms, in crowded markets, or on buses and hard-seat train coaches. It is not like the New York subway or the Moscow trolleys, where people are pressed together in distaste or hatred. No, in China, I discover the pleasure of merely anonymous cuddling and being leaned upon. I lean upon many people myself and quickly learn to like it.

In America I am a Professor of Government. I occupy a chair in Humanities. I direct a research institute. I am in *Who's Who in America*. I am a psychoanalyst. I belong to international societies. I . . . I . . . I! In China I am simply part of the powerful surge of human life. It feels good to become no one, and to merge into everyone.

The sleeping husband shifts and rests his head partly on my shoulder. The waiting room begins to get warm. Suddenly I wake. I too have fallen asleep. My own head has dropped on the wife's shoulder. We are like three peas in a pod. She blinks her eyes at me in a kindly way as I lift my head.

Their train is called before mine. Like circus performers doing a comical balancing act, they gather their packages to-

gether, pile one upon another precariously, and waddle through the exit door.

I inhale deeply, drawing in the air around me, the bodily incense from the spaces they and their bundles had occupied. *I am in China. This is Chinese air. These are Chinese people that have taken me into their impersonal but warm embrace. And I have taken them in, as I fill my lungs with their perfume.* I thought I would come to China to plunge into its soul. Little did I guess that my first spiritual experience would take place in a train station, absorbing strange odors. Ancient peoples believed that the soul was breath. I inhale the soul of China even as I exhale my own spiritual stuff into the waiting room ether.

My train, the express to Hangzhou, is called. There is a great hustle and bustle. On my way to the door I pass a group of Nordic backpackers, male and female, with Dürer faces, like extras from "Martin Guerre." Unconsciously, the sun-tanned girls are stretching their long, bare legs, scandalizing the Chinese. They do not rise. They are not going south with me. I think, *They are heading west, toward Tibet. May they travel well. We are going on separate but similar journeys.* As I look toward them, they smile and wave. Yes, we have a bond, we Caucasians. Or is our bond that we are all pilgrims traveling toward some special grace? Many are the bonds that all people share. No one in the waiting room is utterly unlike me.

On the platform itself, there is a great milling around and a happy hustle and bustle. The train is like a horse in the starting gate. It will leave on time. A very old man looks confused and lost, but then a soldier and his girlfriend inspect his ticket and take him by the arm to bring him to his car.

I have a reserved place in the soft-seat coach and I find my own car with little trouble. I squeeze through the knot of passengers and their friends blocking the steps. My seat is clearly marked. The drab olive of the coach's exterior is streaked with dust. But inside the coach itself, neat cleanliness rules. I look out the window. On the next track, about three feet from me,

is another train. In it, three children and a grandmother press their noses against the glass, looking at me. If only the windows were open, we could reach over and shake hands, but the windows are sealed, and so we five simply stare at each other. One six- or seven-year-old boy is wide-eyed with unconcealed wonder. I open my eyes wide and stare at him. American big eyes. He is astonished. I make a face at him. His sisters look to see what is happening. I stick my tongue out roguishly. They stick their tongues out too. The grandmother looks to see what the commotion is about. She too looks amazed to see this stranger making faces at her grandchildren. He does not look Chinese! I wave at her. Without thinking, she waves back. We are all playing. China is taking me in.

Then their train starts to go backwards. I wave goodbye to them. They wave to me merrily. I realize that they are not going backwards—I am moving forward, and I leave them behind.

Shanghai sprawls like a gigantic stain in every direction. But in twenty minutes we leave the city behind and enter the fringes of the country. Rickety urban shacks give way to tumble-down farm houses. Cars are replaced by pigs and chickens. Asphalt and cement disappear and grass and dusty weeds and stunted trees dot the landscape.

The landscape is monotonous, leaving me with my fantasies. My thoughts go forward to the town of Tiantai where the venerable temple monastery of Guo Qing is my ultimate destination. But first I must go to Hangzhou. I know so little about these places that each of my fantasies is like a bubble—it no sooner takes form than it bursts.

What does it matter? I am not doing research on China, I haven't come to *look* at it, but to be a part of it. Drowsily, I knit the dim passing landscape into my dreams. To fantasize about Guo Qing will require my being there. And then, immersion will be fantasy enough. I dream I am on a train going to Hangzhou, and I *am* on the Hangzhou express. It speeds on.

CHAPTER 2

The Arrival

❧ HANGZHOU IS MY gateway to Tiantai, the heavenly mountain. Hangzhou has Peter Lin, who will arrange to get me to Guo Qing. Hangzhou has West Lake, whose beauties the poet Li Po celebrated centuries ago.

These thoughts flow faster than any diesel train. But the train itself has gone faster than I realize, and it pulls into the Hangzhou station and stops.

On the platform a man picks me out. Peter Lin.

"I know just what you need to refresh you from the long journey you have had," he announces.

My joints ache from the long flight. I hope he means a nice shower and a soft bed. But his heart is set on showing me a bit of Hangzhou.

"First we will have a cup of coffee overlooking West Lake," he says. "Then we can see some of the sights of Hangzhou." It wasn't what I would have chosen, but I am in China to fall into its life, to melt into the crowd, to let myself drift and dream, and discover my desires in the company of others.

We drink coffee in the Blue Mountain Coffee House. Is this really the Orient? The sign is in English, and the specialty is

coffee. I guess it is just the sort of place young Chinese businessmen go to pretend to be Americans. Columbia Supremo is brewed in elegant crystal globes over spirit burners. I am in China for a different brewing and a more intense flame. I look out of the window at West Lake. Li Po was right about its beauty. Here and there tiny pleasure boats leave from miniature docks. Out on the lake are little islands and, in the distance, hills circling the lake. Twilight comes on rapidly. The islands are dotted with lights. Finally, the islands are swallowed by night and only the lights remain, lanterns floating on water.

I ask, "Is there a place for me in Lingyin Temple?" It is a very famous, holy place.

"Unfortunately, it is very crowded at this time. A short stay is not possible. If you wish to be a resident the abbot is willing." But my heart is set on the magic mountain above Guo Qing.

"OK," he says. "I have a nice hotel for you. If you're sleeping, what does it matter where? We will make a long visit to Lingyin tomorrow."

He is right. We go to the hotel. Still dressed, I stretch out and fall asleep at once.

China Dreams. They come to me easily here.

I dream that I am sitting on a bench by West Lake. But as it so often happens when I am very tired, I awaken after only an hour, just as my West Lake dream is starting. I can't get back to sleep, and if I can't dream of West Lake, what is easier than to go there?

I arise and walk to the lake.

A woman asks me to buy a big bunch of water lilies. Another woman shows me a basket filled with woven strands of seed pearls, hardly bigger than grains of rice, dazzlingly white but gleaming with iridescent streaks. She drapes pearls all over her bare arms to show them off.

"Wouldn't you like to buy these pearls for your sweetheart?" she asks. "West Lake pearls, right from the lake. You

know," she adds, "if you buy West Lake pearls you will come back to Hangzhou. Perhaps you will bring your sweetheart with you!"

An old Chinese man sits beside me.

"How are you this evening? Out for a stroll?" he asks in an excellent British accent. "I believe you are an American. As a boy I worked for the Flying Tigers."

I have my doubts about this statement but say nothing. I wait.

"Sir," he says, "it appears that you are alone in Hangzhou. I wanted to ask you a very interesting question."

I smile. What will he ask?

"Yes, I think you might enjoy a girl this evening." He grins politely, as if he had just offered me a cigarette.

"No, thank you very much."

"You are certain?"

"Thank you," I say.

"Well, then, I wish you a pleasant night." He coughs into a handkerchief, spits into the lake and disappears.

Back in my hotel room, I am now ready to sleep.

My dream of West Lake picks up—but how changed!—where it left off. Li Po takes my arm and we stroll along the water's edge. I tell him about my mentor and second father, Conrad Aiken. I talk to him about the time I lived with Aiken on Cape Cod when he was writing the best of all his poems, "A Letter from Li Po." Li Po likes my story and speaks about wine cups and beautiful young ladies as his own best poems.

At this point my dream becomes blurry, like an ink painting doused with too much water from a big wet brush. I glimpse fuzzy outlines of myself and Li Po in the painting. Then we are washed away.

I wake up. It is morning, sharp and clear.

Of the City of God

✤ **PETER AND I** are at Lingyin Temple—the "Temple of Inspired Seclusion." It is anything but that. The grounds of Fei Lai Feng Xiaoxing Park, lying before the entrance to the temple, are thronged to overflowing with local tourists. Crowds are busy at the soda and souvenir stands; most are heading to the fun house at the peak of the hill. All the great statues of China seem to have been moved to this one spot. But most are fiberglass reproductions, scattered in with real statues carved into the rock six hundred years ago. From a distance I cannot tell which ones are fakes and which are authentic. The whole place is like jumbling Disneyland together with an authentic Notre Dame.

But in a moment I understand why a real temple came to be built here originally. The lonesome mountainside on which the antique statues are carved is punctuated by numerous caves where early Buddhists, first from India, and then, soon after, their Chinese disciples, would have been able to find refuge. Doubtless, in this rather mild climate, generations of monks had inhabited the caves, carving figures into the rock face, until the sect had grown so nu-

merous that a temple had to be built, and Lingyin Si was constructed.

I could easily be cynical about Lingyin. But actually being plunged into it without preparation or premeditation makes me see that I myself, and all of us, are put together in the same way—a bit of commerce here, some shallow pleasures there, old memories, new desires, new landscapes along with ancient plantings, and all fused with an authentic heart and a sacred soul—we are made of such assemblages. I came to China to live in Buddhist monasteries and to revisit my soul. But I see here, right at the outset, that my quest is much more complicated than I thought. Standing amid these holiday seekers and running the tourist gauntlet, I realize that if I am to find myself at all, it must be in the multitudes and varieties that I possess, the shallow along with the deep, and my very human, superficial desires along with my yearning for a bottomless divinity. China is a big place. If I let it, its largeness will match my small self. This visit to Lingyin Temple started as an act of unwilling tourism, but it gives me another entry to myself. Yes, holy devotion and true spiritual ecstasy and meditative silence are here, along with crass materialism and outrageous fakery and even swindles. These are mixed together in Lingyin Temple, in Fei Lai Feng Park, and in me. China is ready to give me true images of myself, if I am willing to take its lessons into my own being.

I walk the long flight of steps up the hill to the temple, trying mentally to make the crowds disappear. The great central temple lies in front of me, ancient but newly restored, all red and gold, pillars and woodwork surmounted by a majestic blue-black tile roof. The front doors are thrown open, and in the semidarkness inside the temple gold Buddhas on burnished altars gleam dimly, inviting me.

Entering the first temple on this mysterious quest of mine is a special moment for me. As Peter had told me, I cannot stay here overnight, only make a visit. Because the temple has been overrun by Chinese tourists from Taiwan and Thailand

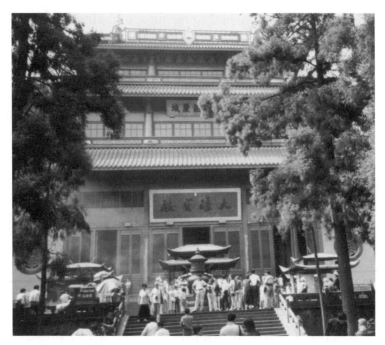

Lingyin Temple

on pilgrimages to spend a night visiting the sacred sites of their ancestors, there is no room at the inn for me. I will have to wait until I arrive at Guo Qing to become a simple monk, an insider, while here I am outside. But, I think, not wholly outside. The wonder is, I *am* here, and since I have come to expand my imagination in a new direction, I might as well start here and now. My dreams have already begun to tell me that I cannot wait for some great, ineffable, perfect moment to arrive and suffuse itself into me. I must *make* those moments myself, or my travails will turn into mere travels.

What will it be like at Lingyin Si when the crowds are gone and the monks go unimpeded about their tasks? For a moment, in my mind at least, the crowds do disappear. I seem to stand alone in the immense courtyard. Silence reigns. The quiet dusk comes on. A soft breeze blows the delicate candles out. It stirs the embers, and little points of light flare up and

die in the incense. The pale electric lights are switched on one by one. I feel in full possession of this temple—it beckons me towards it and calls for me to enter. In the hush of evening, monks in soft slippers glide from every portal and sweep in around me like a silently rushing river that takes me along with it. Inside the temple the chanting is already starting: the hum of valved voices, the musical tones, the rocking rhythm, the intoning of Amitabha's holy name all blend together with my own soul's sounds.

I cannot make this vision last. Chattering tourists jostle me as I stand vacantly at the temple's entrance. It is holiday fun for them. They are, after all, inside *their* dreams. They commemorate their forebears by waving flowers and incense between folded hands at Buddha, bowing, then breezing away with joyful noises.

I settle for an attempt to at least pay a call upon the abbot of Lingyin. In a side building is an office, for, after all, this popular temple is a going business concern. I stand before the monk sitting there.

"I have come from America and am going to stay at Guo Qing in Tiantai," I say, " but I am here now, on my way. Is it possible to pay my respects to the abbot of this temple?"

My unexpected arrival here and the remarkable request I have made occasion no surprise. "I will see," he responds. He gets up, adjusts the wide sleeves of his robe and leaves.

I wait. I see that I will do a lot of waiting in China. But I decide that simply waiting has a holiness all of its own.

After a time he returns. "I am sorry, he is not immediately available. In fact, I cannot find him," he says in a friendly fashion. "But Master Lao Shi is on his way to greet you."

Almost at these words, a short, rotund monk sweeps into the room, folds his hands together in greeting and says in good English, "Welcome to our temple."

"I have come to China because . . . ," I start to say, but I realize that even now I have not yet formulated an adequate explanation of why I have come. There are so many reasons

for me to be here—and, at the same time, no way of putting them into words. What I need is some simple explanation that I can utter whenever the formal occasion arises. But I am standing here openmouthed, and I have to say something.

"I am going to Guo Qing in Tiantai tomorrow," I say feebly. "But I wanted to start my journey at this famous temple before I leave Hangzhou."

"Of course," he says, and waits with a pleasant smile.

When I say nothing in response, he kindly helps me.

"And I think you would like to have us know that you have arrived and are ready to start."

He expresses the very idea that I couldn't produce myself.

"Yes, I am here, starting out."

"But not knowing exactly why you have come and what you will find?"

It was a statement—but politely expressed as if it were a question.

"Yes."

"And now you have found Lingyin. And me. You have started. I think you did not want another day to go by without beginning your journey, as you called it."

I simply nod. He is far ahead of me, even on my own path.

"Well, then," he says, "we should have a cup of tea."

He speaks softly to a monk hovering nearby. Perhaps he says only one word—"tea." And in a minute, while we settle into the straight chairs in the reception room, the monk returns with a carafe of hot water, a teapot, cups, and a brightly decorated tin of tea.

We drink. The room is quiet. For all I know, the tourists have all departed. Peter Lin is strolling outside the window, patiently waiting for me.

Did I come to China to drink tea? My fantasies had been larger, much larger. I had pictured myself discussing complex religious questions with wise masters, settling issues of the universe, perhaps experiencing a degree of spiritual exultation, meditating and soaring with visions.

And here I am, merely being here, without a thing to say, drinking tea.

Yet I realize, to my sudden surprise, I feel happy. Suppose my journey were to end right here? So far I have merely sat in a railroad waiting room leaning against two fine citizens, I walked by West Lake, I had a good dream, and I am here at Lingyin. I feel accepted by this monk and warmed by his tea. If this were all I would be allowed to experience, it would be enough.

I already sense that in China the kind of clarity I treasure back home is utterly pointless. How old is the monastery exactly? (I could consult a guidebook for that data if I had remembered to bring one.) What kind of tea are we drinking? What does Lao Shi think about transmigration? These questions fall away. I just sit and sit.

"Thank you for seeing me," I say as I stand to go.

"Will you come back to visit us?"

"It seems unlikely. I am glad to have been here today."

"In another life, then," he says, his calm eyes twinkling.

"Perhaps," I say. The idea, so easily and lightly expressed, is embarrassing to me.

I join Peter Lin.

"Tomorrow Mr. Hou will take you to Guo Qing. It is a long trip," he tells me as we drive back to the hotel.

I do not use my alarm clock. Mr. Hou will not pick me up until noon. I expect to dream all through a long night about Guo Qing. But no sooner do I lay my head on the pillow than I fall asleep and remember nothing when I awaken. But I feel blissful, as if a dream is just about to begin.

The Ascent

❦ **MR. HOU ARRIVES** precisely at noon with his Volkswagen sedan. Still we delay to prepare for the journey; he insists that first we must have a fine lunch of shrimp cooked with Long Jing ("Dragon Well") green tea leaves at the famous Louwailou restaurant. Tiantai, where Guo Qing is situated, lies almost 125 miles south of Hangzhou. By the standards of Southern California, this trip should take less than three hours. Not here. To my surprise we actually do travel rapidly for a while on a new tollroad, but what with stops for gas and drinks, slow travel on the other roads that wind through little towns, and the fact that this is a Saturday market day, the trip lasts almost six hours.

As we ride along, Mr. Hou switches the radio on and becomes lost in the music while otherwise intent on his driving. He is a fine driver.

I think about where I am going. Though I have chosen to make my way here, I wonder why, really. I have taken Chinese lessons, but will I really understand my new companions? I have studied the sutras and practiced the chants, typical ones, by means of a tape recording bought in China-

town in Los Angeles. As we descend deeper into the rural world, I realize that here there are only Chinese. I saw my last European face in Shanghai. I am a Catholic going to live in a Buddhist monastery and anxious to join in all the rituals there. But can I do it? Have I come to be a monk, or will I be unable to escape my research proclivities and merely study monks?

I know a little about Guo Qing, some told to me by Ying Chow, my Chinese-American friend, who has stayed there. The rest I gleaned from books. I knew that this was the be-all, end-all temple of the branch of Mahāyāna Buddhism that is so central in Chinese history. It had direct connections with the Indian sages who brought Buddhism to China. It is very revered and very old, having been founded in the Sui dynasty, late in the sixth century. In 595, Young Guang, Prince of Jin, followed the suggestions of his teacher, the famous monk Zhi Yi, and ordered a temple to be built at the foot of Mount Tiantai. An unrestored Sui pagoda that was built in 598 still stands majestically near the entrance to the temple, so Ying tells me. Even before the temple was finished—and the initial construction took only two years—it was named "Guo Qing"—meaning, "The country will surely become peaceful and orderly as soon as the temple is completed." Would it be peaceful for me—and would I be peaceful there? I didn't pray as we drove, I just hoped . . . but hoping, I guess, is praying too. For all these facts, Guo Qing is still a mystery that my desires are leading me towards.

We arrive in Tiantai as darkness is falling. The town is bustling with evening traffic, buses and jitneys, bicycles, taxis, motorized rickshaws. There is not a single private automobile in sight.

We take a two-lane country road out of town. On the right, the heavily forested hills rise up sharply from the edge of the road. On the left, the terrain descends precipitously into the bed of a river that runs parallel to the road. Beyond the river are rice paddies and vegetable patches as far as I

can see. Small dwellings dot the high side of the road. Occasional farmhouses can be seen among the fields to my left. As my mother used to say, we are in the middle of nowhere.

A couple of miles from town the monastery entrance appears. I catch a glimpse of an old pagoda on the rising ground. The Sui pagoda. This is *Guo Qing!*

Along the right side of the road is a long stone and stucco wall, before which many carved granite and limestone pagoda-like pillars stand. Once red but now faded to a pinkish-orange, the walls are decorated with inscriptions in brilliant calligraphy and marble panels of fiery imperial dragons. As we pass under the arch over the road, the outer walls of the temple come clearly into sight. Two arched cobblestone bridges

Wall at entrance to Guo Qing

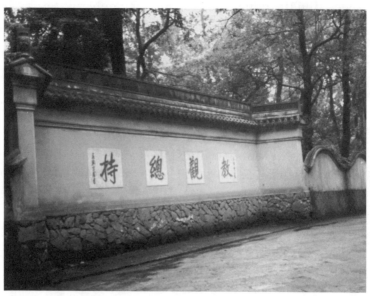

guarded by immense stone lions cross the stream to the temple grounds. The first leads to a public entrance. The gates are closed. The second leads to a big opening in the wall, where once horse-drawn wagons and now trucks get through. We pass the first bridge. I will not enter by the tourist gate. Yes, I realize, I am not a tourist here, but a resident—one of the monks, at least for a while. We turn onto the second bridge. At the entrance is a gatekeeper's room. We stop and he looks out. It is "after hours"; all the regular ceremonies of the temple are concluded. Mr. Hou speaks a few words to the gatekeeper through the little window. Then he drives forward inside the walls to an open space and turns the car around.

"Here is where I leave you," he says.

I had assumed he would spend the night. I feel unexpectedly alone. One part of my trip is ending, while the others have not yet begun. To my surprise I feel nervous, deserted. I have come thousands of miles and taken days to get here, and now that I have arrived at my destination, with its splendid isolation, a little shiver of uncertainty shoots through me.

But this is no time for remorse. Now I have to hurry to get out a good tip for Mr. Hou beyond the agreed-upon price. But perhaps he will remain a few hours longer?

"It's a very long ride back," I say as I slip some bills out of my wallet. "You could stay."

He pauses briefly, then shrugs. "Well," he says, "there is a girl I know just outside Tiantai."

By this time the gatekeeper has managed to communicate to others that I have arrived. I am not to be alone long, after all. A tall man walks down the path toward me. I recognize this stranger whom I have never seen before, because in my bag I have a color photocopy of him, given to me by Ying Chow, an American patroness of Guo Qing, who arranged for me to be accepted here. This is her favorite monk, Chung Miu. He is charged with caring for the "foreign" visitors who occasionally reside at the temple. The temple, as I would

learn, is a very Chinese place, scarcely changed in its ways from its earliest days. I am foreign here—but Ying would be foreign too. She is Chinese, but at Guo Qing she, like me, would be an *American*.

He shakes hands with me heartily, saying, "We expected you earlier. We are very glad you have come."

We both wave to Mr. Hou, and as Chung Miu takes my arm and turns us toward the monastery, the VW clangs into gear, the tires hiss on the gravel, and in an instant Mr. Hou is gone.

Chung Miu says, "Ke Ming, our abbot, will be resting now. I will lead you to your room and show you where to meet tomorrow, and then leave you to sleep."

"I want to get up tomorrow when all the others do. Ying says that this means, 3:00 A.M. Is that right?"

"Yes, around that time. You will hear a bell."

"I'll set my alarm clock for 3:00."

"If you feel more comfortable and will sleep better, by all means do so. Here, you will not need your clock or watch. You will see. Here time is different from what you know. But for now, follow me."

He brings me through passageways, up and down steps, through a dark hallway. When we cross the courtyard in front of the big temple, he says, "This is where you will come tomorrow. Follow everyone else. But try to remember the path I will now take you along to your room, and retrace it tomorrow morning to get to this spot."

In a matter of a half-dozen twists and turns and dozens of steps up and down we arrive at a hall where residents can stay. I feel that Chung Miu has made the way to my lodging sound overly complicated. Following him, it seems very easy.

He leads me to a room at the very end of the hall where there is actually a suite, with a little sitting room separated from the bedchamber. To my surprise I catch a glimpse of a television set on a corner table.

On the floor outside the door are two large red plastic carafes with big cork stoppers in them. Chung Miu points to a table

where there are lidded cups and a tin of Tiantai green tea. "Hot water is in those red jugs," he says, "in case you want tea."

At the window he checks the screen.

"Tight. It's OK," he says. "I don't see any mosquitoes in here. But just in case, do this every night. Watch me." Into an electric outlet he plugs a round plastic dish. Opening a box of blue cardboard-like tablets he slides one into the dish.

"Remember, every night. It will keep the mosquitoes away. When the insert turns white it is no good. Put a new one in. This one will last the night."

He smiles and starts to back out of the room.

I am in a foreign place, in a very isolated, ancient part of the world. I have followed Hou Shih mar and Chung Miu, two strangers whose characters are really still unknown to me. One has taken me all the way to Guo Qing and the other has led me through a darkened monastery as night is falling. As I fall happily into step with Chung Miu and let him lead me, I already begin to feel the first beats of the rhythm of what will be my new home in China, at Guo Qing. I leave my modern world behind and am ready to slide into temple dreams.

But the day is not yet over. Other monks who had learned of my arrival now begin to congregate outside the door of my room. In America, this would have seemed impolite. But such curiosity is natural here. *Another member of the community has arrived. He is one of us, however different, however long he stays. Let us see what he looks like, talks like, thinks like. He is a foreigner, but now he is monk at Guo Qing, as we are.*

As I look up and see them quietly smiling at me from the doorway, my own smile is a sign of permission for them to enter. A dozen monks, garbed in loose gray or brown clothing, tumble into the room, pushing happily against each other as they squeeze through the doorway.

We aren't exactly introduced. What does it matter? Anyone here must have had a thousand names in other lives. Besides, most monks choose their monastery names in order to signify what they wish to achieve. As their aims change,

they may change their names, too, so names are not all that important. Being here, being together, breathing each other's air, is introduction enough.

Chung Miu points to the TV in the corner. "Here is a television set. For a distinguished visitor," he says. This is also said for the edification of the other monks, as if to say: "Look how well we treat this foreigner!"

The way he announces this piece of information makes me realize that this room is probably the only one in the monastery that possesses this rare treasure.

There is a hushed, expectant silence to see how I will respond.

"This is a wonderful room," I say, " a room that anyone would be proud to occupy." At this, I hear small sounds of satisfaction.

"Yes," one monk says, "and with a television set."

"It's a very fine one, a large one," I remark.

Then several people begin to mumble: "The World Cup." "Tonight is the World Cup."

"World Cup?" I innocently ask.

"Yes, in France."

"Football."

"Is China playing?" I am trying to understand.

"No. China is not in the World Cup," Chung Miu explains, "but we are very fond of the matches. The highest salary in China is paid to a football player, we are told."

"Well, then," I say, "would you like to watch the World Cup here?"

Smiles light up on all faces. But they are guarded.

"We could not disturb you in your room."

"If you wished to invite us, we could."

"It would be a special pleasure," I say.

One young monk offers: "We could eat a watermelon and watch the matches."

Watermelon—*waigua,* meaning "western melon"—this American fruit is beloved in China, and now is as Chinese as

tea. Watermelon *and* football!—a humble young monk's vision of heaven on earth.

"Let's turn the TV on then," I say. "Let's see a game."

The smiles flicker out. I hadn't understood.

"No matches are being played right now," another monk says. "The time difference between here and France means that the first match will not start until two in the morning."

Two in the morning. I am still suffering a bit from the long trip I took from Los Angeles, and the thought of being able to stretch out for a night of uninterrupted sleep constitutes, at this moment, my highest aspiration and passion. Even before I have time to think, my answer comes.

"I have an idea. This is my room, but what I really want is to give it to you all, to invite you into my room, to watch the TV whenever you may wish, especially to watch the World Cup matches. Let me take another room." I had seen through open doors that almost all of the rooms in the residence hall were empty. Only a few visiting nuns occupied one room. "Then you can watch the games to your hearts' content."

At this there is a murmuring among the monks. I cannot catch its meaning specifically, but what I do hear leads me to believe that the general consensus is something like: *This American is a true Buddhist. All Americans love television, but he has come to our temple with the most pure intentions, and is even willing to sacrifice his TV.*

And so there is no protest. They joyfully carry my bag to a musty room down the hall, all the while thinking of a nice watermelon party and a couple of hours that night watching Japan play some Latin American country. So I start my days at Guo Qing by easily earning a grand reputation for self-denial in a holy cause. I know in my heart that this flicker of regard, such as it is, is wholly undeserved, but I am glad to have it.

My friends leave my new room to fetch some watermelon and wait until the time for the game to arrive. Chung Miu also departs, but not before he carries down my tea and my

electric mosquito device and plugs it in. He goes back and gets a carafe of hot water to leave by my door. "Goodnight," he says. "I will find you tomorrow and bring you to breakfast."

Alone, I forget my earlier fear of aloneness. I am too excited to notice much. I can scarcely even think. My thoughts flash around like goldfish in a crystal bowl stirred to a frenzy. At the prospect of staying up to await a mere game of soccer, I felt exhausted, but now I feel ready to climb Tiantai Mountain right to its summit—and then keep on ascending like some crazy devotee climbing straight to heaven.

The door is closed. I look around the room. Nothing matches. Everything is worn and threadbare. A bed, a scarred dresser, a table and a chair. These are enough.

The room is a history lesson. I have a flush toilet—and also a chamber pot. A modern bedstead—but the mattress is filled with straw. The walls were painted mustard color sometime in the twenties; but the ancient plaster, gray and flaking with age, shows through.

When Mr. Hou left me, I was scared. Now I feel full of life, a man ready to give birth. I am alone, but also merged in a company of holy men. The spirits of all those who have stayed in this room, some of them undoubtedly unknown saints, cluster around me too. If I cried out in need, the hosts of angelic orders would hear me. Here, at the foot of this magic mountain, one can't really be alone. Lives, soul lives, like geologic layers, are deposited about. Even the chamber pot has been sanctified by the thousands who have used it before me. Everything here is holy—and home.

Yes, home. It all feels so warm and familiar that it is just like being back in the tenement where I grew up. I "know" my new ancient room as well as I once knew every inch of that Brooklyn flat.

The years melt away. In my mind I *am* climbing from Brooklyn to Tiantai in one long ascent.

I am home. But now home is China.

CHAPTER 5

Drawing the Veil

❧ MY MOTHER'S WINDUP alarm clock ticks louder and louder. I don't want to get up and so I keep my eyes shut tight as if it is still dark. I am eight years old. Then the sound changes from tick to *CLICK click click,* the sound going away from me. I realize that my eyes are open and it is dark, completely dark. The clicking sound isn't that hated tick-tock, but the strange sound of a wooden stick hit against wood—bamboo, perhaps. Then I am not eight anymore, but a grown-up. And I am not in my little bedroom on Menahan Street in Brooklyn, but in a tiny, unfamiliar room—yes, it is true . . . in China. A monastery in China, the Guo Qing Temple in Tiantai, Zhejiang Province. And it must be 3:00 A.M., when I said I wanted to get up for morning chanting. Sure enough, my little portable alarm clock begins to beep and the dim light on the face shows 3:10.

I drift, thinking about those old times when I was a boy, when my mother was still alive. In that past time, a sentimental chromolithograph hung above my bed. A little boy sat by a brook listening to a bird singing on a branch. I fall back to sleep. Suddenly a big bell starts tolling. It makes

me jump; it seems almost to be in the room. The clock reads 3:20.

The trick is to get into the present, out of Brooklyn, into China. Here, on the first morning of my stay at Guo Qing, I am already in danger of being late, and so I have to hurry. Try to wash. Should I shave? No hot water. How could it be so hot in the room while the water is so cold? No time for tea. Tomorrow I can shave with hot water. I put on my clothes—not much to choose from—and then the black monk's robe I had been given. At first, I can't find one of the strings inside the robe, and then I have trouble fastening the old-fashioned Chinese knotted button. Yet, in minutes, as the bell sounds more and more insistently, I step into the hallway. Pitch black. Where is the red flashlight I had brought, with "K-Mart" stamped on it in big white block letters? I think I put it in the corner of my suitcase. Sure enough, there it is.

In the dark, Guo Qing is a labyrinth of halls and stairs and twists and turns, for this is no simple monastery. One building leads to another, and in the dark every corridor looks like every other. Guided by Chung Miu on the previous evening, I perceived that the temple was large. But now it seems vast. Recklessly I had assumed that it would be an easy matter to find my way around in the dark. Now I am lost.

But as soon as I see some shapes flitting in front of me, I am saved. All I have to do is follow them. Unless these shades are ghosts of ancient monks, they will lead me where I want to go. Soon, very alive monks are streaming from every direction, converging at a single point—the fine old incense burner in the middle of the courtyard. As I step out into the courtyard and open air, the censer is already aglow with light. Already candles are lit, and in the temple the electric lotus lights on the altar are blinking merrily.

The temple is large and grand, all red and gold, with broad steps leading up to the entrance. Inside, the ceiling seems immensely high. Candles burn, incense streams toward

heaven, lights flash. Sakyamuni Buddha presides over all, a gilded wooden statue twenty feet high. In the early morning darkness the whole impression of the temple is that it welcomes me, wants to take me in, draws me to it. Aside from the brief visit to Lingyin, Guo Qing is my first temple. I know already that henceforth, when I picture a temple, it will be the warm, garish, sacred Guo Qing that will arise in my vision, even in my dreams. As I see it now, this first morning, I believe I will always see it.

If I stand back as an observer of the scene and myself, I would say, "I am content." But I am simply *in* the experience. I am content, breathing easily, without knowing it.

I turn right at the incense burner and walk rapidly up the steps to the temple. Without hesitation I step over the high doorsill, meant to keep evil spirits out. Now I am in the temple's *dian*, the main hall of worship.

There I pause. But a tall monk who must have been looking for me motions me to move to my left. He stops me before a kneeling cushion in the back row. I have a mischievous thought that I might joke and say, "How could you tell that I am the foreign visitor?" Obviously, I resist. After all, I am the only foreign visitor here, so it would have been a bad joke. I nod politely and smile slightly, and take my allotted place.

The temple is still only partly filled with the monks. So, I am early after all. Each monk who arrives at the temple starts a round of the building, greeting each of the statues: Amitabha and the Arhats and Guanyin and Ksitigarba. I am aiming at living the life of a monk in China. So I leave my place and follow them around, doing as they do, holding my palms together, bowing and kneeling. Good morning, Sakyamuni. Good morning, Guanyin. Good morning all.

By the time I get back near my place, it is clear that assembly is in order. I see a solemn man who must be the abbot, Ke Ming, waiting outside the open door of the temple. He stands out from all the other monks because of his

garb. He is dressed impressively in a bright yellow robe with a red garment falling from his left shoulder and reaching halfway across his body. He steps through the door. The big bell sounds. A small handheld bell tinkles. An apple-red wooden drum covered at each end with an animal skin sounds in a solemn way. Ke Ming bows profoundly, practically prostrate on his yellow cushion. The chanting begins. I *am* a Buddhist now. Ke Ming and we, all of us monks, bow and chant and kneel, urging Buddha to be present at our prayers. The incense drifts in clouds toward the roof high above us, carrying our chant upwards, carrying our song of supplication to Buddha.

Then suddenly the whole tone changes, the chant breaks into a rapid, excited hymn of joy. Buddha is here, among us, in the hall, in our hearts. The chant becomes more rapid. It goes too fast for me to keep up. I need more practice. I know "O-mi-to-fo," Amita Buddha's name, which even if chanted alone is said to be powerful enough to earn nirvana. But at Guo Qing this first day, everything goes too fast. The chant runs before me like a gazelle fleeing from a lion. I cannot keep up. The bells tinkle, the wooden drum is struck forcefully, rhythmically, the chanting races on in a frenzy. Buddha is here. Good morning, Buddha. I can only stand in silence as the others express the excitement of his arrival.

Soon, I see that the monks of the first row are beginning to move. The chant becomes solemn but forceful, slower but with increased confidence and strength. Is the ceremony about to end? No, the line of monks passes behind me, and soon Ke Ming, a hundred monks in black or brown robes, three visiting nuns, one Taoist—and I!—begin to make a procession about the temple, around and around, in and out of the pathways between the cushions, backward and forward, reversing direction, as we—or rather they—chant.

We pass by the Arhats, disciples of Buddha. We bow to Guanyin, we walk in the same paths that monks here have traced for more than a thousand years. Their spirits hang over

us, in the smoke, in the rising song. I am wearing a pair of stout walking shoes from L.L. Bean, but as I follow the footsteps of the monks before me and the older footsteps of long-dead acolytes, I feel myself entering an ancient world, wearing sandals, worrying about the doings in the Tang dynasty.

After a long time I see that the monks in the first row are resuming their original places, and soon I come back to mine. The chanting takes on very much the tone of the opening prayers. Buddha departs—but leaves something behind. I see that the ceremony is about to be over. The sexton —a monk, of course—closes and bars the two side doors.

Then it is over. But—of course—not over, since it will resume tomorrow and never end until the world does. And if the Buddhists are right, the world will never end. The monks file out, first rows first, following Ke Ming, and I and the sexton are left to the last. He waves me out. I step back across the sill. No evil spirits have entered here this day—or ever. He closes the central door. It is 5:20 A.M. Breakfast time.

When I was a boy my father and I would vacation at summer resorts. Breakfast was always an agony, the worst way to start a day, with a meal of uneaten Rice Krispies, untouched eggs, and a half-finished glass of milk.

Now here I am in China many years later, at breakfast time, a guest in another country place. The years had at least brought one fortunate change: I had learned to eat almost *anything*.

Good thing! After brief prayers of thanks, a monk passes down our table with a wooden bucket full of congee, a thin rice gruel. As a foreigner I am given a bit extra—on the first day only—a few peanuts and a vegetable. What vegetable it is, exactly, is hard to tell. It is cold—a leftover from some previous day. Is it wintermelon or squash? The congee looks at first as if it would be impossible to eat with chopsticks, but I soon see that it is a perfect child's meal. If I were to do as I see others doing, I would hold the bowl up to my mouth, push the rice toward my lips with closed chopsticks—

and *slurp*. Even as a child, I hadn't been allowed to slurp. At Guo Qing, the dining room echoes with slurping, smacking of lips, and clicks of chopsticks on teeth. The Chinese love noise, noise of any kind, preferably loud, and this mouth music itself seems to engender as much pleasure as the actual food does. I slurp along with the rest. I suppose I slurp in English as the others do in Chinese, but at least in this area I feel that I have mostly mastered the music of chanting in congee language.

Six o'clock. Already the first episodes of my life at Guo Qing are behind me. Lunch will not come until ten-thirty. I want to be a monk—but what does a proper Chinese monk do between breakfast and lunch?

Ke Ming has anticipated me. As I pass through the reception room, the abbot, already reduced to his ordinary clothing of gray blouse and knickers, steps out of his adjacent room and motions for me to take a seat. This seems right as rain. He expects me. I appear. His steward comes in with a tin of green tea, cups with covers, and a blue carafe of boiled water. The cups are filled with tea leaves, and then water. Ke Ming remains silent during the tea making. Now Chung Miu also appears in the room, ready to assist should need arise. Ke Ming calmly inquires of me: "What would you like to ask me?"

This is merely his polite way of opening talk. I am rather stunned that this is all happening so quickly. Somehow I thought that we would work up more slowly to serious sacred matters with such banal questions as, "Where do you come from?" "What is your interest in Buddhism, precisely?"—and so on. But at Guo Qing there is no interest in chitchat or in testing my sincerity. I am here. I am accepted. I can be talked to—straight out.

I ask Master Ke Ming what he thinks is the core of Buddhism? He takes the ordinary question seriously. This is not polite conversation for him. It is so serious that, as he speaks, he writes out in Chinese characters what he is saying so that his words will not be misremembered.

自覺心是佛　　是心作佛
理性德　　　　事修德

修心勝于一念迷心
儻不宗此觀，﹍﹍﹍﹍
對境心不起分別就是定

諸法都是一念心生
一念心具足十法界
十法界一念心生

"According to the Lotus sutra," he says as he writes,
"every person who comes into the world has Buddha inside
him, and that presence is something he can learn about. He
reads sutras in order to know more about the moral and spir-
itual life, and to learn that at the end of the world everyone
will merge together in Buddha. The common people do not
know that we all have Buddha in our hearts, and that Bud-
dha is the people, and that Buddha's purpose is to teach us
and to lead us to the phase of self-understanding. Monks
know this.

"Buddhism is a theory of wisdom.

"When the Buddha arrived at his enlightenment under the
Bo tree, he said: 'Every creature in the world has Buddha-
spirit inside him,' so everybody can be Buddha. But you
must first do what Buddha teaches and follow the directions

in which Buddha leads you. Then you can reach the same level as Buddha."

I ask: "How long does a person have to cultivate his understanding in order to become like Buddha?"

Ke Ming replies: "According to the Lotus sutra, from the time that the Buddha began to cultivate his soul to the time he reached enlightenment he had to pass through the three jewels—the personhood of the Buddha, the dharma teachings of the Buddha, and the community of the faithful—that is, self, wisdom, and the community of saints. And this takes a long, long time."

I ask him about the relationship between Buddhism and Taoism. This is on my mind, since I had just seen the Taoist—recognizable by his unusual dress—who had been taking part in the morning chanting, and who was obviously staying with the Buddhist monks at Guo Qing.

Ke Ming answers: "The Taoists want to be gods, to have a long life and never die but go straight to nirvana. Buddhism says that every person may be a Buddha. But Sakyamuni did not differ from the common people. He met death. So will we all."

Naturally he makes no reference to the Taoist staying here, but continues: "The way to cultivate the heart is to rely on a very peaceful state of interior being and a calm sort of life such as we have here at Tiantai. The mind of the Buddhist cannot allow itself to waver, even in the smallest way, in response to the changing conditions of the world. All Buddhists have three hearts. The first is the 'kind heart.' The second is the 'devil heart.' And the third is in between. The Buddhist should get rid of the 'devil heart' and enlarge the kind heart by cleansing himself of desires."

At this point, concerning the conventional Buddhist antipathy to desires, I ask Ke Ming his opinion concerning what one desire is the most difficult to give up. At once, without hesitation, unequivocally, he answers, "Beauty!" His response is so quick and so unexpected that I am stunned.

"Beauty?" I merely repeat.

"The beauty of women," says this seventy-one-year-old man.

"Do you mean sexual desire?" I ask, suddenly feeling all reserve slip away, trusting in Ke Ming to accept with ease almost anything I could say to him.

"Yes, of course. But not only lust. The desire for beauty is part of our holy impulses, but it can lead us to want to possess

Ke Ming, Guo Qing Temple

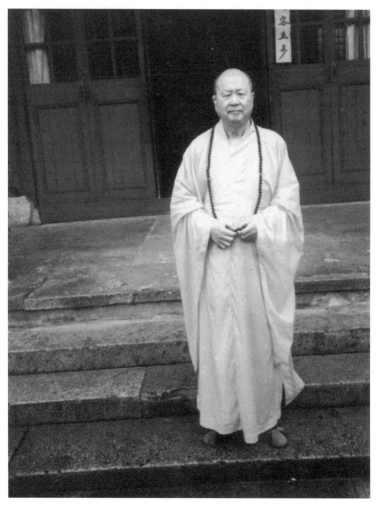

anything beautiful, especially a beautiful woman, and to control her. This means that to have possession of so beautiful a thing or person, you will have to devote your life to keeping it. Now your life is no longer your own. Your life belongs to that woman, or those beautiful clothes, or your house, or beautiful banquets. You have lost your soul and instead are trying to find enlightenment in your senses."

Ke Ming's religious name I'd translate as something like "interested in wisdom," and he was showing here why he had chosen this title for himself. The greatest desire of man is for beauty, but beauty diverts one from wisdom; therefore, wisdom has to displace and dispossess beauty.

I answer: "Wisdom is the most important virtue, then?"

"There you have it all. You need say no more. The rest follows."

I take one last sip of tea. I thank him.

"The hour I have spent with you," I say, "has been very enlightening. Thank you for allowing me to intrude upon your time."

"I encourage you to do so. I understand from our friend Ying Chow that you wish to stay here for a month or more. This is entirely permissible. And then we will help you to find other places to go, and venerable—wise—masters to consult. But while you remain here, come to see me whenever you wish."

Then he adds, in a kind, not stern, admonition: "If you do not do so because you believe I am too busy, I will seek you out."

He speaks a word to a monk who slips out of the room.

"Now," he says to me, "we will have an early morning party.

A watermelon appears. With a glorious gesture, Ke Ming splits it from end to end with one stroke of his big knife, and then cuts off great slabs, handing them out himself, to Chung Miu, to several other monks who appear from nowhere—and to me.

Green tea and watermelon!—an unsurpassable party. At this moment, I realize that this is my birthday party, for it is the first day of my life at Guo Qing. As I bite down on the juicy melon and the luscious water drips down my cheek, I learn that conviviality, generosity, good talk, fun, and yes, wisdom and spiritual ecstasy too, could all so mix and merge and become folded into each other that they became one inseparable vision of the nirvana I could reach at this moment.

The time between breakfast and lunch, I think, can't be spent in this way every day. This is an unrepeatable pleasure. But, I believe, as other mornings flow toward noon, other, different visions will come. There never will be a need, I realize, to call these epiphanies that will come later better or worse—but simply to take them all as good.

Still, one doesn't have a birthday every day. I leave Ke Ming's reception room a wiser and happier man.

CHAPTER **6**

A Newcomer

✿ **IT IS PAST** eight o'clock. My first teaching from
Ke Ming is over. Chung Miu walks back to my room with me
and we agree to meet at nine to take a walk. He wants to
show me the temple. I go back to my room, wash and shave
and reflect upon the day, wanting to remember it all.

I walk outside my hall to wait for Chung Miu in the open
air. A young monk goes by.

"Peru 3, Hungary nil," he calls out.

I see that the World Cup is going strong.

Chung Miu arrives for an excursion. "You must get to know
our temple," he says. This is the day for another lesson.

He tells me that he has spent most of his forty-four years
in the temple. He says, simply, that it is a very sacred place
for him, very important personally. I tell him that I know
something of its origin and subsequent history.

But Chung Miu doesn't want to give me a history lesson.
Instead, "I want to introduce you to Zhi Yi," he says.

This is no historical introduction. For Chung Miu, Zhi Yi
is a present reality. It's as if Zhi Yi is alive, or recently de-
parted. Chung Miu knows as well as I do that Zhi Yi has been

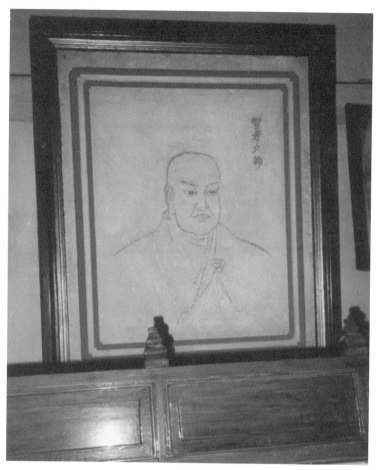

Drawing of Zhi Yi on marble

dead for more than thirteen hundred years. But, at Guo Qing, Zhi Yi is like a big brother, an older friend—gone but remembered by all. His spirit is all around. He might return at any moment, coming to a monk in the middle of any night with a new thought concerning dharma teachings, or he might be glimpsed walking the hills as he loved to do all those centuries ago.

"In a hall near the main temple," Chung Miu says, "is a nice drawing of Zhi Yi. We'll walk over there. Later on, if we can

find time to travel up to the mountains, you'll see another portrait, done on stone, of our old master. It's near his tomb."

We find the temple where the drawing is hung. The portrait is striking. The master looks vigorously back at me. Perhaps he will come to visit me in my room some night? Guo Qing already seems to me to be filled with ancient spirits. Phantasms live here, even in the daylight.

"Even Americans, I think," Chung Miu says, "must know the famous story told by our master Zhi Yi about Zhou Chou, who dreamed he was a butterfly. Zhi Yi tells us: 'The man passed a hundred years as a butterfly. His sufferings were many and his pleasures few. At last he broke into a sweat and woke with a start, whereupon he found he had not become a butterfly, a hundred years had not passed, and there had not been either sufferings or pleasures. All were falsehoods, deluded thoughts.'"

Of course I had heard the story. It had been retold by Li Po, but I heard it from Conrad Aiken that summer he was writing "A Letter from Li Po" at Brewster, on Cape Cod. And now, here I was, where the tale originated, if anything ever originates anywhere. As if I were in a magical diving bell, I had gone from my youth with Aiken down in watery time to Li Po and then deeper to Zhi Yi, and finally arrived here on the ocean bottom of history, at once in the past and also ineluctably in the here and now, the incandescent present. Zhi Yi is almost whispering to me: *You are here! And so am I!*

"Let us walk up now to the library. Let me show you our treasures," Chung Miu says. "We have a rare collection of Buddhist writings here."

We walk to a building close by and ascend to the upper floor. Not one of the buildings in Guo Qing has more than two floors.

A venerable monk opens the door. He is so old that I can imagine him to be a contemporary of Zhi Yi's. He is stationed here to keep watch over the manuscripts that have been collected in this place from as early as the sixth century. He

moves so deliberately that he seems not to move at all. But he steps back from the entrance and we come in.

In a low voice he murmurs words that I assume are welcoming, and so I smile at him.

Here, in this large, airless, dim room, the walls are lined from floor to ceiling with manuscript boxes. Every box is the same—size, shape, and color—about ten inches square at the end and made of a light dry wood. The ancient guardian—Chung Miu introduces him in hushed tones as Master Something, but I cannot catch his name—removes one carefully selected box from the shelves and carries it reverently to a yew wood table, a piece of furniture from the Tang dynasty. He slides off the top of the box noiselessly to reveal the rolled-up sutra inside and then carefully lifts it out. So delicately does he hold the revered scroll that he almost manages to hold it without touching it. I see he is wearing white cotton gloves, but only a millimeter of the cotton touches the ancient rice paper. With anxious care he unrolls the scroll.

The black calligraphy spills down the page like an ancient river cutting through sun-drenched, golden snow.

Of course, I cannot read a single character of this antique text, but with my eyes and words I try to express the amazement that I feel.

Centuries ago some master on a quest like mine sat on a bench and wrote this sutra. I hear the old monk whisper to me that it is the Lotus sutra. I picture that ancient transcriber filling a big brush from his ink cup and spilling these swirls across a fresh sheaf of paper. I see the wet ink sparkle in the sunlight. Perhaps, after all, his quest, his yearning for the ineffable beyond, was not so different from mine. Or perhaps the enchantment I am feeling now is emanating from his written characters, dried for centuries. These enter my heart as if his own heart could flow directly with his inscription and penetrate mine.

The master of the library is satisfied by my expressions of wonder. He rolls this scroll up, and places it back into its

resting place. From across the room, he draws out another container and brings forth a yet older scroll. The characters are more primitive and yet at the same time more intelligible. I cannot "read" them as such, but I feel I see their meanings: here is a character that looks like a mountain, and another that looks like a person; another that is a cup or a bowl. Unlike the more artistically rhythmic musical strokes of the scribe of the Lotus sutra, he who wrote this was living in the reality of what he wrote, drawing characters that picture what they mean.

"It is very ancient," I say to the librarian.

He nods solemnly. This is a place where words are counted out and rationed.

Then he motions me to follow him to a special cabinet, out of which he takes a small box, lettered in gold on its top. He swings the hinged top open, and we, all three of us, look, as if we are dumbly entranced, at the single page, only about seven inches wide, with dim letters inscribed onto a brown leaf. The box is opened only for a second. The leaf is, of course, untouched.

No need for explanation. With forethought, the venerable keeper of treasures has taken me into the ancient origin of Guo Qing and laid its heart open before me, passing in a matter of minutes back through eons almost to a time before time began. I have no golden bough and no Virgil except Chung Miu, but this guardian of the gate of history has let me in. Everything that happens to me at Guo Qing welcomes me, folds me into the monastery, but these fifteen minutes in the library embrace me in the deepest way.

As Chung Miu and I descend the steps, he says, "No one here can read the brown leaves. We are assured by our recorded remembrances of the ancient ones that the characters are Sanskrit and were written on pattra leaves by the Indian master who brought news of Lord Buddha to this place in China. I have seen the leaves three times now in my life. I like to tell myself that Sakyamuni may have looked

upon these very leaves and consecrated them with his eyes. But who can know such things?"

We walk up the steps past the small temple and arrive on a paved ridge above the main complex itself. Here are pavilions and stone stupas—monuments containing Buddhist relics—and steles into which prayers have been etched.

Chung Miu reaches his hands out towards one particular place.

"This is an area sacred to the Japanese. No doubt you will find a Japanese group here sometime during your stay. This is because it was here that the famous Japanese monk Zai Cheng came during the Tang dynasty to study and then to bring the spirit of Tiantai back to his own country. This pavilion," he says, pointing now to a pleasant teahouse-like pergola, "has been built by Japanese contributions, just in recent years. Similarly, that other section over there"—he points some way down the path along the ridge—"was donated by the Koreans. For Korean Buddhism also had its origin here in Guo Qing in the person of Yi Tan, a monk who studied here to bring Buddhism back to Korea."

From this height I look over the main section of Guo Qing. Building has been in progress here for over a thousand years, and I see how much more vast and complex it is than I ever imagined back in the United States. Temples of all sizes, bell towers, dormitories, gardens, monumental staircases, statues, kitchens, study halls—there are so many buildings that I suppose I might never see them all. I turn around and look at the wooded mountain rising above me. I assume that tucked invisibly among the trees are other buildings and pavilions and cleared areas with benches or commemorative stones from antique days. The gravesites of several centuries of monks must be nearby. And what continuations of other places connected to Guo Qing might Tiantai Mountain contain in its unseen reaches?

This is exactly a symbol of my own soul's state at this moment—looking ever more vast and bewildering than

I imagined it to be, but with more and more of it visible. At the same time, like the secrets hidden in the wild unexplored mountain above me, my soul is becoming ever more mysterious to me. I cannot see the top of Tiantai, or how far up to heaven my own soul's peaks might reach. There is still, as there will always be, a lot I do not know.

CHAPTER **7**

An Ordinary Holy Day: A Visit to Qing Wai

❧ **THE BEAUTY OF** Guo Qing is that nothing, and everything, happens here. Every day is the same, and each one is a miracle.

We all arise shortly after three each morning. All year round it is dark at that hour. We wash and dress and do the things our fathers and grandfathers at the temple learned to do, all the way back to Zhi Yi. We pray to Buddha and daily learn anew that we are worshipping the Buddha in ourselves. What a thing it is to discover, if not yet really to feel, that the Buddha-spirit in our simplest souls might elicit the worship of even Sakyamuni or Guanyin, themselves, were they here—and they *are* here! I get that idea clearly from dharma teachings, and I say the words, but I think that only the oldest monks can really feel their own grandeur.

We chant, we reflect and meditate and read. We walk—for walking is holy too. We converse with each other—we keep the wheel of community turning. We teach or learn—what is the difference? We bless visitors. We eat, though if a mealtime were not announced by striking the gong or wooden fish, some of us would forget mealtimes, so little value do we

give to food—except, of course, for the occasional celebratory watermelon or fresh lychee. Some others watch the World Cup games on TV—a rare treat—but I do not do so, even now that I am rested, because they are already monks; they know how to "do" it, how to be monks. But I am not yet accustomed to the monk's way, and I am afraid that watching TV will prevent me from truly experiencing this unique life. (At the same time, I know that this is absurd. Wonder of wonders, I have rapidly realized that even watching TV with passionate engagement can be a sacred activity.)

We monks do not "work" in any sense. Unlike the monks in Europe and America, in China we "work" only at achieving wisdom. And each of us decides on our own how do that.

We make no brandy or Benedictine. We do not cook fudge, as the Brigittine monks do. Neither do we make cheese like the Trappists, or sausage like the monks and brothers of New Skete. We do not train German Shepherds or equip St. Bernards with brandy for stranded skiers. We hire farmers to grow fruits and vegetables. We are vegetarians, and do not even eat eggs, so there are no livestock or chickens to tend.

But we *do* our own kind of work. We aim to be wise. And so we must leave free time for that. For us, wisdom is higher than holiness. Actually, no one thinks of holiness as such. We are holy.

Well, that is to say, we are each as holy as we can be at the moment. We "borrow" holiness from our community, and that helps to teach us inwardly how to be holy, little by little, in ourselves.

Such holiness as this, that is active only inwardly, is hard for me to manage. I wish someone would ask me to do something, some tangible bit of work. I hang around the cooks, and wish they would ask for my help. To chop vegetables would make me very happy. I follow the gardener from tree to tree and bush to bush, hoping he will turn his pruning shears over to me. Then I could say to myself at the end of the day, "I have been a good servant today. I have

earned recognition." But no one wants me to be a servant. The cook smiles at me, the gardener chatters as we go, glad for the company, but they do not earn their own holiness through work, and it never occurs to them that I would want to become holy in that frivolous way. They are content to let me be. I am the only one seeking to earn nirvana by shredding cabbage.

I try to follow the paths to wisdom that others seem to pursue so easily, as naturally as breathing; but it does not seem easy to me. Just being is the hardest work I have ever done. How can I be sure at the end of the day that I have achieved anything at all? If I were asked to climb Tiantai Mountain I would know when I completed my task and how high I had mounted. But to climb the higher heavenly mountain of my own soul, how will I know when I reach the summit? That's just it—there is no summit, one just keeps going. One's own mountain keeps rising to the beyond, even to the dome of heaven.

The hardest thing for me involves the problem of how to read without desiring to read. It is no problem to give up reading itself. I can do that easily—so long as I have another piece of work to do, like writing or revising my notes. But since I turn to reading as a duty, a way of learning wisdom, I see that it is my chief barrier to achieving wisdom. If reading knowledge is required for holiness, many of the monks here will not get to heaven, for I learn that several of them cannot read at all. Were such a fact to be discovered of a monk in Europe or America, a dozen monks would volunteer to correct the deficiency at once. Many monasteries there would have a few Ph.D.'s who would be scandalized by illiteracy. Some orders would even have a reading specialist ready for such a dire emergency. Here, no one cares. Those who don't read memorize the chants or merely mumble. Free from reading, they do other work—they tell their beads, they talk to each other about the future Buddha, or they simply smile at the sun and rain equally. So long as it is work to climb the

magic mountain, there is something unhealthy about it; the only way to get to heaven is to start joyfully at the top—and then keep going. Ecstasy alone is health.

I do not know a Buddhist monk who worries about politics. Politics is the same at all times—the opposite of wisdom —for them. No one reads the newspaper or tunes in religiously to the six o'clock news. The Hong Kong Hang Seng stock market average or the value of the yuan against the dollar is of no consequence at Guo Qing. A monk's "pay" is about a hundred dollars a year; a nun's less than a quarter of that. Not enough to worry about. No one has an attitude about homosexuality, or heterosexuality, for that matter. How can sexual politics count when celibacy is the rule and the route to freedom? Never do I hear anyone wonder what the next menu will be. An American or German monk might want to alter a prayer to make it accord with political correctness, or worry about Jeremiah's view of women. Not here. The ancient copy of the Lotus sutra in the library and the new copy used by Ke Ming have the same text. It would be unthinkable to revise it.

At first I think that the Chinese have reduced life and religion to nothing and are missing the fullness of life. Slowly, I perceive that the Christians and the Chinese simply take different paths to get to a very similar place.

I have come to China for a brief time to learn to be a monk. I have several printed introductions to Buddhism, but I realize now that they tell me nothing. To become a monk here I have to unlearn everything. I think that if I can learn only wonder at my own immeasurable ignorance and at the bottomless grace that is the keel of all creation, I will have learned enough, which would be a very great deal.

I know all this—or rather, almost at the first, I suspect this—but I still cannot resist my old grooves, and I want to visit the great master Qing Wai to learn dharma from him. I already know enough to understand that research, listening to discourses, or note-taking will get me nowhere. If Qing

Wai is to educate me, I know that it will be the way Wagner's Siegfried learns, by understanding the birds of the forest, immediately and intuitively. But I cannot help looking for a teacher. So I go to Qing Wai for that.

Qing Wai knows better. The first time I go to see him he smiles and shakes my hand.

"As you see," he says, "I am very weak. I must be so, for even my own friends are urging me to take some meat extract for strength. What do *you* think?" he asks me. "Would that be wise?"

I have come to him for wisdom. He is reputed to be the wisest person in the temple, wiser than Ke Ming. He is Ying Chow's guide. Everyone reveres him. And right away he is asking *me* if it would be wise for him to take meat extract.

I can give him no answer. In the eyes of the monk who attends him, I see a look of pained fear that this American—me—will mislead or overtax Qing Wai. But the master smiles and plays a little with a bracelet of wooden beads. He does not ask me why I am here, what I want from him. I try to fill the silence by telling him about myself. But when I stop, he has no queries to put to me. I accept silence, and it is comforting.

After a while, he says: "I have a present for you."

From under the coverlet he takes a mustard brown cloth bag. I see that there are Chinese characters on it in bright yellow.

"A Buddha bag," he says sleepily.

It has a modern zipper and looks machine made, but it is a Buddha bag for all that.

He hands it to me. Inside is a bracelet of modern beads, exactly like the ones he has been fingering. I take out a booklet, printed badly, on cheap paper.

"Ah," he says, "the Lotus sutra," as if he is surprised, but very gratified that it is there.

Last is a laminated photograph of Qing Wai himself, rather dwarfed by his glorious ceremonial robes. "To thank you for coming to visit me," he says.

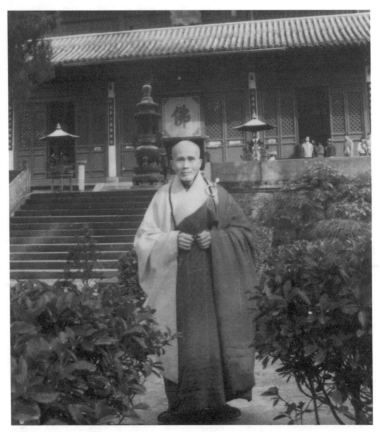

Master Qing Wai at Guo Qing

Clearly, it is time to leave.

"I will think with pleasure about our talk," he tells me. "Please remember me and the dharma we have had when you go back to America."

I leave.

Our talk? The dharma? We have hardly said anything. The wisest master at the most ancient of temples has not spoken a word of wisdom.

Yet, walking back across the great central court toward my room, I see that he has told me by his gestures that what *he* has, I have—the same beads and the Lotus sutra. I had placed

him on a pedestal, and he raised me up to it. We both have the same simple equipment, and if he has wisdom, perhaps I do, too. Our cheap, tawdry bodies, frail, and in his case almost torn to shreds, sick to death, will suffice so long as we carry something of value in them. I have the sutras as much as he does. The ability to pray in equal measure to his own. And he has given me an image of himself to carry with me. It should be up to me how to improve that image. It's Zhou Chou's butterfly story all over again: Am I dreaming that I am Jay Martin, and might I awake to find I am Qing Wai, and he, me?

I ask myself: What will Qing Wai say to all of this should I go back on another day to tell him of it? Perhaps he will say: "I have been dreaming I was Qing Wai, tied to a dying body, but now I have awakened to realize I am in the midst of a fresh new life, as Jay Martin. Thank you for letting me become *you*."

For it was this, after all: In the community of souls—represented here in the community of monks—we do become a part of each other. This ancient, revered one, in reaching out to a foreigner, a total stranger, has scooped my soul into his by giving himself without reserve to me.

I did not learn any words or formulas of wisdom from Qing Wai. But he drew me through wisdom's gate simply by being himself.

CHAPTER **8**

After Breakfast

❧ **ALL MONKS MEDITATE.** So far as I can tell, in China no particular mode of meditation is rigidly prescribed. For some it is good enough to hold together the tips of their fingers on both hands and say Amitabha's name. For others, meditation on a single word in the Lotus or Diamond sutra will suffice. Others reflect on a minute episode in Buddha's life. Still others, I suppose, stare blankly into the ineffable mysteries of nothingness. Some go to sleep and dream.

I do everything the others do. By receiving dharma from Ke Ming on my first day, he and I followed the decorum of the temple. Then he left me to myself. Every now and again I return to him with questions. These he always answers patiently and fully. He talks to me, I think, as long as he believes I am still capable of concentrating on his words. When I am filled to the brim, he brings our session to an end.

Sometimes, after breakfast, I drift back to my room and read some stories from Edward Conze's *Buddhist Scriptures.* I get drowsy from lying there on my bed reading, and I often daydream about the stories, putting my book down and stretching out on my back. Sometimes I even invent stories

of my own about the life of Buddha and other holy persons. I expand the conventional biographies, and I fill in the gaps with wholly new incidents. This is like doing spiritual research. I "discover" what had been previously unknown about Buddha by creating it. Perhaps in this way I really do uncover some truths.

I wander around the temple grounds and get to know the buildings intimately. Behind the latticed doors of the main temple I step into a riot of joyful colors. The floor is dark stone. The round kneeling cushions that are immediately before me as I enter are decorated with cloth petals and made to look like mythical lotus flowers, red, yellow and green. On the red and gold altar are bronze lacquer and stone candle holders and incense burners; at each end are electric lights whose bulbs rise in the center of lotus plants. Behind this is a higher table on which sits a beautiful figure of Buddha in the calming position that wards off desire. Then behind this is a very large, ten-foot-high image of Buddha preventing evil. An altar canopy, decorated and carved intricately, rises behind him. On one side of the altar are the musical instruments, drum and gong and clacker, in rich reds and gold and black. On both sides are rows of brown kneeling cushions. One is mine. The ceiling must be more than twenty feet high.

Then, when I go around to the very opposite door to the entrance, there sits Guanyin, back-to-back with Sakyamuni, the two forces of the world, female and male, bodhisattva and Buddha, the yang and yin of all existence. Surrounding Guanyin is a diorama depicting her rising from the sea, gathering disciples all about her.

On each side of the temple are life-size figures. On one side, very individuated and easily identifiable by name from their looks, are the hundred arhats, followers of Buddha. On the other side are the successors to Buddha—Amitabha and other Buddhas and bodhisattvas, past and to come.

I can locate and name these, but what I can't convey so easily are the glorious colors and the smooth textures, the

play of shadows and light upon the figures at different times of the day. Sometimes, when the temple is being cleaned and polished, I sit inside in the dim, unlighted recesses of the temple and let its cool, unhurried tranquility wash over me. How different this is from the mighty chants that are offered up each morning, when the temple is ablaze with lights and the statues dance in a red and gold fire, or peek through a maze of incense smoke.

Nor can I easily feel the hum that stirs in my heart whenever I enter the temple, alone or with my fellow monks. Something sings in me, but very distantly, so quietly that it is almost inaudible. I make myself silent in order to have a chance to hear these remote grace notes.

This is the way I learn all the buildings. Each one has its own music. The small temple where we pray at night is just as familiar and loved. So is the newer upstairs hall where special ceremonies are held. It is rather vacant, filled only with benches that can be moved around. I visit the little store where tourists can buy Buddhist souvenirs, candles and incense. I begin to think I could walk around the grounds and go from building to building with my eyes closed. So I try it, and with some practice it is possible.

As the days go by, I venture farther and farther out from the still center of the main temple. As Chung Miu had hinted, I find a nice solitude in the Japanese pavilion a little way up the mountain. There I pray for all the souls that had been lost in our war with Japan—and when I realize that I am thinking only of the American dead, I pray fervently for those who had been our enemies. The defeated and the conquerors—all now rest equally in peace. Many of their souls, perhaps, are already leading newer lives of calm generosity, leaving their former hates behind. I try to leave my own enemies behind, too, and it is true that after a while I cannot remember even one person whom I call my enemy.

I go beyond the Japanese pavilion, and invade the wooded precincts of Guo Qing. Ascending the mountain, I

find ancient paths. Doubtless these are old—much older than the antique temple—and must at first have been made by wandering animals, and eventually walked and deepened by those who settled here long before the first Buddhist saints set foot on Tiantai. Less old than these paths, but still very old, are the Buddhist petroglyphs and the rock pile shrines that occasionally dot the hillside.

One day runs into another. Breakfast and lunch are absolutely indistinguishable from each other and from one day to the next. We sit in rows on benches at tables in a large, airy room behind the big wooden fish-gong. Two bowls are turned upside down at each place.

We turn our dishes over, and two monks come to each place with big wooden vessels to fill our dishes—one with rice, and the other with a vegetable. A brief prayer is chanted, and then we fall to eating. Some of the monks quickly empty their rice bowls and go back for more. For me, the rice is—well, rice. What more can I say? But my fellow monks love rice and eat it with gusto. When we have them, the green beans are delicious—seared by the fire beneath the great wok, but still crisp.

I have to admit that I am not overly concerned about getting hungry at the temple, whatever I might be served, for in my luggage back in the room I have a pound of salted cashews and a couple of packages of beef-flavored vegetable jerky that I had bought at Trader Joe's. And so I eat slowly without any thought that I should fill my rice bowl again. However, I seldom resort to my provisions. I forget about them. After a month here I come upon them and taste the jerky. It reeks with a meat smell. On one of my walks I take it into the hills and leave it for the ants. It is, after all, vegetable, and even Buddhist insects will happily feast on it, I think.

Dinner is an exact duplicate of lunch: the same prayer, the same two bowls, the same rice—only the vegetable is different. About this there is nothing to tell. But this poor diet worries me—not for myself, since I will be here only

Prayers before a meal at Guo Qing

briefly, but for the monks who will spend their lives here. I ask a young master, Fo Yuan, "This diet does not offer a complete protein. Don't some of the monks here suffer from malnutrition?"

His answer surprises the part of myself that still clings to Western values, but my new Chinese self is unsurprised.

"We know about that," he says. "Yes, we get rickets from the inadequate diet, and other ills befall us. But we consider the fatigue and the aches in joints and muscles that develop to be further sacrifices that we make in this devotional life. We do not consider it malnutrition. It is Buddhist nutrition."

I see what he means. Yes, the monks find health in this food which brings diseases only to the body, and they really do rejoice at every tatter in their mortal dress. But I can't help thinking of the penalty they pay. The old master, Qing Wai, is so frail that he seldom gets out of bed. He is sunken into the coffin of his dying body. Soon his disciples will close his lids on lifeless eyes. Surely he would have remained more vigorous had he been better nourished, and lived to give dharma

to others after me. But I doubt that when Ying Chow comes here next year she will find her beloved teacher alive.

After dinner, around five o'clock, comes "night-work," mostly consisting of ceremonies performed for families. Sometimes there are additional smaller ceremonies, gatherings of a dozen or so monks. I attend every ritual that is offered.

Best of all are my encounters with my companion monks. Of course, they really are monks, while I am only a temporary one, but I am accepted just as if I were a famous, life-long guru in America, who has come to spend some time with them at Guo Qing in order to ascend still higher, to an almost impossibly recondite pinnacle of grace.

"Why are you here?" I am asked occasionally.

I try to explain. I talk about my interest in spiritual life, I recount incidents in my personal history. They listen respectfully, but I feel I am not convincing them.

One day, I learn why.

"We have asked you why you are here," one says, "but of course we know the answer."

I am surprised and expectant.

"We are sure that you were here in a past life. Of course, you were. That is why you have come back, to visit the holy spirit of your past life."

I realize that there is no way to argue with a Buddhist's impeccable logic.

On another occasion, Fo Yuan says to me: "You are a Buddhist."

I know it will not matter to him whether I am a Buddhist or not.

"No, I am a Catholic."

"A Catholic?"

"Yes."

In any other place, the obvious question for Western empiricists would then automatically follow: "Well, then, what are you doing pretending to be a Buddhist monk?" Not here.

"But, of course, Catholics," Fo Yuan says, "are on their way to becoming Buddhists. You are just a little bit ahead of other Catholics in the journey."

Buddhist logic.

I have talks with my companions all through the day, and after evening prayers and special ceremonies.

When I go to my room alone, I am not alone. For all the remoteness of its location and the solitude that is always available here, no one is ever alone at Guo Qing. No, alone in my room, I take my companions along with me. As I fall asleep I think over the day. My friends stay with me even in my dreams.

Chung Miu and Fo Yuan and I are walking on a hillside. I see only three of us—but I sense another presence. The sun is brighter than I have ever seen it. I am sure there is a ghost, a spirit, with us, but in this glare no ethereal body can be seen. This eerie feeling, that someone walks with us, carries with it a powerful aroma of strangeness.

I awake but carry this dream with me. It seems for a moment that my room is haunted. I stare into the unyielding blackness, but as I sit up in bed, all I see is a flicker of motion in the dark mirror opposite my bed. Is the alien presence myself? Is the hungry ghost myself?

CHAPTER 9

Analysis

❦ FO YUAN DOES not always come to the early morning chanting. He is a serious scholar; he has been to the Buddhist College in Suzhou, and at a young age he is already a master.

He has studied with renowned teachers in temples at Wutai and several other places. He is a really nice person and a devoted Buddhist. I'd translate his name as "Not-to-Worry," and he really does achieve tranquility. Some of his peacefulness rubs off on me. I spend a lot of time with him. He tells me that at the invitation of the American Buddhist Association, he will travel to the United States and spend a year there, teaching and meditating.

At present he is teaching dharma in Guo Qing. Of all the people I've met here, he is the most purely devoted to Buddhism as representing the central truth of humanity. He knows the history of Buddhism and he reveres the great masters. He is strict in his observance of the rituals in which he participates. He certainly believes with all his heart that a monk is at the apex of society. I tell him that in the United States some priests and ministers have been elected to

Congress. He is shocked. "A Buddhist monk," he says firmly, "would never be part of the government. He lives in a different world." When I ask Fo Yuan my question about the most difficult desire to overcome, he says: "For a long time, until recently, I was troubled by sexual desire, but that has passed. Now the emotion that bothers me most is anger that many people in the world hold monks in contempt and do not appreciate our importance." This is certainly a Tiantai idea that the monks are a vanguard party in the quest for Buddha-wisdom, but for Fo Yuan it is also a deeply personal idealization of Buddhism that rules his every act.

On this day he comes to morning chanting expressly to tell me an important bit of news. "We can have the car today," he says, "with a driver. And immediately after eating, you and I and Chung Miu are going to drive up Tiantai Mountain to see the famous waterfalls and stop at a temple that belongs to Guo Qing."

Sure enough, as I step out of the refectory, my two friends are waiting for me. They fall in on each side of me, and shoulder-to-shoulder guide me through the main buildings down past the storage sheds to the entrance gate for residents. I see that they are excited at the prospect of the outing, for they know the pleasure that is in store for me. I do not know what to expect, but I get excited, too, at the mystery.

The black car is waiting for us. The driver is at the wheel. Everyone seems expectant. Even my friend the gatehouse keeper comes out of his cubbyhole and looks on joyfully, as if he is mentally dancing in gleeful anticipation of the great event which I am soon to experience. To my eyes even the auto seems anxious to go. The driver is revving it up, racing the engine, blowing puffs out of the tailpipe. It's like the big excitement just before the New Year.

We pile in. The car tires hum on the loose gravel even before the doors are slammed. We are jolted and jostled in our seats as the vehicle careens out of the gate, turns left abruptly, and shoots up the hill. A hotel on our left, where

pilgrims visiting the temple for a day sleep, is a blur as we go by. Chung Miu is beaming. Fo Yuan is trying his best to maintain his habitual tranquility, but I see a smile peeking out of the corner of his lips. We all like the speed and the rush. Perhaps we are secretly glad to shed a bit of "monastery fever," though we are hardly imprisoned within these walls.

We follow the road up the mountain, and I am surprised to see how high it is—far higher than I have yet climbed, though I had thought that I had gone a long way up the steep path. When we eventually reach a place near the summit, the driver pulls the car to the side of the road and we all get out.

We are at the top of the world. We stand on a strip of grass, on the edge where the ground drops off, and there is only dazed air below us. Far below are clouds. And below that hawks are flying. They swoop and swing a thousand feet below us. And then, still farther below us and for an immeasurable distance, the valley rolls out its carpets of cultivated ground, rice fields, and ribbons of water. There are tiny houses, like the miniature garden decorations one buys in Chinatown, and even tinier boats, guided downstream by fishermen too far away to be seen at all.

"This is Tiantai," Chung Miu says in a whisper. His words are so hushed and reverent and yet so palpable and real I breathe them in and I feel the wonder that he feels.

Fo Yuan cradles one hand in the palm of the other in Buddha's lotus position, and he also breathes in, I think, the majesty that I feel.

I start thinking about how big, how immensely wide, the world is. Condensed into this little patch of China, itself only a fragment of our globe, is all the breadth and width of being that anyone's imagination would require in order to know the world. The world is big, but from this little piece of it the rest could be understood. I cannot see Guo Qing temple below us, though I lean out as far over the precipice as I

dare, until Fo Yuan kindly and silently takes my arm. Perhaps he should not have recalled the danger to my mind. At his touch I almost jump, so hard am I concentrating on the scene. I think, What if I did sail out beyond the road, would not the angelic souls of all the monks who had lived and died in Guo Qing, packed into its upper atmosphere, waft me down softly and safely to the temple grounds? This very air is alive with spirits. But better, of course, not to risk a trial of their willingness to catch me.

So I do not see the little postage stamp of Guo Qing below me. But I realize that it too is large enough to serve as a world. It suffices. And yet I also feel unending richness in my realization of how many places in the world will serve; how many good, holy, complete places exist.

We get back in the car and drive on, arriving at the top in a few turns of the road.

"We are going to Fengguang Temple, " Chung Miu says. "It is part of Guo Qing. Once it was a very famous place. Then it fell into ruin and disuse. Recently we have rebuilt it."

My third temple. Lingyin, my first temple, had been rather overwhelmed by the expansiveness of Hangzhou and the scurry of so many tourists. When Guo Qing was first built, it too was utterly remote. Now the town of Tiantai, about two miles distant, has grown up near it, and it is not so utterly removed from the precincts of society as it was originally intended to be.

Fengguang, I think, seems as if it must always remain very secluded, almost lost in these hills. Chung Miu speaks my thoughts: "The most ancient and the best Buddhist temples are always built in some secluded place," he says. "The grand city temples, such as Lingyin or Langhua Si in Shanghai, may be majestic in wealth, but they are damaged as places of meditation and peace by the skyscrapers that dwarf them, and also by the hectic pace of the city."

It strikes me all at once how different Buddhist temples are from European churches. In Europe, a proper cathedral

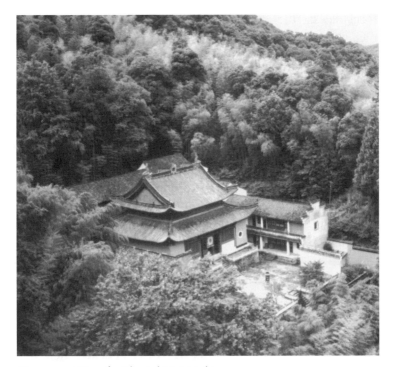

Fengguang Temple, Tiantai Mountain

should be situated in a great city, at its very heart—like Notre
Dame or St. Peter's. It is meant to unify the people and in-
vigorate the hustle and bustle around it with spirit. The
tower bells ring, the grand processions pass in and out, and
the city folk feel anew the life beating at its spiritual center.

But a Buddhist temple is different. It must be set apart. The
people come to it; it does not stretch out to them. A remote
country place or an island is needed for a proper temple. If
a temple is tucked into a declivity where two mountains
meet, that is the best. It should also be built near some natu-
ral wonder, especially where massive boulders may be found,
for these make perfect canvases on which to inscribe Budd-
hist sayings. If there is a cave adjacent, or a crude natural
amphitheater, these would make everything better still. Add
a hot spring or a river that sounds musically over rocks. A

forest is essential, and a bamboo grove would be especially nice.

Chung Miu says that Fengguang Si has it all. Though recently restored, it still retains its ancient dignity and self-possession. We have driven far into the Tiantai mountains, so far it appears that any vestiges of civilization, except the road itself, have been left behind. We do not meet another car. Every twist of the way opens new vistas. But we might as well be on the moon. In the distance other mountain ranges rise up so high they are lost in fog. We have entered what my monk companions call a "Buddhist paradise" of serene, unmoving, unyielding, ongoing nature, magnificent in its deep tranquility.

The illusion shatters as the car pulls to a stop and we pile out. Here in the primal wilderness, I, an American, imagine Deerslayer and Chingachgook stalking their prey. A Chinese Buddhist, I suppose, would just as easily imagine, instead, a white-haired bodhisattva emerging from a simple hut in the woods to greet the first visitors who have appeared here in a decade.

But the first thing that I actually see is an enterprising old lady merchant selling Pepsi Cola from a Coleman ice chest. The first thing I smell is a portable toilet that has not had the benefit of a cleanout for a long time. Civilization has invaded nature—with a vengeance.

To my sorrow, as the path opens up for Fo Yuan, Chung Miu, and me to follow, I see that other small capitalists line the path, lying in wait for the unwary Buddhist faithful who, in very small numbers, make their way here. Three other visitors besides our little party of pilgrims are here also. There are more merchants than there are customers. On many days, the merchants must be the only persons here, and they would have had to walk many miles to get here and then, at dusk, return to their homes. These hopeful capitalists would make ideal candidates for converts to Buddhism, for they exhibit such endurance and hope and faith in the possibility

that a sale might soon materialize that with just a small turn of the wheel they might easily exhibit the same fervent belief in the possibility of enlightenment and nirvana. As things stand, these entrepreneurs have learned to wait by the paths along which pilgrims come to sacred sites.

We run the gauntlet of merchants and eventually leave them behind as we follow a stream beside our path. Soon, fed by other brooks, it is a river that we follow. Now we are in a forest that dwarfs the path and us. If pilgrims such as we did not occasionally come this way, the path would soon disappear into the forest.

By now, the river is roaring, and as the path turns downward, the river begins to fall, but not as smoothly as the path did. It roars over a series of step-like falls. The boulders in it, rolled down from the hills above, grow larger and larger.

And then the forest curtain lifts. The path comes out in a clearing, and we can see before us the river, ever growing and rushing and widening, cascading down until it reaches a precipice beyond which nothing of the river can be seen, only the quiet, grayish-green mountain ranges in the distant background.

In a matter of minutes we reach the falls themselves. This, Chung Mi tells me, is the famous Xiling waterfall. Tucked into the forest here, at the very edge of the precipice, is a temple, ruined certainly, but quite far along in the process of restoration. The steps leading up to its entrance have been restored and are filled in with cement. The exterior has already been painted a pinkish, orangey red.

As we go down the steps Chung Miu says, "Be careful, it's very dangerous here. Look at the bridge."

The spray from the torrent rushing beside us towards the falls drenches the steps. I try to peer through the curtain of spray.

"Look here," he says.

The steps lead to a natural stone bridge beneath which the water dashes at the precipice. Probably eons ago the

water had eroded the rock and worn a hole in it, in that way creating the bridge. Now the same water is eating away at the bridge. It, too, is soaked. If we had gone down the stairs incautiously, we might have stepped upon the slippery stone bridge, and certainly plunged helplessly down the falls.

Before reaching the bottom of the stairs, Chung Miu steers us to the right and into the old temple. Cement bags, paint cans, scaffolding, buckets of whitewash, and all the other paraphernalia of restoration are strewn all through the building. We avoid these booby traps and come out upon a terrace. To our left the falls crash downward. Far below where the torrent calms into a swift river is Fengguang Temple. Seen from this perspective, it is a perfect paragon of calm orderliness. Surrounded by restored buildings and its newly established gardens, it reposes in unruffled contrast to the wild falls and rapids that are part of the same scene. It certainly offers a perfect Buddhist—and even Taoist—lesson, with a calm, sacred center in the midst of nature that is at once easeful and chaotic.

We take a long time to reach the valley floor. When we at last make our way down a safer flight of stairs and into Fengguang Temple itself, I get a surprise. Most traditional temples have a formal reception room where the abbot can hold court. Modeled after the reception rooms in upper class private houses since the Ming dynasty, such a room is usually spacious. At its center, typically, are two lines of straightback chairs and tables facing each other, arranged so that ritual courtesies and conversations can take place there. This is the way it is at Lingyin Si and Guo Qing.

In Fengguang, everything is the same outside, but inside it is very different. We go to greet the abbot in an *office*, not a reception room. He sits at a desk in a modern swivel chair. On the desk is a computer. The walls are not covered with traditional brush paintings, but with bookshelves; and the shelves do not contain ancient camphor boxes holding brittle sutras, but nice, shiny, colorful new books, with paper wrappers, recent books on Buddhism.

And the abbot is not a seventy-year-old sage, but a bright, vigorous man in his late thirties.

As soon as I am introduced to Tian Shan, the abbot, I see that he has already been told about me. He is perfectly aware that I am a psychoanalyst. Most Chinese abbots would certainly not be acquainted with psychoanalysis, but this is a modern man.

Without further ado, he launches into a little lecture: "Sigmund Freud," he says, "did not go far enough. He certainly did not know what we Buddhists know. He arrived at only the seventh Buddhist level of understanding when he 'discovered' the unconscious. I say 'discovered' like that because, centuries ago, Buddhists knew about what Freud called the unconscious—knowledge that goes beyond conscious awareness. Actually, we think that he didn't really understand what he had discovered, and surely he didn't know what to do with it. Of course, he was entirely unaware of what we know to be the eighth and ninth levels."

"I'd be very interested in learning about these," I say— I hope not so skeptically as to be impolite. He would not notice impoliteness anyway. He is intensely focused on the point he is making.

"The eighth has to do with wisdom concerning the truths shared by all people, with what lies behind and around the knowledge of the individual—"

"—What Jung called archetypes?" I half interrupt.

But Tian Shan is not going to allow psychoanalysis to reach beyond the seventh stage.

"No, Jung's ideas are all derived from art, repetitions, patterns. He misunderstood the Tibetan mandalas, as if these were formal structures, artistic ones, which we see all over the world. No, in the eighth level you enter into the world of spirit, beyond the individual. The individual, one might say, 'melts' into the world of spirit. It's a bit like that sacred religious 'oceanic' feeling that Freud acknowledged to Romain Rolland he couldn't understand. Jung couldn't really

understand it either and reduced it to aesthetics. And that is precisely because neither of them understood the ninth level, or even perceived its existence."

"And the ninth—?"

"It's the direction of the Buddha. Without a clear understanding of what direction Buddha demands of you, what good is knowledge after all? Psychoanalysts 'empathize' with their patients, they give them support, they 'give them a frame,' they 'mirror' them. But what good is all that, pleasant as it is, when this kind of procedure, which is based on not understanding the eighth and ninth levels, just 'mirrors' back the patient's neuroses? If the analyst doesn't have a direction —a really good direction—the direction of Buddha—to give the patient, how is the patient to know where to go in his misery, and how to take a path out of it? Without Buddha-knowledge, both the analyst and patient are simply stumbling about in the dark. That's why so many people, and most patients, are lost today. Do you tell your patients to find the Buddha inside them?"

"No—"

"Then all they will find is their own sickness, 'sickness unto death.' What a poor thing to discover. That has already led them into disaster. They certainly need to find health— health in Buddha."

Figuratively, I guess my mouth has been hanging open since I walked into Tian Shan's office. "You'll catch flies," my mother used to say when I did that. Certainly I am surprised by the pretty wide acquaintance that Tian Shan has with contemporary psychoanalysis, with even an allusion to Kierkegaard thrown in on the chance that I might not credit him with learning.

Still, that he is nervous all during this discourse I have no doubt, for he constantly moves his beads between his fingers, he taps his foot on the base of his chair, he arranges and rearranges the sleeves of his robe. At first I think that these are signs that he might be afraid I would take offense

at his scathing attack on one of my professions, but soon realize that this is not the cause of his agitation, for his nervous gestures continue even though our discussion of psychoanalysis ends.

In fact, I really do not feel any sense of annoyance at his words. Like many other Buddhists, he is simply passionately absorbed in his spiritual quest, and I know he is trying to assist me in mine. He means to give me instruction. But above all, what I learn from him is an example of a faith so simple and pure that it survives his education. I conclude that he doesn't like Sigmund Freud, but he wants to like me, and he hopes I like him.

I am right. He has had his cook prepare a lunch that must have strained to the full the culinary resources of his little monastery. We eat eggplant in garlic sauce, green beans and tofu, vegetable noodle soup, watermelon, cabbage, greens, and mushrooms. We consume a whole garden, it seems, in one meal, Tian Shan, Fo Yuan, Chung Miu, and I. Tian Shan expresses special wonderment, as all Chinese do, at my use of chopsticks—there seems to be a fixed belief among Chinese, especially those who have never seen a Westerner, that the use of chopsticks is a genetically endowed capacity of the Chinese. Still, he insists on helping me, piling food on my plate, filling my soup bowl, pouring fresh water into my green tea. He is as generous as any emperor.

Lunch is finished.

"Now, we will take a nice stroll in the forest along the river," Tian Shan announces.

We pass through the moon gate of the monastery, amble down a smooth path, and walk into a beautiful, tall bamboo grove.

As we come out beside the rushing stream, I am glad to see that Tian Shan is already beginning to relax. Chung Miu and Fo Yuan go ahead, chattering merrily, like two liberated birds. Tian Shan stays with me. We have to clamber over big boulders, and he usually goes first. He doesn't caution me in

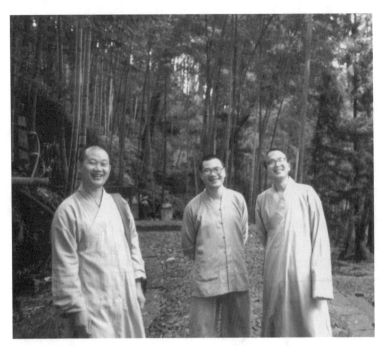

(left to right) Chung Miu, Tian Shan, Fo Yuan

any way, but I notice that he is watching me to be certain that I do not slip on the wet rocks. No, he cannot unshoulder his cares entirely.

We pause for a breather, sitting in the sun on a big flat rock. I decide to ask him the question I asked Ke Ming and others.

"Would you mind if I asked you your opinion about what the hardest desire to overcome is, on the way to enlightenment? And, what do you think is the greatest virtue?"

Tian Shan is a very bright man and supremely aware of what motives drive him. He is also honest, painfully honest. His answer allows me, at least a little, to understand why he is so nervous. We start walking again as he answers. He can't sit still.

"You see, back at the temple, we have a computer, and we're on the Internet . . . Be careful," he interrupts himself suddenly, as I go sliding down a big rock drenched by the

river spray. "These rocks are slippery." He catches me by the arm as I slide by him, and stops me from falling. This does not interrupt his thought. He is very organized.

"That computer is of great use to us. Right now, I am downloading sutras that have been newly edited and published in Taiwan. Maybe you think I'm not answering your question—but I am. I don't really *need* these sutras. I believe —I *know*—that I can do all I need to do in the world without all the scriptures that I have never seen. If I had only *one* sutra, that would be enough. I know that. But I *want* more. There is a danger in this desire.

"I love finding what the scholars have put there. I love the commentaries. I love the scholarship too much. I could stop at that and say no more. It is a great fault. But to answer your question truthfully, I have to say more. I love the machine itself, the keyboard's sound, the glowing screen, the shiny metal, the mystery of it all. I get pleasure just from holding a disc. I love to get a response—I mean, any response. It's even exciting to install a program. It's bewildering for me, but true: I love the computer too much. I can't get it out of my mind when I'm in the temple, anywhere near the machine. I picture myself just resting my fingers on it, holding the monitor between my two palms. Just to picture turning it on and to see Windows 95 come up on the screen—even that is thrilling.

"Yes, my yearning to be on the computer is the one desire that defeats me. I try to stay away from it. I think I will assign the tasks on it to another monk. But then the crazy thought—yes, crazy, I hate to admit it—comes over me that I would have to kill the monk who has taken it over, so that I could have it back. It is 'mine.' I feel like a spoiled child.

"You ask about the greatest virtue. That's just the trouble. I say that the greatest virtue is wisdom. I believe that. But then, what I'm calling my greatest virtue justifies my worst vice, for I tell myself that my love of the computer is just coming from the love of wisdom, even though I know that

the machine itself is what I love, and that will never lead me to wisdom, no matter how much dharma I print out.

"But if I cease to discover the teachings that are on the Internet, the wisdom there, then I won't be true to my goal of achieving the direction of Buddha.

"So I'm trapped, and your questions hit me between the eyes. If I don't go to the computer, I soon come to feel an incredible urgency to turn it on. If I start to work on it, I am feeling that it is a millstone around my neck, calling me to itself and away from Buddha."

Finally he stops. He shakes his head sadly.

No person ever in my life has answered a question of mine with such an anguished flood of words. This torrent, so similar to the river that is crashing and dashing down the rocks beside us, is ready to push him under for the third time. He has almost given up hope. And I have nothing to say. Tian Shan's "bad" desires, he believes, are so intermingled with his "virtuous" aims that he cannot untangle them. This is tragic for him. There seems to be no way out: if he possesses the virtue, he has to accept the vice. It is easy to see that this worries him a lot. I start to blame myself. Out here, in the forest, where keeping a solid footing as we climb across gigantic rocks takes all of his attention, he probably can usually find a little peace. But my questions bring him back to his worry. He sags visibly and falls into a long, gloomy silence. I feel bad that I have been the cause of his unhappiness, when he had meant nothing but kindness for me.

For a long time he says nothing. Then he mutters: "You know, I've made a vow not to leave Fengguang for three years, and during that time to try to give up desires." He says this, almost despairing, pleading for surcease of sorrow.

We both know that this self-imposed exile from the world will be of little use. Once, hardly more than a century ago, a monk in Fengguang could have been completely cut off from the rest of the world. But now the modern world reaches its fingers into the most remote places. Where once there had

been footpaths, used rarely and only by devout pilgrims, now there are roads. Tourists who come to Guo Qing can jump into their cars and take the difficult road here, inspired by a desire to stand under Xiling waterfall. Casually, they might throw stones in the river, or float an empty plastic Coke bottle down it. Worse, they can stroll over to Fengguang and thrust themselves into it, lighting incense, trying to open the locked doors of the temple, rattling the silence away.

But even these are not the problem. During the long winter months, snow falls heavily on these mountains, the roads are fairly impassable, and tourists make no appearances for weeks at a time.

No, the real devil is the one that Tian Shan himself has brought into the temple, and into his heart. The day that he first unpacked and plugged in his computer, the whole of the modern world flooded into the sacred space. There is no way it can ever be pushed out again.

Eventually we say our thanks to Tian Shan and our goodbye to Fengguang Temple. Chung Miu and Fo Yuan will doubtless be back here again, but I am sure that this is really good-bye for me.

Our way back to the car takes us, of course, through the same gauntlet of merchants that we had walked past earlier in the day.

Fo Yuan, who is usually calm, looks increasingly upset. I see the fact, but I don't understand the reason. His mood grows darker each time that we pass a merchant who has captured some little animal or frog or turtle or fish to keep imprisoned until a sensitive Buddhist comes along and buys the creature in order to free it. Otherwise, after a period of confinement, naturally, these animals will die. The devout Buddhists hold life so sacredly that this is a horror to them, this torture of the creatures' souls, these premature deaths.

At last, Fo Yuan can stand it no longer. He stops before a woman who has two plastic liter bottles containing fish imprisoned in a little water.

I can see that he is just barely keeping his rage at the woman bottled up as he stops in front of her. She is as indifferent and unruffled as he is overwrought.

"How much?" he says, jabbing his finger at a bottle.

"Ten yuan," she answers.

This is an enormous sum, at eight yuan to the dollar, especially on a monk's salary, but it is obvious that Buddhists are ripe for the plucking and will not be let off easily.

"Both bottles," he demands, "for ten yuan."

Imperturbably, from a sack behind her she lifts two more bottles. "Ten yuan each," she says, raising the ante. Now there are four bottles staring Fo Yuan in the face.

He is furious. Quite unmonk-like, he throws a crumpled ten yuan note into her lap, seizes one bottle, and marches relentlessly toward the river. If ever anyone had a penumbra of storm clouds surrounding him, it is Fo Yuan at this moment.

Chung Miu and I wait patiently. I suppose that he, good-natured fellow that he is, feels just as deeply, as Fo Yuan does, the Buddhist commitment to the sanctity of life. But he is too realistic to think that he can ever buy up the world of captured lives. No matter how much money he has, at least one Chinese entrepreneur will always be one step ahead of him, he knows. Even when the last bell of the apocalypse is tolling, an imperturbable Chinese matron will be standing at the edge of doom, swinging a bird in a cage, and he—he would find he had spent his last coin freeing a turtle. What is the use? He has learned practical wisdom.

He doesn't say anything like this to me, and he studiously avoids any reference to the fact that we are waiting for Fo Yuan to free three fish, while thirty still remain in various bottles along the path. But his smiles and winks and his chirping chitchat make me guess that he finds this rather amusing. Doubtless, this sort of thing has happened before while he and Fo Yuan were together.

Since we must wait for Fo Yuan, I have time to ask Chung

Miu the question I ask often: "What is the hardest desire to overcome?"

"This is different for each of us," he says. "I heard you make this inquiry of Ke Ming, and I heard his answer. My answer is, for me what I find hard to overcome is the desire to possess the attractions of society."

I see his problem. He is a very pleasant, agreeable fellow in charge of foreign visitors. He comes into frequent contact with the outside world—more than any other monk at Guo Qing. His talent for sociability is his greatest asset and therefore it also causes him the most difficulty.

Fo Yuan returns, with the same crunching steps—and an empty bottle. He is not content. For a moment he stands in front of the woman. He tries to stare her down, to intimidate her. He attempts to pierce her with his eyes and to impale her on the prongs of his moral superiority. Even I can see that this is a total waste of energy. She—she calmly takes out a pack of Marlboros, lights one, and wafts a puff of smoke in his direction.

That is it! The storm cloud breaks. Thunder and lightning are in his eyes. For a moment I am afraid that Fo Yuan might leap upon her and pound her, just where she sits, into the ground. But, instead, he throws the now empty plastic bottle into the dirt and begins to stamp upon it. Then he jumps on it with both feet. He has lost control. This young master looks like a cartoon character. The bottle is flattened, but it steadfastly refuses to pulverize. Clearly he wants to reduce it to atoms, or smithereens—whichever is smaller. But the Pepsi Cola Bottling Company had other ideas and the bottle is virtually indestructible.

He gives up—but he is not calmed. Methodically, he bends down and picks up the flattened bottle. He gives the woman one last contemptuous glare and lets the bottle fly, like a Frisbee, far over her head, into the woods.

Poor Fo Yuan! I know that afterwards he will regret this last gesture of scorn. In fact, two days later he confides to me:

"I keep thinking about that plastic bottle, you know. I was so angry with her that I forgot that, throwing it carelessly as I did, I contributed to the littering of that holy place. Somehow I thought I'd punish her by destroying her bottle so that she couldn't use it again. But I keep thinking of that bottle lying in the forest from now to eternity. It will never decay. And I will never forget that in being angry I gave myself a punishment that will last through many lives."

Poor fellow! Like Tian Shan he is much too serious. He thinks and thinks and broods about the most minute acts of his life. What will happen to him, I wonder, when he gets to America, where the temptations are so much more numerous and will come at him in swarms, like mosquitoes in Minnesota?

CHAPTER 10

Changes

 ❧ TIAN SHAN IS a remarkable person. Anyone can see that. He would be remarkable anywhere. But daily at Guo Qing I meet others who are just as remarkable— though on the surface they are simple people. Mostly these are residents of the temple, monks; but they could also be visitors. I am thinking about a visitor I met once and never saw again.

Every evening after dinner, we monks troop out of the refectory and, after a few minutes' pause, we head back to the small temple for night prayers.

What I call the small temple is, at Guo Qing, actually quite big. I should say it is the "smaller temple," for it is about eighty feet long and forty feet wide. As I enter I look straight ahead at the triple altars, each in back of the other, each bigger than the other. First a small altar, hardly more than a carved table, with electric candles and incense burners on it and a very small but beautiful Buddha. Behind it is a higher altar, with three figures placed on it. The center one dominates. Then, finally, near the very back of the temple is a large altar with Happy Buddha on it, flanked by vases. On each side of the

figure are wooden panels incised with beautiful calligraphy. I look up. The ceiling is beamed and illuminated by green lanterns. At evening it is still warm here, and electric fans are running above me. On each side of the central row of altars are benches behind long tables. For evening prayers we sit, not kneel. I turn left at the entrance and go in.

This is the time that most of the families who travel to Guo Qing in order to perform some special ceremony show up at the temple. I am told that in temples located in cities I will see some families even at the early morning prayers, but Guo Qing is too remote to receive visitors that early. So they come at night.

On this night at Guo Qing a family of four—a husband and wife and two teenage girls—show up at the door immediately after the monks file in and take their places. You can tell that the man, the head of the family, is a farmer just by looking at him.

The bells ring, the wooden gong sounds, the drum beats, and the chanting starts immediately. We know our ritual. We have performed it every day since the sixth century.

The little family at the doorway doesn't know what to do and stands at the temple's entrance awkwardly. I can see that only the wife has any but the vaguest idea about how they are supposed to behave. The husband stands there, rocking stupidly from one foot to the other, while the two teenage girls giggle and awkwardly push at each other. The older one is looking at her mother, trying to catch a clue concerning the correct ritual. The younger girl focuses her concern entirely on trying to pull her miniskirt down. No matter how hard she tugs, it will never reach her knees. She is a very modern girl and will not stay on the farm long. In a year or two, perhaps, she will be found in Shanghai. I am close enough to her to see that she has beautiful nails. On one of her pinkies alone she must have lavished a thousand times more attention than she is giving to the ceremony this evening. No farm work for her. I say a little prayer that she will be safe in Shanghai, find a

good man who works in an office, get married, and go to computer school to become an expert in information technology. But I am afraid for her future.

Xin Cai, the master of the ceremony, a very solemn, even stern, man of middle age, comes up to them, motions them to enter the temple, and places them before the small altar. A little uncertainly, they hand him some packages, which he places on the altar.

The ceremony starts. With various gestures Xin Cai indicates when they should bow, when they should light incense, and when they should pray. He takes from them red strips of paper on which characters and prayers have been inscribed and lights and burns them.

The wife does her best to observe the instructions he is giving them. But the husband soon starts to look bored. He gets out of sync with the bowing and kneeling. Eventually he stands vacantly as an onlooker, letting his wife do the best she can for him and the family. The older girl is the most awkward, self-conscious person I have ever seen. She bows like a figure made of wood, without joints, twitching and jerking rather than flowing. In less than a minute, the younger girl tries to disappear into the woodwork. She edges away from the altar and presses herself into the slim shadows of the back wall.

I am at my usual bench sitting on the left side of the temple. Only about half the monks are here tonight. No one takes attendance, of course. I suppose I am doing pretty much the same thing as the family. I am partly involved and casually participating, but also partly looking into Buddhist texts, partly taking note of the little family, so obviously even more inexperienced in Buddhism than I am, and partly drawing a diagram of the temple in my notebook so that I will remember it in the days and years to come.

All at once, I notice that the husband has fixed his eyes upon me. He must be amazed to see me, so evidently not like the other monks, unlike anyone he has known all his life. To

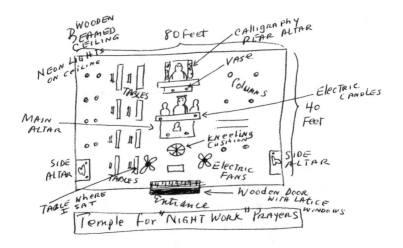

The diagram is labeled with: WOODEN BEAMED CEILING, 80 feet, CALLIGRAPHY REAR ALTAR, NEON LIGHTS ON CEILING, VASE, Columns, TABLES, Electric CANDLES, MAIN ALTAR, 40 Feet, SIDE ALTAR, Kneeling Cushion, SIDE ALTAR, TABLES, Electric FANS, TABLE WHERE I SAT, Entrance, Wooden Door WITH LATICE WINDOWS, Temple for "NIGHT WORK" PRAYERS

him I must look like a strange beast that has wandered far from its territory, working its way from a foreign continent to this one. I must look like a polar bear strolling down to a Malaysian beach resort, or an elephant finding itself in Port Lockoroy in the Antarctic. I am the perfect distraction for him. I provide just the excuse he needs to drop the ceremony that he finds so boring because it makes him feel uncomfortable. His eyes light on me with interest and he detaches himself from the ceremony and walks swiftly toward me.

He sits down next to me with a big smile on his face and regards me in silence.

"I'm from America," I tell him.

He is not surprised. Had I told him I was from Switzerland or Sierra Leone he would have remained calm. He is fully prepared for the greatest of surprises.

"Ah, America."

"And where are you from?"

At this he *is* surprised. I have caught him off guard.

"Why, from Tiantai, of course. Where else would I be from?"

All his life, I see at once, he has been among people who know who he is. All his life he has lived near Tiantai. He

knows everyone who lives near him; he has always known them. They have always known him. No one ever asked him where he is from.

But he recovers quickly from the shock of my ignorance and tells me about his life.

"I am here at Guo Qing because my mother died. It is for her we come. My wife knows about these things. We will come every seventh day, seven times, to say prayers for my mother. She was very old when she died. Seventy-five years old. Sometimes, my three older sisters will also come. Their daughters, my nieces, will come, too. I think they will all come seven days from today. Just now, only my own little family is here. We took a taxi to the temple. We came here an hour early. I was not certain how long it would take to get here from the farm. Yes, I am a farmer. Please let me introduce myself. My name is Xu Sanlin. My father was a farmer. We were always farmers here."

"And my name is Jay. I am just staying at the temple for a brief time," I say.

I decide that I should give him a little more information about myself, to balance all that he has dropped on me.

"I am from California," I tell him.

He smiles broadly to show that he welcomes this incredibly interesting piece of information, but I can tell that he hasn't the slightest idea what California might be. I am not ready to give up.

"I grew up in New York City," I continue.

This strikes a little spark, but also causes confusion in him. An exchange of a few words clears up the reason for his confusion. Yes, he *has* heard of America. Not of California. He has a dim awareness that he has heard of "New York City." But he believes that New York City is the name of a country. What I had told him, then, is as utterly incomprehensible as it would have been if he had said, "I come from China and Japan and England."

No, he was Xu Sanlin from Tiantai, period! I should have

said, "I am Jay from Claremont," and we would have been on the same wavelength.

It's a good feeling—as I have said, one that I frequently had in China—to attract interest and even admiration. Especially in rural places I am a rarity. In China, I learn what it must feel like to be a truly fascinating person.

For Xu Sanlin, I am not only a strange planet that has drifted into his orbit, I represent the extra benefit of justifying his withdrawal from the boring, unfamiliar ceremony.

He notices my open notebook, in which I had been diagramming the temple. He seizes upon that. He picks up my pen.

"I'll write my name for you, so you can remember me. You will keep it."

And he did, he wrote it down—my own pen, writing in Chinese—something I myself could not do.

"Now you," he points to the page.

"You want me to write my name?" I ask.

"No. You write *my* name. Let's see."

I take a deep breath and dash it off. To me, my rendition appears almost perfect, a virtual Xerox of what he wrote. But he looks at it rather curiously. Perhaps he is very punctilious about penmanship. Or, equally likely, maybe an ever-

so-slight slip of the pen caused me to write something like "the manure dump" or "the limping rabbit"—perhaps something worse!

There is only one way to get out of this pickle.

"Now, I'll write my name," I tell him, "and you copy mine."

I do. Then, to tell the truth, he does a very creditable job of copying it. But, after all, my pen is fully accustomed to writing in English, but is not at all practiced in Chinese.

Meanwhile, one of the younger monks whom I call Charlie has also wandered around in back of us. When he sees a chance to write in English, he reaches over and takes the pen from Xu Sanlin's hand and writes his version of my name —not quite as good a job as "Three Forests" had done.

With the two girls in tow, Xu Sanlin's wife comes over to get him. It is time to "burn money" for the use of the dead. He insists that I go with them. Outside the temple, by the big censer, the family has piled up red paper wrapped packages. Inside the wrappings is newspaper cut up into the size of yuan bills. This represents "money" that the deceased will need in the next world. The two girls also made red paper models of items that their grandmother will need in the next world—a little house, some rounds for paper plates, strips for chopsticks, an automobile, and such. I think it is nice of them to give the old woman a car in the afterlife. She would never have dreamed of owning one in this life.

I help to unwrap the money so that it can be burned. Pretty soon, we have a good blaze going. We burn up a million or so of eternity yuan, as well as all the necessities of life—in death.

The wife drags the girls back inside the temple to finish the ceremony while Three Forests and I poke half-burned scraps toward the fire to be sure that every cent is deposited in the heavenly account.

At the very last, one of the girls is sent out to fetch her dad. The chanting stops. Xu Lin unwraps a bowl full of one yuan pieces, and as the monks file out the door, each takes two coins. "Night-work" makes a small but valuable addition to a monk's meager income.

At the end we five all join together outside. I bow slightly to the wife, smile at the two girls, and survive a hearty farmer's handshake from Three Forests. Good-bye all.

Night shadows lengthen over Guo Qing. The solid wood doors of the temple are quickly closed as soon as the candles are all snuffed and the electric switches snapped off. In the censer at the entrance, the last fragments of the paper fortune sent up to heaven glow in little points of light and flicker until darkness extinguishes them, too.

Just as a three-quarters moon starts to show above the pine trees that cover the hills in back of the temple, I make my way through the labyrinthine hallways toward my residence before the night becomes so impenetrable that I might be lost until the next morning.

CHAPTER **11**

Among School Children

❦ GUO QING FLOURISHES sufficiently in fame that when the buildings seemed in danger during the Cultural Revolution, Zhou Enlai placed soldiers around it to keep it safe. Even under Communism it is a national treasure. After all, way back in the Tang dynasty it was known as one of the "Four Uniques," and in the 1980s it was named "one of the main temples of Han nationality."

Today, patronage from abroad is flowing into the Guo Qing coffers, with no apparent interference from the government, and so Ke Ming has started ambitious building and restoration programs. Fengguang's renewal is one consequence of that. But rebuilding is starting up in several places on the heavenly mountain.

It is mid-June. I have been at the temple a little more than a month now, for I left California as soon as my college duties were ended.

Xin Cai, the master of ritual, has a fine idea. "Today, a truck is delivering building supplies from our warehouse to a remote place where a ruined temple, once a very beautiful one, is being rebuilt. It was completely broken down."

I listen, simply content to be noticed by this man who seems to be the most reserved monk in the temple.

"I am going to see my friend who is in charge of a handful of monks there. He was at Guo Qing until this new work began."

I wait.

"Why don't you ride along in the truck and I will show you this very interesting project?"

"I'd be glad to go."

With Xin Cai, a word is as good as an act, and he leads me immediately down to the truck, without allowing even a second for me to visit the toilet or get a drink. I understand that a monk well practiced in meditation can go for a day without urinating. I must meditate hurriedly, for I am already in the truck, and we are off!

It takes over two hours to get to the site. I have conquered my bladder. Perhaps in another million years I will become a sage. The stone and stucco walls around the temple are well preserved, broken only here and there. They have stood for a thousand years. We drive on a dirt road through the wide gate, rumbling the modern truck into the ancient enclosure. Surely, the last time this temple had been active, trucks didn't even exist. Only wagons drawn by horses and lumbering oxen passed through these gates then.

And, sure enough, just beyond the front entrance, in the fields lying before the scaffolded, partly rebuilt temples, there are oxen and horses. The farmers who are helping the monks and craftsmen in charge of the rebuilding are engaged in preparing the fields to be rice paddies. The plots for rice are already dug and channeled for irrigation, and a few inches of water fill them. On the right side of the road tiny emerald rice plants are being dropped into the rows of muck. On the left side, a farmer is still plowing furrows into the moistened soil. His plow is pulled by a great hairy ox. Even for this strong animal considerable effort is required to draw the big iron plow through the crud. Over on each side of the

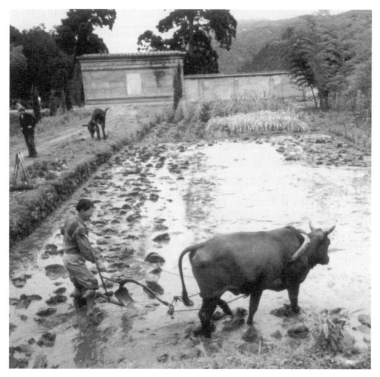

Outside the ruined temple

rice fields vegetable gardens have been planted, and green shoots are already showing through the dark loam.

Our truck stops between the rice fields, for some supplies need to be unloaded here, and Xin Cai and I jump out.

We walk up to the main temple. No one is working on the scaffolding. The shell has been partly reconstructed, but once we are inside it is obvious from the shafts of sunlight that pierce the walls how much is still to be done.

The woodcarvers are busy at their work. They hardly notice me. They nod pleasantly to Xin Cai, but keep at their task. Immense, unpainted wooden statues of the two main figures—Sakyamuni and Guanyin—are emerging from blocks of wood. Perhaps the antique originals were carried out and burned by marauding Red Guards during the Cultural

Revolution—or more likely stolen by the military leaders. So new ones are being carved. Wood shavings cover the floor, curled off by the long planing tools. Invisible clouds of cedar fragrance perfume the sacred air. The shaved statues are themselves emitting delicious scents. Merely to breathe them in is to live in a heightened atmosphere. Except for the last sandings, Sakyamuni, I can see, is ready to be painted. Red lacquer and gold will soon seal in the fragrance, like a mummy in its wrappings. Guanyin is merely roughed in— but indubitably she. Over toward the back of the temple, someone has placed an old three-foot-high gilded Laughing Buddha on an uncut block, as if a temple, even the skeleton of a temple, needs the presence of a finished Buddha to sustain it. Perhaps that statue is all that keeps this ruin standing; perhaps it is all that keeps hope alive.

Eventually, this shell will be completed, painted, and occupied by devout acolytes, chanting and praying and rising in spirit even as their songs and smoke rise to the ceiling. But I am glad to have seen it in this simple, unfinished, naked state. I have looked upon Buddha bare, and that is beauty too.

Sakyamuni dominates the room and calmly seems to promise that all will certainly be finished in good time. Patience and faith are all that will be required—that is the sense that the simultaneously finished and unfinished Sakyamuni conveys of what it already is and what it will become—past Buddha and future Maitreya Buddha simultaneously.

The master of the band of five brother monks comes running into the temple, disrupting our peace, but bringing sociability back into our world. He skips over to Xin Cai and seizes both his hands.

"I was working outside the walls and heard the truck. I am so happy you've come."

Even though Xin Cai is a stern, very regulated fellow, he melts at seeing his friend. I can see that he really enjoys greeting him.

"And this is Mr. Jay, who is with us now," he says.

"I have heard. Come, let me show you our grounds."

This is actually a large complex. Everything is in shambles. Beams prop up the walls that have not yet crumbled. We walk about and look into the broken residence hall and the wrecked room that must have been a kitchen once. We see smaller temples in even worse shape than the main hall. In some places only a hole where a foundation once existed is visible.

This is a very rural place, so remote and removed from paved roads that for months or perhaps seasons or years a resident would see no unfamiliar face. There is no famous site here, like Xiling falls, to attract visitors. Even the word "resident" seems wrong, in the sense that it points to a population. This is an isolated temple set in the midst of nowhere. It's amazing, though, in China, how often in what looks like a completely unpopulated landscape you will come upon a child walking home—how far?—from school, or a solitary woman toting a plastic bag of supplies to some remote destination. And so I should have known that if there are a few workers here hired to reconstruct the temple, and some farmers planting rice with a water buffalo and a dog, then there will also be women nearby. And if there are husbands and wives there will certainly be children.

And, of course, there *are* children. When the three of us reach the most remote building on the temple grounds, it turns out to have been converted into a little two-room grade school. In the first room that we look into, at the instant of our appearance the children collapse into a frenzy of stares, giggles, and astonished gasps. The teacher looks at us so angrily I immediately withdraw from the door. We look into the other classroom. There is no teacher in it. Each little scholar sits at a two-person desk, hands folded, perfectly quiet. When Xin Cai and I step into the room, several pairs of hands unfold to cover up astonished faces, especially of the shy girls. These perfectly behaved children are the first,

fourth, and fifth grades of this rural area. The schoolroom is the poorest possible, with unpainted plaster walls and crude double desks that were constructed, obviously, by some of the temple workmen. The only adornment on the wall is a picture of a Chinese soldier. A big coil of construction wire has been thrown into the back. The "blackboard" is not slate but a board painted black and tilted against the wall. But the children are very neatly clothed. The girls wear dresses with collars, and all of the boys wear jackets with shirts buttoned to the neck. They are bright and attentive, waiting a little apprehensively and a little excitedly to see what will come out of this strange person who has dropped from the moon into their classroom.

Obviously, no one here has ever seen a non-Chinese person before. I ask them about that. They say it is true, and we start to talk. The hands come down and the smiles come out. Then one brave boy says "hello" in English, in a loud voice, and the room erupts into an uproar of laughter. I say "hello" back, and another volcano of laughter follows. We are all instant comedians. To cause a riotous uproar all we need to do is utter any English word. All are astonishing. Then someone else calls out "hello," and I say quietly, "How are you?," pronouncing every syllable clearly, which allows one boy, after a pause, to say, "How are *you*?" That makes another sensation—their own classmate is speaking English.

"Where do you think I come from?" No one is willing to be committed to a guess. Perhaps they think it is a trick question. Or do they wonder what else there is in the world besides China?

"Have you ever heard of 'the United States'?"

More silence. Expectant smiles. They look as if they think I am about to tell them a remarkable secret.

"How about 'America'?"

Broader smiles. Yes, they nod, they have heard of America.

"Has anyone heard of California?"

None.

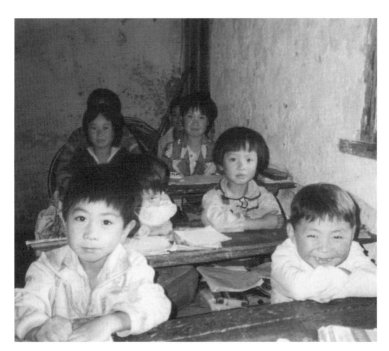
Children in rural school

"New York City?"

Still none.

"Hollywood?"

"Mickey Mouse?" someone says vigorously. Yes, they had heard of him—"Mi Lao Shu," they tell the younger students.

"Well, I come from Hollywood, America!" It wasn't quite true, but it was true enough. Where Mi Lao Shu lives.

Ah, the secret is out. The world is clear again. I am an American, an intimate of Mickey Mouse.

"Hello!" a girl suddenly breaks in with a low voice, then hides her face after exhausting her entire stock of English.

"Hello America," someone else says.

"Do you know where America is?"

No one knows such a magical secret.

"Let me show you." I pick up a lump of chalk at the board and draw a map of America. I put the United States in the

middle of my map. In it I write "U.S.A.," forgetting that to them the letters U. S. A. are as incomprehensible as chicken scratches. "And here is 'Canada' and here is 'Mexico.'"

"And now," I inquire, "where is China?" No one ventures to locate his own country. To the west I draw China, and I try to fit in a peninsula for Korea and a long island for Japan. I probably give the Orient a whole new configuration.

I put in an "X" for Los Angeles on my map of the United States. "That's where I come from." Lots of smiles. *His* home. *He* lives in "X."

Now I put a "Y" indicating a place somewhere near where we are in our classroom. I scribble in waves between the X and Y and say, "This is the Pacific Ocean. Water."

I get serious attention, wide-open eyes, knitting of brows.

I draw a line with an arrow pointing from X to Y and say, "I flew an airplane from here to here—X to Y."

Pause. Bewilderment. I guess Y does look that far from X. Then I say, hoping I remembered correctly, "This is about ninety-five hundred miles. A long way."

This produces complete incomprehension, dazed looks. Finally Xin Cai whispers to me: "They don't know 'miles'."

Myself, I hardly know kilometers. I tell them it is 17,500 kilometers. Astonishment. I realize that I am probably ruining their geography for good. If their teacher comes back, perhaps I could be arrested or at least deported for corrupting Chinese education. The newspaper headlines would read, "CRAFTY AMERICAN TRIES TO SUBVERT CARTOGRAPHIC EDUCATION OF CHINESE YOUTH!"

Still, I smile at them. They beam proudly at me. Even if they understood nothing, we had a talk.

I want to leave at the pinnacle of good will. I take photographs of them all. And, finally, I trot out an American word that I think they might know. "Bye-bye," I say.

Here I am definitely right, for a ringing chorus of "Bye-bye" shoots back at me as I leave my first substitute teaching post in China.

The abbot wants to give us tea, he wants to keep Xin Cai longer for old times sake, but the truck driver warns us that unless we start soon night will fall, and driving on these treacherous mountain roads will be difficult.

I hadn't realized that time has passed so quickly. Chung Miu had been right when he predicted I would not use my watch at Guo Qing. I had put it in my dresser weeks ago.

But the sun still tells the time, and it tells us to go.

CHAPTER **12**

My Magi

❧ 1: The Cook

Every day at Guo Qing I pass through the kitchen several times. This room contains two very large woks built into a wood-burning fireplace and several wood-fired burners for cooking rice. In addition there are a few tables, crude shelves, benches, and racks on which wooden serving buckets are set. Usually, I'd see the cook and his four or five helpers cutting and peeling or stoking the fireplaces. All is usually calm here. Just once, as I passed by, a wok became overheated and a great fire burned up the vegetables for lunch.

But, as I say, calm usually reigns in the kitchen. The center of this peacefulness is the old cook. One afternoon, after lunch, as I pass through the kitchen to get back to the Japanese pavilion where I had been reading earlier, I find him alone. He sits on an ancient bench, leaning on a long table which is black and scarred from years of chopping. He looks up at me inquiringly, but certainly not intrusively, as I am going by. And so I pause and say, "The broccoli was delicious." My comment is an invitation if he wants to take it that way.

He motions for me to sit down opposite him at the table, and when I do he says shyly, "You come from somewhere." He doesn't know quite how to begin, but I can see that he has some sort of inquiry that he wishes to make of me.

"Yes, from America."

"There are lots of places in the world," he ventures.

"Well, yes."

"And have you gone to other places besides China?"

"Yes, many."

"Please, would you tell me the names of some of them?"

Just as I am about to start, I find myself in a dilemma. I have no idea what the Chinese names might be for, say, Tanzania or Monte Carlo, or almost all other places in the world. So, I say, "But I have to say them in English."

He waits patiently without an answer.

I think, *He wants an answer, and so I'll really try to be complete.* I start with the continents: "In Africa, I've been to Kenya and Tanzania." Then I remember that I had also been in Morocco and Tunisia. I go on to Europe, trying to picture the map, and say: "England and Wales and Scotland and Ireland. Sweden, Norway, Denmark, Germany, Belgium, France, Switzerland, Spain, Italy, Gibraltar"—and on and on and on, until I cover all the places I can think of anywhere in the world.

I finish naming all the places I can remember—but I soon realize that I left out Andorra and even Portugal. I add them, then stop. I forget entirely about the Americas. Out of pride of travel I think that he will probably be dazzled by all the places I have been, while he has probably never been any place but Tiantai. But he is not dazzled at all.

This ancient, simple man summons up his most kind, polite voice and responds: "I can hardly give belief to all that you have said."

He hastens to explain by stretching his arms out as far as his fingertips can go. "China is so big," he says, "that it occupies almost all of the world. It simply could not be that there would be room enough, outside China, for all these places

to exist, unless they were very, very tiny." He holds his thumb and forefinger an eighth of an inch apart to indicate extreme littleness.

In my silly American rationalist way, I want to argue with him. I am ready to contend that China is not *that* big, and that there is plenty of room left over. I am ready to tell him about the time I lived in the Soviet Union, and how many miles—or kilometers—it is from Moscow to Samarkand or Ulan Bator. But almost immediately I feel that this will be impolite, a denigration of China.

"Yes, indeed, China is very big and many of these *are* very small," I say. "Why, you could walk across the Vatican, for instance, in a quarter of an hour."

This satisfies him completely, or almost completely. He smiles broadly as if to say, *I knew it!*

"But America," he adds, to give me back a compliment, "America is not that small. America is a fine place."

"Yes, it is not as small as the Vatican," I say truthfully.

"But, of course, not as big as China."

"No, certainly not as big as China," I say forcefully, though I am not at all sure myself that the United States isn't as big as China. I realize then that my own sense of geography is nearly as poor as his. On *my* maps, the United States is in the very center, and China is split in two, making it difficult to compare the sizes.

"Of course," he says, "in America you have heard of Thousand Buddha City?"

I don't know how to answer. I just repeat flatly, "Thousand Buddha City." I end with a slight question mark. I feel that I am about to lose my credibility again.

"Yes," he tells me earnestly, "it is a very famous place in America. Everyone knows of it. We believe it is there that the start will occur when everyone in America becomes Buddhist."

He looks at me quizzically. Don't I know about it? Am I really an American?

I pause only briefly. Perhaps he means the Hsi Lai Temple in Hacienda Heights, the largest Buddhist temple outside China. There certainly are at least a thousand representations of Buddha in it. Or is it a place near San Francisco? "Ah, Thousand Buddha City. Yes, Thousand Buddha City," I say. "Of course. It's a wonderful Buddhist place. Yes, everyone must know of it."

With a simple lie I get my credibility back. The cook is a happy man. I stand up and bow slightly and say my "see you later" and promise to come back to talk to him again. Actually, I do come back, many times. I stand beside him while meals are being prepared and watch as he supervises the preparation. One day, I even volunteer to help him and his assistants chop cabbage. It doesn't seem to me possible to chop cabbage incorrectly, but I'm afraid, from the strange looks I see, that I am doing my cabbage wrong. I talk to my cook about the stars above Guo Qing and about driving a car, and about the zoo in San Diego. He teaches me lots of things, but mostly just how to be at peace. I think of him, and his kindest of faces, often.

11: The Gardener

One day while I am having a conversation with the cook concerning what flying in an airplane is like, a middle-aged man seats himself at the table and listens politely to our discourse. I wonder about him, for his head isn't shaved. And unlike all the monks who wear soft gray or brown outfits during the day, he wears a dark blue jacket.

I nod to him, and he smiles at me.

"Chung Miu thinks you will like to see my trees," he informs me.

I realize that he has been sent to look after me.

"Of course, I certainly would," I answer.

The man in the dark blue coat turns out, not surprisingly, to be the gardener. He leads me to the upper reaches of the

temple and with pride shows me the miniature trees that he grows. They have been pruned and clipped and tended with holy care.

"I suppose that everyone at Guo Qing is a monk," I say curiously, instead of saying directly that I wonder what his position is. I have not yet learned Buddhist directness. I am being too circumspectly polite, like a well-mannered American. But he goes right to the point.

"Oh, no," he says. "There are many people at Guo Qing who are not monks. Let's go down by the kitchen where I found you, and I'll show you a remarkable sight. We hire farmers to grow our food. They should be coming by just about now. Have you ever seen them?"

I hadn't. Usually in the afternoons I'd continue my morning's reading for a while, then take a walk in the hills.

Nothing is stirring by the food storage room, and we stand under the big wooden fish while he tells me all about how to start and maintain bonsai trees.

Then a half-dozen farmers troop in.

The Middle Ages come alive. Each carries two straw baskets full of vegetables hanging from a bamboo stick which he balances on his shoulders. The sight of people toting heavy loads is not, in China, anything remarkable. It is their costume that looks medieval. Each wears a tattered broad straw hat on his head that, in my childhood, I would have called a "coolie" hat. Their upper bodies are sheathed in a dark brown, very rough sort of jacket that looks like it is woven of horsehair and hemp. To my eyes this vest appears insufferably itchy. The shoulders point outward stiffly. The jacket reaches below the waist. It almost seems like a short coat of armor. It looks so thick and matted and hairy that no sword could cut through it. My friend tells me it is woven from aquatic reeds and is waterproof. Beneath this jacket each wears a white or gray cotton pullover shirt and, below that, loose gray pants that reach only to the knee. On their feet are crude sandals. The farmers are followed by several stern,

aged women carrying enormous loads and dressed in black or dark blue coolie blouses and long black pants with slippers. The hair on each woman's head is braided in one strand. They look just like extras from *The Good Earth*. World War II and the communist revolution and nuclear weapons and cell phones are not even distant rumors to these farmers and their wives or slaves. The clock runs backward. For a moment I am in a world that passed away several hundred years ago.

The gardener introduces himself as Sheng Tai as we walk back to the gardens.

"As you can see," he says, "those are certainly not monks. With the help of a little crew, I could grow the food we need, but Ke Ming believes, and of course he is right, that we must continue to support the farmers whose ancestors always grew food for Guo Qing, for hundreds of years, for generations of families."

We go slowly from one small tree to another as he carefully clips a leaf or twig. "No, there are many people here who are not monks. I myself am not one."

"Really?" I say, to urge him to continue.

"Yes. I am now forty-two years old, and I have been here for nineteen years. When I first came I was certain that I wished to become a full member of the community. For four years, I listened to dharma, I chanted and prayed, I meditated and reflected. And then, after all that, I realized: now I am less sure I want to be a monk. For three more years, I did the same. Then I found myself less sure. I did the same again. For three more years I prayed to Guanyin. Then I prayed to Buddha. And was less sure. At last Ke Ming spoke kindly to me: 'I think you have prayed enough,' he said. 'Perhaps you are thinking too much, trying too hard to achieve wisdom. I want to find something you can *do*. What shall it be?'

'I do not know,' I answered.

"'All right, then,' Ke Ming said. 'I am a busy man here, locked in my office too many hours. I am no longer young,

and for me it is hard to walk the uneven paths of Tiantai Mountain. Make me some miniature trees and place them by my office so that I can walk out now and then and be surrounded by the calming forest that you will create for me.'

"So that is what I have done for the last nine years. I am not sure right at this moment that I want to be a monk, but I am waiting to learn whether I shall be or not. Perhaps something in my past life has to be worked out before I will know. Or perhaps I will become one, after all, only in my next life."

In the days that follow, I see that he works not just on bonsai trees, but everywhere in the extensive gardens of Guo Qing. Perhaps this is, after all, his religion in this life, what he has instead of Buddha, for the bushes are always pruned, the trees are clean of dead branches, the flowers bloom with fresh colors, and the subtle distillations of their perfume mix and merge and drift sensuously on the summer air. It is as good a vocation as any, and he does it scrupulously. I am learning that Buddha is everywhere, as common as a leaf or summer fog, or the rich dirt that feeds the plants.

The gardener and I often like to stroll about the property. I try to learn the names of all the plants, but this seems impossible. I discover that I have a special form of Alzheimer's limited exclusively to learning names of botanical species. Often we end up near the entrance to the temple. Here we stop to talk to the old gatekeeper. I really believe that the first time we do this it has been all planned for him to bring me here. For the gatekeeper immediately exclaims with pleasure at my presence, as if he is especially surprised, and shows me that he has a little porcelain bowl of peaches.

"You will have one of these peaches? It would give me pleasure," he urges me politely. To accompany me, out of courteous fellowship, he and the gardener each take one.

I am about to take a big bite out of mine, as Americans tend to do, when I see the gardener unfolding a little knife with a wooden handle. Deftly he slices the skin off, careful

to see that I am watching him. He peels it in one ribbon. Then he hands the knife to me, and I do the same.

The gatekeeper has really nothing to say to me. For him, it is enough that the three of us sit together, in silent fellowship, eyes glistening, holding our peeled peaches up to the sun like the golden fruit of Guanyin. For me, it is just as good an expression of holiness as chanting. On this first meeting, toward evening, as the three of us huddle together in the gatehouse, I find in these three juicy peaches and my two companions a simple summary of the holiness of Guo Qing.

III: Yin Ling: The Nun

Three nuns stay at Guo Qing during most of the two months that I myself remain there. I get to know one of them, Yin Ling.

My impression is that two of the sisters, who are painfully thin and very severe looking, are precisely what a Buddhist Puritan might look like. These two are earnest and unsmiling, correct to the utmost degree in every rule of the rituals. They are even more strict than Xin Cai. Of course, their heads are meticulously shaved, which itself is strange for me to see. Hardly a stubble of hair is allowed to peek out before it is razored away. And both have coin circles burned into their heads. It is painful to see and even more painful to imagine— but it must have been, of course, ever so much more painful to do: to place old Chinese metal money on your shaved head and burn incense on top of it until the coin burns into the skin, leaving a permanent scar. Of course, the coins have to be placed in precisely measured rows, arranged on the scalp with geometrical exactitude. On the head of one of the nuns two rows of four "coins" each are deeply burned. On the other are four rows of four each. I never saw anyone else with more than these sixteen coins. To me this last nun looks so solemn, so serious and rigid that I believe she could endure any pain. She is the epitome of the suffering, saintly heroine so common in Buddhist legends.

I never hear these two nuns speak. I know that they do speak—for I see them leaning close and whispering to each other—but they never speak to me, or near me.

But with the third nun it is different. She is short, under five feet, and round and unscarred by coins. But most of all, she is jolly and talkative and interested in everything.

One night when I come back after "night-work," my friend Sheng Tai, the gardener, sits talking to the third of these nuns. Naturally, I say, "Hello, Sheng Tai." He introduces us. Her name is Yin Ling. But in my mind I think of her as the Happy Nun, for she looks for all the world like the little roly-poly Laughing Buddha that is seen in every temple in Southern China. Perhaps she is destined to become him in her next life and is trying out his body in this one.

With little in the way of preliminaries, she gives me a friendly test.

"How old do you think I am?" she asks, with a big grin on her face.

I do not welcome this sort of question, for a guess too high always brings discouragement and a guess too low proves one a fool. Besides, I don't feel confident at all in estimating the ages of Chinese faces or hands.

There is nothing to do but take a leap into the dark. She looks about—say—thirty-two, and so I say, "Twenty-six!"

Bingo. She and Sheng Tai are struck dumb. Amazement and delight combine.

"But how old am I, then?" Sheng Tai demands.

This is easy. In his excitement he has completely forgotten that a few days earlier he had told me a lot about his life, including his age.

"Forty-two!" I say instantly.

Astonishment!

"It is magic," he says reverently.

Outside, a monk walks by the door. Sheng Tai leaps to his feet and collars him.

"Come inside, come here," he urges. "He's guessing ages."

He places the monk before me.

"Try."

I might as well get it over with.

"Forty-four," I say. He looks older, but I calculate that this is about the oldest he could be, for the Cultural Revolution had left a gap in the initiation of monks between about forty-five and fifty-five.

"Forty-three, I'm forty-three," the monk says happily. He seems pleased that I got close and, I imagine, happy that I have been stumped, though, actually, I see that my failure also disappoints him a little.

Mischievously I decide to trick him. "But *close* to forty-four," I say.

"Yes, in a month I will be this age."

This is a partial victory: as anyone can see, he is closer to forty-four than to forty-three. But I decide to try for a complete triumph.

I ask him in what time of the year he was born, and he tells me that it was in the late summer.

"How do you know this?"

"My mother herself told me so."

"But are you sure she did not say: 'Early summer?'" I summon as much authority into my voice as I can. "Yes, you certainly, very definitely, look to me to be an early summer baby!"

"Is it so?" he says in a doubtful tone. "Do you think so?"

I appeal to the others. "What do you think? *Early* summer, eh?"

They believe in me. I have converted them to absolute faith.

"Early summer, surely," Sheng Tai declares.

"Early summer," Yin Ling chimes in.

The monk himself is persuaded. All his life he has been joyfully believing what others tell him to believe. He takes authority on faith.

"I think she may have said 'early summer,' yes I think so, for I grew very fast and they say that by the fall I was quite a robust boy."

"Then you are *already* forty-four," I say.

My three friends are even more full of wonder. Two of them *knew* I was right about them, and the third is now also convinced of it. Even the monk himself didn't know how old he was—until I told him.

"I didn't know I was so old. Thank you," he says with a little nodding bow.

I see Sheng Tai start from the couch to fetch another subject in for ratification of his age, but I stop him.

"I can do no more than three a night," I say.

Even at the time that this was occurring, I realized that a bit of the shrewd Yankee character had worked its way into my personality. I reminded myself of nobody so much as Hank Morgan, the Yankee of Yankees, in Mark Twain's *A Connecticut Yankee in King Arthur's Court.*

Yes, it is cheap magic—but it amuses my friends. The story goes around the monastery. These lucky three whose ages were divined by me are briefly the center of attention, for only they had seen this wonder, and only they can tell it authentically. I didn't do it—I think—to enhance my prestige, as Hank did, but to delight these people whom I really liked.

When the guessing is all done, Yin Ling tells me a little bit about her life. First of all, she and her two friends came here from a temple near Ningbo to learn dharma from Qing Wai, who, everybody knows, is dying. Second, they came to say special prayers for the father of the most severe nun.

She herself, the Happy Nun, has listened to Buddha-wisdom from the time she was a little girl, and when she was eleven years old she joined her female master in the temple. She didn't have her head shaved until she was fifteen, when she knew she would be a nun forever. Tomorrow, the three will return to their temple. Meanwhile, it has been wonderful to hear the teachings at Guo Qing.

"And I will never forget that some Buddha sent you here, with your old soul and its gifts," she says to me. "Think of

the incredible lives that you must have led already, and those you still have before you."

It makes me feel a little ashamed that, after all, without intending to, I bought regard with luck and my tawdry tricks, but I get over that pretty quickly when I see how really pleased she is.

"I hope you will come to the special prayer we are having tonight for my companion's father. It will be an honor, a special blessing, to have you take part in these prayers."

Of course I go to the ceremony, about an hour later. It takes place in one of the upstairs rooms. It turns out to be the strangest sort of ceremony. Two monks sit behind a rickety table up on a small stage. Their robes are red and yellow, and they wear red, medieval-looking cocked hats. They chant in strange, wholly artificial, high-pitched falsetto voices, and they ring bells continually. I close my eyes and merely listen. It sounds for all the world just like a Chinese opera.

Visiting nuns at night ceremony

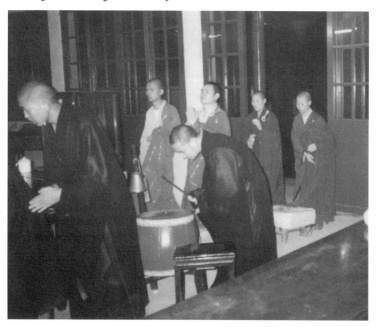

Thirty or forty monks are in the room—just a hall, a big vacant hall. In the back row the three nuns stand together. Each wears a ceremonial brown mantle over her grey robe.

For the sake of this night they made a very long journey. They follow the ceremony carefully, seriously.

I can't follow it at all. I understand hardly a word of this squeaky singing. My attention wavers. But I try to keep some focus. In my notebook I start to make a quick sketch of the celebrants—if I can call them that. The monk next to me sees my sketch and somehow communicates to others—who must have been watching me anyway—that something of interest is happening, for several drift by to peer over my shoulder.

A sudden controversy erupts. The onlookers whisper agitatedly among themselves. Perhaps I am breaking some rule or offering some unforgivable affront to the ceremony by sketching the leaders? No. A monk emerges from the whispering as the deputy of the others.

"We say that in your drawing you have made his nose too big." He points to one of the figures. "It looks like an American nose. American noses are big like that."

With a stroke of my pen, I scratch out half of the indicated nose. There is a murmur of approval behind me.

"Americans have big noses?" I ask.

"Yes. Chinese have good noses, little noses." There is no insult whatsoever intended in this. It is just a fact.

I think that perhaps I can make some sort of diplomatic comment. I try. "Well, God made the Chinese first," I say, "and he gave them the biggest country . . ." All nod in agreement, ". . . and he made the Americans last, and the only big thing he had left to give them by that time was noses, so he gave them the gift of big noses."

The comment falls flat. It is a complete bust. It is a new thought for them, and they can't take it in because, after all, they really believe that small noses—tiny, beautifully shaped Chinese noses—are a gift from God if any noses are. How

could big bulbous noses be a gift, unless they are gifts from some ugly evil spirit?

But I find out that I do have a gift that fascinates them. I don't know at first if they think it good or bad. I guess they simply see it as exotic. It is this: I have hair on my arms-brown, curly, soft, fleecy hair! Their arms are hairless. The monk standing next to me reaches out and lightly touches my arm. He shows me his arm. A bald arm. Then all the monks around me want to touch my arms. I am a sort of big American puppy whom everyone wants to pet.

Of course, all this time the Chinese opera continues. The bells ring, the little gongs are struck, the drum sounds. The majority of the monks continue to chant. The three nuns fold and unfold their hands in prayer, kneeling and bowing, all in unison.

No one pays any attention to the one-act play that has assembled around me in the corner. It is generally this way in all the temples. *Fay çe que vouldras!*, the motto that Rabelais

placed on his Abbey of Thélème, reigns in China too. *Do what you will!*—it all goes up to Buddha. Praying, or feeling the wonder and holiness of the hair that God has given to American arms for their greater glory—those could be equally sacred gestures.

As we leave the hall, I ask one of the monks to tell me what the ceremony has been about, for it was completely impenetrable to me.

"It is to prevent people from doing bad," he says.

That statement is almost as impenetrable, but I can't stay to discuss it. The three nuns are leaving and I trail them back to the residence hall with the hope that Yin Ling might pause and tell me more about her life. But I can see by her gestures that she is intent upon comforting her severe companion for her loss, renewed all over again, and the three sweep up the stairs to their room without a glance back at me.

The next day they leave for Ningbo and I will never see any of them again.

Excursion Into a Past Time

❧ **DURING MY TWO** months at Guo Qing, I keep close to the daily activities of the temple. I do not ask myself, What would you want to do? I have happily entered a community and like a cork floating on a lazy stream, I simply go with the current. I pray when the others do. My attendance at the ceremonies is perfect. If Chung Miu or Xin Cai brings me on a tour, I simply go. I ask for nothing. I decide as little as possible on my own.

The town of Tiantai is just two and one-half or three miles from the temple—an easy walk. I know the direction. I could walk it easily. In fact, outside the gate of the temple there is frequently a rickshaw run by a lawnmower motor whose driver would gladly take me to the town for a dollar or two. I pass him several times on my way to walk about the Sui dynasty pagoda, built in the sixth century and decrepit because unmaintained but still noble and aged in dignity, though birds have built their nests in it.

But no one asks me to go to the town, and so I simply remain here.

In only a few days I am going to leave Guo Qing. With

some sadness mixed with anticipation, I think that I will probably leave it forever, never, ever to return.

To gather the papers that he needs in order to get permission to go to America for a year, Fo Yuan has to go to Tiantai town and appear at the communist city office to file an affidavit swearing that he has "worked" at Guo Qing for two years. This is one of the forms required in his application to obtain his exit visa. He asks me to accompany him to the civil office, and I readily say yes, since I really like him and like talking to him.

At last I get to take the modern rickshaw. The driver recognizes me. We are both glad that I am making use of his vehicle at last.

In fifteen minutes we are in front of the office of the City Commissioner. Fo Yuan even pays for the trip.

It is an affair of only minutes for Fo Yuan to appear before the bored official, swear to his declaration, and have it notarized and filed. There is no need on his part or mine to get back to the temple immediately.

"What about taking a little walk together?" he proposes. He knows the town well, I gather. "Perhaps," he says, "you'd like to stroll through a street that still very much preserves the architecture and, in general, the life of a Chinese city of a hundred years ago."

I seize the chance eagerly. The place is not far off. We step into a bicycle-drawn rickshaw now. Fo Yuan gives directions, and we head for the enchanted gate that will take us into the old China.

When we arrive, it is, of course, just an alleyway, a narrow, winding street that immediately loses itself in its own maze. It is no more than ten feet wide. A great deal of the work of the small city must be done here. The first floors of the houses on both sides of the alley all hold little businesses —dressmakers, tailors, noodle-makers, butchers, barbers, beauty shops, stores with pots and pans, pet shops, tofu makers, bakeries, and tobacconists. None of these stores is more

than seven or eight feet wide. Above the stores are the habitations, all made of wood that age has turned to silver, with shutters and windows thrown open to the street. Narrow entrances lead from the street to the upstairs. I cannot escape the impression that the upstairs rooms must be packed to bursting with people and their possessions, stuff that has been accumulating for a hundred years. Certainly, too, the distance across the alley is narrow enough that if Jackie Chan decides to make a movie here he could easily leap from the buildings on one side of the street to those on the other side, even while fighting a determined gang of cutthroats.

This ramshackle alleyway has the same rundown, crowded, workaday character as the street in Brooklyn where I grew up. On my own street, stores and even little manufacturies were mixed in with the shabby tenements, just as they are here in China.

Without a doubt, the most sensational element of the street life in the alley is—me! Each step that I take deeper and deeper into its recesses attracts more eyes to me. The work at the stores stops. Hairdressers' hands freeze in the air above shampooed heads. Butchers suspend cleavers above juicy legs of pork. The rattle of sewing machines falls into silence. Talk ceases. I pass a worn, once elegant building that had been a temple in past years but now has been turned into a senior citizens' center. Everyone pauses in the dissemination of the alleyway's latest gossip to stare at the American.

I hear people calling ahead to warn those whom I had not yet reached that an incredible sight is on its way. I feel as if I am the circus arriving in a turn-of-the-century American town. Then, "The circus is coming, the circus is coming" people shouted excitedly in advance of its arrival in every middle-sized town in the South and Midwest. Here, it is the same. I am a clown . . . I am an elephant . . . I am the whole Barnum and Bailey menagerie rolled into one! Behind me I hear people shyly whispering "Hello!" and then giggling just as the grammar school children had done. But now it is the whole

adult population that regards me as a wonder. Even the senior citizens become children again. They smile, they offer me a seat, they hold out pieces of fruit or sweets to me, all the while nodding and bowing slightly to express friendliness.

Then the alley explodes. School is just letting out, and streams of students pour from the tributaries into the main alley, each stream consisting of students of a different age. I am soon surrounded by a now undifferentiated mass of students. Many of the older ones are obviously already in possession of some English that goes far beyond the universal Chinese capacity to say "bye-bye." They call out: "My name is Charlie. What's yours?" "Pleased to make your acquaintance!" "Where are you from?" Obviously some rote learning of routine phrases has taken place, for one cries out, "Very good to see you again." And another says, "Thank you for the telephone call!" But mostly the alley rings with English conversation as never before all during the last century. History is being made. The future is being created here. Imagine! Nineteenth century China chitchatting in English. I shout answers as well as I can, and hear them echo back. This is grand merriment.

I am the Pied Piper of Tiantai. As I walk along the alley, children and even some adults are hypnotized into following me, dancing with excitement, racing ahead, the bravest ones running up to touch my sleeve. I am suddenly a person of immense power. If I utter even the slightest laugh, I can cause an uproar. With a grimace, I can cause little girls to run screaming. With a word, I can start a rolling thunder of response. When I reverse my path, the whole line in back of me twists upon itself and doubles, almost tumbling over itself.

I am nearly at the end of the alley. I have been passing through it for almost an hour. My procession has been like a typhoon that sweeps everything in its path along with it. I'd like to think that the alley will never be entirely the same after the swath I have cut in it. Later, I know, it will certainly settle back into its nineteenth century existence, but for now the foreign, modern world has dropped into the ancient one.

As we approach the outlet, I see a man signal to Fo Yuan. "It's someone who used to be a monk at Guo Qing," Fo Yuan says quietly, "but now he's married and has a child and is living in this alley." No tone of condemnation or scandal tinges his voice, only an air of bewilderment about how such a thing could happen. And I guess that there is a bit of sadness too. Fo Yuan is a very devout monk. But such things do happen.

Fo Yuan and the man exchange a few words. I am busy saying good-bye to the youngsters and don't hear what these adults say to each other, but later on I wonder long about this man and how he came to enter and then leave the temple, what kinds of regrets and what happiness he has with his wife and little one. Had sex gotten him into trouble? Or was impregnating a woman a way of justifying a departure from the temple that he wanted to leave anyway? Had he, one day, taken a stroll through this alley, as Fo Yuan and I were doing, and paused to look into a shop where a lonely woman was rolling out noodles? Perhaps he talked a little to her, and then returned another time, and another, until she began to look for him and he began to yearn to see her, every day. One day, did they move hesitantly to the rear of the shop, and shyly close a curtain behind them? Or did he help her to roll out the rice paste and announce suddenly that he had left the monastery, and ask her to marry him? Even as I am weaving these fantasies they sound like a bad Maupassant story to me, but I can't get them out of my mind.

I spin many fantasies about the few words that Fo Yuan and the former monk spoke. I have him rejoice to enter a new life. I imagine him regretting that he ever left the uncomplicated life of the monastery. I draw a vibrant scene in which this twenty-five-year-old man has sex, glorious sex, for the first time. And I also imagine a scene in which he is wracked by guilt and can't perform. I give him, I suppose, a richer and fuller life than he has. But who knows? Perhaps he experiences an array of emotions far beyond anything I can imagine.

I will never really know, of course. Fo Yuan breaks off conversation with him and, in saying farewell, touches him affectionately on the arm, for the two of them (I learn later from Chung Miu) had been special friends at the temple. It is time to go. Time to leave the alley. And so, Prospero-like, I unfasten the magic spell I had wound around the children, and step out of the alley into the modern street.

Fo Yuan walks in silence for a while. Then he brightens. I suggest that we stop in a restaurant for a bite to eat, since it is already a quarter to five and we have missed dinner. He likes the idea. However, the first restaurant we go into has such an odor of meat that I fear Fo Yuan is going to be sick at what must have seemed to him like the stench of dead bodies. Frankly, after weeks on a vegetarian diet, the meat smells sour to me, too, and we hurry away. But we find another place and enjoy a nice array of the sort of vegetables and sauces that the temple would never offer. It costs me almost seventy-five cents for the two of us.

Later, as darkness comes on, Fo Yuan stops to buy some mangoes, along with some spiky, cherry-like fruit that I have never seen in the United States. He proposes that we go back to the temple and eat this nice dessert together.

I think, as we take the motorized rickshaw back to Guo Qing, that it has been just like going back to my little street in Brooklyn. Sometimes you travel far to get home.

Descent from Heavenly Mountain

❧ **THIS IS THE MORNING** of my last full day here. Tomorrow, I will leave Guo Qing. When I arrived, it was the only destination to which I could look forward with certainty. Now, in my notebook, I have several letters of introduction urging abbots of other temples to allow me to take up residence there; and I also have many suggestions from my friends about where I should stay. Fo Yuan has written a reference for me to stay at Wutai, in the far north, near Mongolia. I doubt that I will have time to go there; but other summers will come in the long fullness of time. Ke Ming suggests that I go to the Putoshan, Puto Island, south of Shanghai. I determine to take his advice. I bear a letter from him to the abbot of Puji Si. When Yin Ling heard, before she left, that I am indeed intending to go to Puto, she said, "Why, then, you must stop at the beautiful little city temple at Ningbo, which we nuns have often visited." She also urged me to visit Sunlight Rock Temple on Gulangyu Island in Xiamen. A few days ago, Xin Cai promised to write to tell his friend, the master at Tiantong Chansi, to expect me. I have a map and mark all these

places on it. Then I put my notebook in my Buddha bag, and start to pack.

Unexpectedly, Chung Miu knocks on the door of my room. "Today is my last chance to take you to see Zhi Yi," he says. "I asked the driver yesterday and he can take us up there this morning.

So we go to visit a master who has been dead for more than thirteen hundred years. The car winds into the hills, and on a high place with an extraordinary view we pull up to a clearing, get out, and walk through the gate.

A couple is weeding a garden off to one side. Slow with age, they rise and bow to us in greeting. Chung Miu whispers to me: "Years ago, when I was a young monk I spent a lot of time up here, weeks at a time, and learned to care deeply about these people. They are the caretakers here, mostly to keep the occasional tourists from despoiling the property—but the place needs constant maintenance too."

He takes their hands in his and addresses them warmly. I hear the old woman say with a sigh, "Our son has returned." He leads me to them, and puts my hands in theirs. They beam, as if they had known me as long as they have known Chung Miu. Now I am their adopted son, too.

"We will go to Zhi Yi first," he tells them.

We make our visit. An ornately carved white marble tomb stands serenely in the center of a little temple. A portrait of Zhi Yi, looking very much like the painting hanging in Guo Qing, is carved into a sheet of marble fastened to the wall.

"Here is Zhi Yi," Chung Miu says, as if the tomb is merely a little house in which the master is taking a sleep.

For a while we stand silently, not in prayer exactly, but in reverence, before the resting place.

"Do you believe that Zhi Yi reached enlightenment at Guo Qing?" I ask.

"Yes, certainly. But I feel he is still present, here and at Guo Qing, a great bodhisattva, who did not pass on to nir-

Ceremonial tomb of Zhi Yi

vana, but stays with his people." This thought makes stand-
ing here in silent wonder all the more moving. Was Zhi Yi
the presence I sensed one dark night in my room?

We walk over to a little reception hall where the couple
had gone to fix tea. We drink it from tiny cups, hardly bigger
than thimbles, which are refilled several times.

Chung Miu stays to talk to them while I walk outside, padding softly over the bed of pine needles and finding splendid vistas from which to take in the valley and the surrounding mountain ranges. I am content.

After a while Chung Miu joins me. We walk to the rear of the buildings, then downhill.

"Look here," he exclaims. "This is a fish paradise!"

It is a big round pond, in a stone basin, about thirty feet in diameter. The dark water is dotted with lotuses. No way of telling how deep it is. On the surface, water bugs make ripples. I hear a splash and see a little circle of water spread. The fish have no hesitation in destroying bugs.

"A fish paradise?"

"Yes, sometimes visitors come here to catch fish, and then we release them all back into the pond. It is a nice small source of revenue for the two old ones here."

"People pay to catch fish and then release them?"

"Yes, it is good luck—to have a life in your hands and to spare it."

Buddhists know how to make their own luck.

"Come, do it—for luck," Chung Miu says. He gives me a line with a bent pin tied to the end, and from his pocket he takes a crust of bread and covers the hook.

He has planned this all along, I see.

I toss the line into the pond. The bread floats undisturbed for only a second when, in a flash, a fish takes it violently. He is hooked. He splashes, he beats his tail against the surface and almost immediately dislodges the barbless pin.

"You have saved a life. You will certainly have good luck in your travels," Chung Miu declares.

When we walk back, the busy couple is weeding again. The driver of our car is down on his knees helping them.

I am willing to do some weeding, too, in honor of Zhi Yi, and make a contribution to the orderliness of his residence. But the driver reminds Chung Miu that he has errands to do back at Guo Qing this afternoon. And so we leave.

Good-bye, Zhi Yi. Are you an enlightened one, still dreaming you are a man, and still consorting with men, even with such a monk as I?

Tomorrow I will leave Guo Qing for the city of Ningbo. Getting there by bus will not be easy, not as easy as if Mr. Hou Shih-mar were driving me. Yin Ling had described to me the route that she and her companions would take back to their temple near Ningbo, involving a series of transfers from bus to bus, since there are no main roads leading from Tiantai to the coast. Complicated as this trip is, it will take me to the next three places that I want to visit—first to the old city temple, then to Putoshan, a sacred island of many temples; and finally back to Ningbo, where the revered temple of Tiantong Chansi is located.

This is the morning I depart. Nothing is different in Guo Qing—except me. The chanting is the same. Guanyin and Sakyamuni and all the others smile with the beneficence to which I have become accustomed. As usual, sunrise comes at the same time that we finish our prayers, as if our reverence has brought on the light. Time flows like a tide over us with the same measured, steady rhythm that it possesses on any other day.

But, from being a stranger, I have made my way into the life of the temple. With the others I have joined in many ways—in prayers and laughter and wonder and easy contentment. I have made friends with people I will never forget. Perhaps they too will hold some memory of me in their hearts.

I look the same as when I arrived many weeks ago. Only my hair has grown and my heart has changed. As a child I became very accustomed to long, anguished periods of lonely silence. But now silence has meaning, value. In my youth I yearned to find some way to be distinguished. But now, from my fellow monks, I have absorbed something of the higher distinction of simplicity. Above all, I sense that I am beginning to find new resources for my spiritual life. My spirit has changed, not by deepening but by expanding. I feel that I can

take in and contain everyone and everything that I touch, that all of existence, body as well as spirit, is open to me. Anything is possible. Suppose I take the wrong bus going from Tiantai to Ningbo, or the wrong boat from there to Puto? What will it matter if I end up in Wenzhou or Fuzhou—or Timbuktu? Wherever I land, something will be there for me. The destination no longer matters—the going is all, for everywhere is sacred. Many times when I was working on my book about him, the novelist Henry Miller would say to me, "Do anything—anything—so long as it produces ecstasy!" At last I understand what he meant, for I see that anything *can* produce ecstasy. In leaving Guo Qing I am taking it with me.

Chung Miu and Fo Yuan and the gardener, Sheng Tai, meet me by the residence as I come out with my bag. They walk to the gate with me. For them, there is neither arriving nor departing. Doubtless we have met many times, in a multitude of forms, all good, in past lives. Certainly we will meet again. I can accept that idea, for I also realize that, even in my own Western way, before I met them they were part of what I had set out to find. I would certainly meet them again, many times, if only in my memory of them.

The gatekeeper steps out of his lodge and stands nearby, smiling and silent. I go over to him and shake his hand, then the hands of the others, saying my thanks.

Then, Ke Ming hurries down the path. He has a concerned look on his face, but when he sees that I am still here he relaxes and breaks into a grin. He comes right up to me as if the others were not there, as if we were the only two persons in the world. He gives me two tins of Tiantai green tea and a little illustrated pamphlet about Guo Qing.

"We will never forget you," he says. "You have Buddha in your heart. Take it to America."

No further words are necessary. I put my gifts in my bag and his words in my spirit, and take his hands in mine. And then I simply turn, walk out the gate and over the arched bridge, and step into a motorcycle rickshaw.

In the West such a departure would almost inevitably feel like an expulsion from Eden. But here, Eden goes with me just as solidly as the tins of tea. Buddha goes with me. There is no loss, only the continuous possibility of further experience.

The driver kicks the starter, the engine explodes into life, a cloud of fumes whirls around me, the pebbles hiss under the tires, and seconds later we go through what once had been the entrance to Guo Qing and now is the exit. But I dare to hope that this exit will become my entrance to further expansions of my lives in China.

Lost and found in China

❧ THE ADVANTAGE OF a jigsaw puzzle is that you can put it together, then take it apart, scatter it around, and the subsequent tries at completing it are nearly as challenging as the first time.

The route by bus from Tiantai to Ningbo is just like a jigsaw puzzle. You have to connect one bus route to another and try to go in a straight line for a hundred miles. I wouldn't want to do it over.

City buses in Shanghai or Hangzhou run along fixed routes on a more or less regular schedule. But in the country the bus routes are a maze and prove difficult even for a native speaker and an expert reader.

The route from Tiantai to Ningbo is almost all through country places. It is the heartland of Zhejiang Province's immense agricultural production. A bus trip through here would qualify for three college credits in a course on agricultural plenty. Tea, rice, barley, corn, potatoes, wheat—Zhejiang has them all. But winding roads that skirt large farms do not make for easy, clear transportation.

My motorized rickshaw driver brings me to the bus stop

in Tiantai for travel eastward. As a bus pulls up I ask passengers who are boarding it: "Shaoxing? Bamao?" That is my direction. They nod happily at me and offer me Marlboro cigarettes. I get on.

But it is the wrong bus. I did not count on the fact that the agreeable passengers are merely expressing pleasure and wonder at talking to a foreigner. Besides, I assume that all vehicles leaving here go to Shaoxing, and would stop at Bamao, where I could transfer for Ningbo and eventually find my way through that great commercial city to coastal Zhenhai, whence there would be a boat to Puto.

Eastward I go—but southeast instead of north. So when the torturously slow and crowded bus reaches Linhai, a name I have never seen, I pull out my simple map and find to my horror that I am going in the opposite direction. If I follow this route to its end I will reach Wenzhou in my next life and then be two hundred miles from Ningbo.

This means starting over, of course. The problem now is to find the northern bus depot in Linhai and to get on the right track. But what would the right route be now? I decide to eat and think about it. After all, now it is ten-thirty in the morning, my accustomed time to have lunch, and besides I am hot and thirsty and frustrated—not to mention: LOST.

At a shiny new restaurant I order the best vegetables available, all sorts, and have a fine feast—not as magnificent as that which Tian Shan produced at Fengguang, but splendid enough. And with that, I drink two very cold orange sodas.

I spread my map out on the table and try to figure out a proper route. Stubbornly, I want to do it all myself. But I also suspect that if I inquire of the restaurant owner, "What route do you suggest I should take to get to Ningbo today?" he will look at me in amazement. *All the way to Ningbo?* To him my question would sound pretty much the equivalent to my saying, "How do you suggest I proceed to the moon this morning?" Very probably, he had never been to Ningbo himself. Perhaps he had heard that someone knew someone who

had been there. He would regard nearby Haimen as a distant destination. Perhaps he would say, politely, "Ningbo? But Ningbo is so far, too far to go today. Why not go to Fanqiao? It's a very nice place. The air is very fresh, and there you may spend a day or two climbing the mountains beyond Youxi. "

The more I fantasize about his possible response, the more the attitude I ascribe to him seems right and mine seems wrong. *Why* do I have to get to Ningbo—in this lifetime or in the next? What is Ningbo to me or I to Ningbo that I have to go there? I can manufacture a plausible reason. It is a part of my plan, it is a way station on my itinerary. But this is not a good reason. I hadn't come to China to fulfill an itinerary, only to expand myself. And since I arrived in China two months ago, I have subtly changed. What used to seem certain no longer seems so. What is *possible* seems to matter more.

I study my map. Yes, I can devise a wholly different plan. I can ask the restaurant owner to guard my suitcase, buy a few bottles of water at a market, put them and the Buddha bag given me by the old master into a knapsack, continue on the bus south for a dozen miles, and get off at Fangiao. From the topographical shadings on my map, I see that if I walked past the town of Youxi, beyond it I would enter the heart of the Kuocang Shan region, a series of low mountains folded into valleys. Towns are dotted along the Yong'an Creek—Xianju, Tiantou, Hengxi. Perhaps I could loiter at these and eventually walk all the way to Lishui. From Lishui it would be easy to get a bus to Wenzhou, and then in a millennium or two I could make my way north to Ningbo after all.

I have plenty of money in my money belt. If I run out of water, I have a little bottle of citricide to purify the water of the river. Every town in Southern China has discovered Pepsi Cola, I believe. As for food, I can buy a few concentrated provisions here in Linhai. Here I am, then, fully equipped to abandon my plan, to go anywhere I want to go, to strike out across the countryside like an ancient bodhisattva or simple disciple, to cross the boundaries of the ego

and march freely into a boundless eternity. Lao Tzu himself would have approved. I imagine him counseling me across the centuries: "If you head for Ningbo you will get nowhere. If you head for nowhere you will arrive everywhere." Hadn't my stay at Guo Qing prepared me to take my ease on the borders of nowhere, to aim at wisdom, and not at Ningbo? Hadn't I come to China, in fact, to get beyond destinations and plans and to swim slowly in a time beyond time?

I am so torn between adopting the Chinese way of patience and following the American genius for time management that I do neither.

Instead, I order tea. Green tea. In this restaurant the tea is not as good as Hangzhou Long Jing, or even as Tiantai tea, but it is good enough to allow me to sit and sip and think while the pot is filled three times.

The result is I *decide* neither to set out for far Lishui like an old hermit of the woods, nor to hurry on to Ningbo like a tourist on a two-week schedule.

I decide simply to stay in Linhai.

After my third pouring of water for tea, I say to the owner of the restaurant: "Linhai is fine."

"Yes, it is a fine place." His voice is slightly hesitant. I suppose he must wonder what I am doing here.

"I am going to Ningbo," I say.

"Ah, Ningbo." His tone is filled with wonder. "Ningbo," he repeats. "It must be wonderful there."

"Yes, it must be wonderful."

"Assuredly."

"But I cannot really guarantee that, since I have never been there. It is a far place," I tell him.

"Ah, of course," he says.

I feel required to explain.

"I have been living at a monastery near Tiantai, and I am going to Ningbo in order to get a boat to Puto."

"Puto," he whispers. "I believe that is a holy place, a very sacred place for Buddhists."

"You are Buddhist?" I ask.

I hadn't realized that such a question might be very complicated for him.

"Well, my grandfather was Buddhist. It is a thing we know in our family. So I must be Buddhist, too, because I revere my grandfather, though I have never seen him. However, I have taken note that you ate only dishes of vegetables. I believe that you may be Buddhist."

That is a question without a question mark. At least he does not say, *But you do not look like a Buddhist!*

"I am, like you, a Buddhist, but not a Buddhist."

Strangely this answer satisfies him completely.

The conversation lags, for I can see that he is trying to work out something in his mind.

"Tell me," he says finally. "You are coming to Linhai not from Haimen or even Wenzhou, but from Tiantai. And you are headed for Ningbo."

"Yes."

I smile, for it is easy to see what will come next.

"Then, pardon me, it seems just possible that perhaps you may be going in a somewhat roundabout way—one might even say, in the wrong direction."

He is very, very polite. Otherwise, he would have been obliged to call me a fool. "Actually, I am lost," I say, to ease his fear that he just might be insulting me. Or that I am a police spy in a remarkable disguise. "I took exactly the wrong bus."

He brightens.

"But, of course, you are not *lost*. You are *here*."

I like that. It is the direction I want the conversation to go.

"Yes, in Linhai. As we said, it's a very fine place."

"Very fine."

"And it has a hotel?"

"Of course. That goes without saying in Linhai. Of course a hotel. And not just one."

"But it does have one that you would recommend above all others."

This presents him with a problem. One hotel may be owned by a cousin. An uncle may work in another. He surely has friends with connections to hotels. So he pauses while he works out the complicated question, not which the *best* hotel is, but the one to which he has the most filial connections. *That* is the best hotel, period, in filial logic. He certainly does not ask himself the sorts of questions that the American Automobile Club investigators would apply. For him, I believe, the question is an entirely social, familial one.

"Certainly, the 'Peace and Friendship New World Lotus Hotel' is the best, the very best," he concludes.

"It is an excellent choice," I say, though knowing nothing of this glorious hostelry. "And since I have arrived at Linhai and am not lost, I should take a room there in honor of my arrival. Perhaps you could find out for me if I can be accommodated."

"I am sure that a place can be found for you. My uncle, my father's brother, himself has a personal interest there, and his influence will be very important. We can rest assured that he will help."

For him, words are deeds, and he goes straight out of the room to his telephone.

He is back in a moment.

"It is all arranged. I will take you there myself." He gives quick instructions to a teenage girl, his daughter probably, who appears out of nowhere. He seizes my bag and whisks me into a taxi.

The hotel is only about ten blocks away, an easy walk, but it is grand of him to make such a magnificent show of this simple transit.

A man waits at the door of the hotel. He looks like a sign with a motto: Ready to Serve. As soon as the taxi stops, he speeds toward it.

My guide responds warmly, embracing the man as if he had not seen him for years. "And this," he says proudly to me, "this is my uncle, Mr. Xu Lun, administrator of the hotel."

"You are very welcome in your travels," says Mr. Xu.

"I am very glad to be here."

"Luck has brought you to us."

It is a small hotel, four stories high, with no elevator. But it is newly renovated, with polished floors. Doubtless Mr. Xu hopes that there will be a rush of tourists who want to see Linhai. But for now, except for me, he has to be content with Chinese travelers—at lower Chinese prices.

He takes my passport, which will have to be registered with the civil authorities. I fill out a registration card.

I look for my bag.

"Not to worry," he says. "My nephew, Mr. Xu Bao, has already transported it to your room on the third floor. Number 303, with a good view of the street."

I wait for the nephew Xu to come down, shake his hand, congratulate him on his selection of a hotel, and say good-bye.

The room is neat and clean. It even has a reproduction of a famous brush painting of the Yangtze gorges hanging over the bed in a shiny lacquer frame. The bed is springy. I open the window wide and take a deep breath of air.

For hours I had sat in a rickshaw, a bus, and a restaurant. A walk around Linhai seems very appealing. I take my fold-up umbrella because by now rain seems very likely.

A town like this is fascinating. Seeing one small town in China allows you to see a thousand of them. I walk the main street. Carts are parked at corners. Most contain fruits and vegetables, local produce. Some hold big piles of tea under a shady cover. A few have nuts and dried fruits.

Beauty parlors are very common. Outside of one I see the word for "massage." For two months I have not felt the touch of a woman. Is that really the hardest desire to overcome? I do not try to overcome it, though I know that a true monk would not allow himself to be stroked by a woman, even in this legal, nonsexual way. Or is anything nonsexual? I find myself excited.

"Do you give massages here?" I ask the girl at the door. The three other girls inside look up curiously. Everything stops.

"Yes," she says brightly. "Won't you please come in?"

She looks very proud of herself, an independent young Chinese woman speaking up bravely to a complete stranger.

"Come, sit in this chair," she directs.

It is like a spindly barber's chair, but with a low back. I sit down. She touches a spring and tilts the chair slightly backward.

I understand at once that she is going to give me a head, neck, and shoulder massage. I saw blind men doing this sort of massage in Xian a few years ago. But hers is the most deliberate and delicate operation possible. She presses and caresses and touches as lightly as a luminous butterfly, and there is no strain whatsoever. After a half hour she finishes.

"Thank you very much," I tell her. I try to convey the pleasure I feel. "And I should pay you—"

"Fifty yuan."

I give her sixty and she seems pleased.

After that pleasure, I trip along on the streets of Linhai lightly. A young man and a woman sitting in a corner flower shop, only about four feet wide, beckon to me excitedly. I walk up to them.

"You are an American. Anyone can tell," the man says in fair English. "Do, please, sit down. Have an American cigarette."

"I don't smoke, but I will sit down."

"We have both been to the college in Hangzhou to study English," the man declares.

"We are teachers," she adds. "But in the summer we sell flowers and give private lessons. Won't you talk to us a little? We had American teachers, not British, you know."

"I can tell," I say truly.

They beam. Then they simply assume their accustomed position of being good Chinese students, while I become their professor. They fold their hands and wait for me to talk.

All I can think of is to tell them about American poets and China. I talk about Conrad Aiken and Li Po, Ezra Pound's

translations, and Kenneth Rexroth. When I run out of thoughts I tell them about the influence of Buddhism on Gary Snyder, leaving out the fact that it is Japanese Buddhism that interests him.

They both stay very quiet but nod enthusiastically. All they want is to hear the sound of English. In Linhai, unlike Hangzhou, they would soon forget its tones and timbre.

Had I given more practical thought to the content of what I should tell them, I could have imparted useful information on other subjects than American poets, things they could tell their students, about Thomas Jefferson, the Declaration, or a little bit about the development of America. But they are happy with what I give.

"When we close up here tonight, won't you come home with us and eat something?" they ask politely.

I beg off. I am aware that now, ten or eleven hours away from the monastery, I am reveling in the pleasures of merely circulating freely, seeing city sights again. Like pulling a rabbit out of a hat, I have been changed magically. Hocus pocus. The massage turned me into a civilian. Alhough in China, I am swimming in my own element again. I don't want to be tied down. Now I want to be free.

I continue on, soaking up Linhai. I look into an art shop, then a bookstore. On the walls of the bookshop large heroic pictures of Mao, Deng Xiaopeng, and Zhou Enlai are hung. But the shoppers are buying brightly colored children's books instead.

I look into dress shops and men's stores, at fabrics, electronic devices, tobacconists, meat and fish markets, dwellings —at everything, everything. Except for that one hour with Fo Yuan in the Tiantai alleyway, I had stayed away from life outside the monastery. Now I am back in the world in which I grew up, the ordinary world of daily life in city neighborhoods.

In Linhai this evening, the foreboding skies finally open up in a sudden deluge to proclaim the full arrival of this

summer's monsoon. Before long all of Southern China will be soaked. People who step into coastal rivers will be swept out to sea. Swollen streams will overflow their banks in the night and drown whole families in their beds. Mud will slide down the hills, making ancient villages look like new frontier towns.

My umbrella is wholly inadequate. I am thoroughly saturated by the time I gain the entrance to my hotel. I make a little puddle where I stand at the desk waiting to get my key, and all the way up the stairs I leave a telltale trail of wet footprints. I feel a little ashamed at making a mess of the carpet. I hope it will not be noticed.

I undress quickly, hang up my clothes, and take a hot shower. By Guo Qing standards, it is, at eight-thirty, already bedtime. So, after reading awhile, I snap out the lamp and pull the covers up to my chin for a good night's rest.

My last thoughts before I drift into sleep are not about this day, but of my days at Guo Qing. These are now part of me, and will always be. When I fall asleep I am thinking about Ke Ming leading all of us in the early morning chanting. I hear the tentative beginnings of the swelling rhythms.

CHAPTER 16

The Pot Bubbles Over

❧ **REFRESHED, I AM READY** to start out for Ningbo. I get advice from Mr. Xu about the buses. Instead of retracing my path through Tiantai, it is far better and involves fewer chances for missteps to take the route from Gaojian that follows along the coast. But be sure to follow the road that runs through Hengxikou and Xidian. That will lead you straight to the heart of Ningbo. At Ninghai, do not continue east toward Chayuan, or you will be lost again. Ningbo is a big city. You'll know when you are there. You'll find a way of getting to the main street there. You can't miss it!"

But how can he be sure when he has never been there?

At nine o'clock he walks me to the bus station, and a half hour later puts me on the right bus. He tells the driver: "Here is an American monk that I am putting in your care. See that he goes to Ninghai and tell him how to go through Xidian so that he can get to Ningbo before nightfall. It would be a great disgrace if we let an American get lost twice in one week in our province!"

With this admonition, who can doubt that I will be led along the right path?

In Linhai I had had it all—peace and freedom and a new world and lots of grace. Mr. Xu's hotel had the right name. What more would there be to learn in a thousand Putos?

The beautiful little towns that I pass on the way to Ningbo make me almost reevaluate my decision to go on. Hengxikou and Xidian, tucked into the beautiful Bay of Xiangshan, are tranquil jewels. But I cling tenaciously to my destination this time and keep on the road to the great port city of Ningbo.

Few tourists come to this commercial city. People say it is a rough place. Ningbo businessmen are famous for their shrewdness. It is a port town with a long seacoast, lots of coves. At one time this was a place for smugglers. Rowdy sailors. Pirates. Some books say that the reputation for shady dealings possessed by Shanghai is really deserved by Ningbo. So far as I know, there are few monuments or museums to attract spectators, but many tall buildings testify to the lively trade in the city. After all, it had once been a treaty port, and now it is one of the dozen or so cities along the coast recently opened to Western commerce. Ningbo is a "comer," as nineteenth century promoters in America used to say of towns that were destined to build a foundation on stacks of money. The town is alive in a purely commercial sense. It "bustles," it throbs. One store after another crowds onto the main thoroughfare. Everyone here has one object: to work hard and raise cash.

The Happy Nun had advised me to seek out the abbot of the old city temple and ask him to allow me to rest and study there for a day or two before going on to Puto.

"When you come back from Puto," she also said, "then you must stay in at least one of the great temples of the area—Tiantong or Yuwang. It is right for you to hurry along to Puto, but you must not hurry past these places when you return. You may find getting to them difficult, but a visit will be worth your trouble."

She reiterated the temporary value of the old city temple.

"My companions and I," she said, "have taken the trip from Guo Qing to our own temple near Ningbo. I assume you will have an arduous journey. These buses are crowded and uncomfortable. Rest and relax in the old city temple."

But by the time I complete my trip, getting off my bus near a car-and-pedestrian bridge at the center of Ningbo town, then getting directions to the city temple and walking there, the gates are locked up for the night and dusk is coming on. City temples are not as open to the public as the country places are. But even at Guo Qing visitors are not allowed in after dusk. I knock but, receiving no reply after vigorous and extended pummeling of the door, there is nothing to do but look for lodging. Between the bustling downtown, where I had seen several big hotels, and the city temple, ten solid blocks of industrial buildings stretch out. Their doors are locked, too. The area toward downtown seems pretty desolate. I look in the other direction. On the next corner, fifty feet beyond the temple, I see a video store. This means that a population is nearby, not just warehouses. I decide to walk the half block and peek around the corner.

Sure enough, on Caihong Road, I see a neighborhood: restaurants, clothing stores, and . . . the elegant new East Seaport Hotel!

One of the surprises about prosperous Chinese cities is the number of new elegant hotels in them. Invariably, these have marble floors, sometimes even marble walls, and shops, mirrors, fountains. Most cities in America have a superabundance of old hotels and cheap chain motels. But tucked into unexpected byways and backways of progressive Chinese cities are really excellent hotels. My personal desire and my pleasure in China is to live in monasteries. I love the simple room of a monk—without television. But, I confess, I am also dazzled by the museum quality of hotels in the new China.

So I take a room at the East Seaport. A foreign traveler hotel—at international prices. I have a television all to myself. I have not watched television for two months. Well,

why not see what Chinese television is like? I turn it on and see a familiar face—that of Martin Yan, the well-known American-Chinese San Francisco cook. It is an American program. Yan is talking about his recent culinary investigations in Hangzhou. He speaks about the beauties of West Lake and of the famous Long Jing shrimp dish at the Louwailou restaurant. I nod knowingly and smugly about both. Been there, ate that.

Early the next morning I walk over to the old city temple. Two hundred years ago it was a small temple in an obscure town. Now it is an obscure temple in a very large city, crowded among the buildings of an industrial wasteland. The shops leading to the entrance are open. Incense, red and gold paper prayers, effigies of the Buddha and Guanyin, prayer beads, sutras—and, of course, postcards—are for sale. The merchants look hopeful, but no one is buying. Evidently, the city temple has been bypassed. Once it must have sat in holy splendor at a distance from the port. Now it is forgotten, washed up on the shore of business, new China style.

I pay a small entrance fee. This is common. Unlike churches in the West, temples in China always charge a fee, since they are considered by the government to be museums rather than religious sanctuaries.

Inside the walls of the temple I have the overriding impression of how much change it has witnessed. The city has gone up and the temple has gone downhill. The temple buildings are rundown. Admittedly, some restoration has been authorized, for one of the side structures, a bell tower, is surrounded by scaffolding. It is very badly in need of repair. No one at all is working on it.

Perhaps this rickety bamboo scaffold is all that is still holding the antique structure together. But as I study the crumbling building my vision refocuses upon the scene in back of the temple, and what I see stuns me. In the foreground stands the forlorn, woebegone temple, neglected, unusable. But in the background, towering above the temple, not just

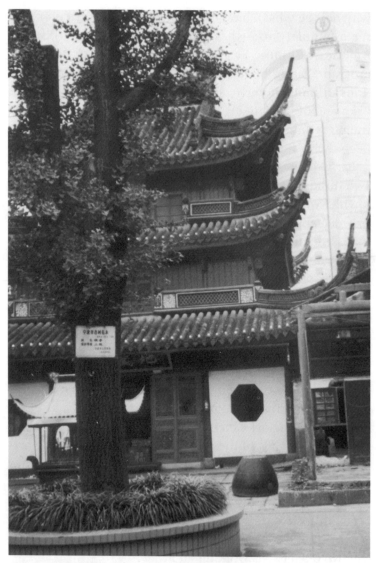

City Temple, Ningbo; skyscraper in background

in size but in modernist majesty, is the new holy power of contemporary life—a skyscraper, thirty or so stories high. This building is as plain as the old temple structure is ornate. It is sparkling new, shiny even in the overcast skies above

Ningbo, whereas the temple is dull, cracked, and superannuated. The old temple seems simply to have given up and surrendered to the domination of the new.

I look to my left, at the main temple building. The same story. Low and humble. Even with its large, slanting tile roof, the "great" hall is hardly two stories high, a low, mean affair. Beyond the temple and above it rises another tall building, as white and pure as it would have been in any city in the world, except that on it, in large letters—in Chinese *and* English characters—is written: "NINGBO I.T., Ltd."

The temple decayed while the new buildings had sprouted into the heavens like powerful beanstalks. At first this contrast is depressing to me. Then I begin to feel differently. This scene is also partly a symbol of myself. I had come from New York City, the quintessence of a skyscraper city. But I myself lived in a lowly three-story tenement in Brooklyn. And here I am, a very modern, very Western man, in love with the ancient mysteries and traditions of China, trying to uncover and recover them. The old and new have always mixed in me even when I was not aware of it. In China they do so insistently.

In truth, I like both. The skyscrapers are fine. I wish them all the modern speed. Yet, after all, they are not holy places, but merely modern wonders of technology. What had seemed to me to be sorrowful, defeated, low, worn-out temple buildings *are* sacred sites that were here for a couple of centuries before the Chinese looked to the West and began to put their faith in the Bauhaus. Many contemporary architects complain that before their deaths a large percentage of their buildings have already been demolished. But temples are seldom if ever replaced. They keep getting restored. Which has the power? As a professor and psychoanalyst, I am almost by definition enlisted in producing and ensuring the triumph of science and the new. But I am also ready to try to preserve the old, the handmade, the things uniquely done by human hands and minds, working together or alone. Ningbo itself may have been broken in two by its uneasy

combinations of the old and the new. But I find that I am not. I want to keep them both, rejecting neither. At the old city temple this day I learn to try to do that.

When my eyes drop back down to the dwarfed structures of the old city temple, I am already feeling a warm affection for them. They fit part of me like a glove. Without taking anything away from the far-flung Guo Qing—a temple that will always, I know, hold an unrivalled place in my heart— I nonetheless feel some special love for the old temple. Love at first sight. It is poor, neglected, and untended—but it has endured and will endure. If I can take some of its qualities into myself—and I can!—then I too will possess what it has, and what I am looking for: simple holiness at the center of a complex secular life. The very poverty of the temple is one of its qualities, I see. Its simple claims make it prevail. It will always be with us. I vaguely realize, then, as I stand in the ancient courtyard, that my own childhood poverty, which I hated and resented and yearned to rise out of, is now acceptable to me. It helped to make me something of what I am—perhaps to give me hope and perseverance and to force my desires into serious channels—though, I have to admit, I also have desires as frivolous as anyone has ever had.

Here in the hurly-burly heart of Ningbo, I find a release from my past and some peace. Old resentments against my father and downtrodden Brooklyn fall from my shoulders. I go to the incense burner before the temple. I have no incense of my own to burn. But from the ashes I withdraw part of an unburned stick that has already been dedicated to other people's prayers. Well, whatever they had wished for, I also wish them to have. I light the fragment from a red candle and add my own prayers to it. "May I remember this moment, and, so far as I can, live by it. May my father rest in peace. Without intending to, he gave me something. May I accept all the struggles and anguish of rising out of poverty." A bit of a breeze blows hot summer air across the censer. The smoke from my shared fragment wavers, then wafts up.

How high might it rise in its fragrance? As high as the "Ningbo I.T., Ltd." sign? Perhaps higher. The modern architect had built as high as he could, at immense cost—but my incense, which hadn't cost me a penny, rises to the heavens. I have some such reverie as this while I stand in the courtyard. Many a wayfarer before me has stood in this same place, and I feel part of their invisible fellowship even though I am solitary in my quest.

What I had thought of as merely a stopover, a place for a pilgrim's rest on the way to the sacred Putoshan, has turned out to be the culmination of a simple acceptance that has been growing inside me. Perhaps it has been developing ever since I bought a little red Buddha with my own money when I was five years old. But here it has come upon me without warning or premeditation, when I expect nothing. It comes so slowly and imperceptibly that I almost fail to notice it consciously. This is the kind of experience that can go on and on in memory and have an annual blossoming, as long as I live to remember it.

I intended to inquire for the abbot as soon as I entered the gates. But I have stood in the courtyard for a long time. I watch my half stick of incense burn down and disappear in a little puff of perfumed smoke. I lean against a wall—not of the scaffolded building! My weight alone might have brought that frail edifice down. I pace back and forth.

Eventually, when I feel certain that the experience I have had here, though still unexplored, will stick, I set out to find the abbot and beg for a place.

Finding him turns out to be a simple matter, for by the time my reveries have run down, lunchtime is near, and in the courtyard, where I had been the only occupant, the few monks of the temple are beginning to collect. I am politely led to the abbot by a novice. I open my notebook to the page on which Ke Ming had given me a testimonial, and my wish is granted.

This is only the second temple at which I have stayed, but I can see at once that meals in Chinese monasteries will

be the same everywhere. True, in the great temples on tourist itineraries, splendid vegetarian repasts, overflowing the lazy susan, are offered to visitors. But for the temple residents, the usual life-sustaining meal of rice and a vegetable suffices. Today, at the old city temple, it is rice and mustard greens.

Afterwards, the abbot waits for me.

"Surely, you will tell me about yourself and the journey you are taking," the abbot says.

Instinctively he would have known that I must have been driven to China by some impelling need. Otherwise, why would I be here? He himself is content. He is simply *here,* as if he has been waiting for me to arrive. I am the one who has journeyed around the world to see him. What is my motive?

We sit in his reception hall, an affair of four straightback chairs, two by two, at a table. These are not only simple Ming style, but probably authentic Ming, for they have become dull with age and use. He busies himself with heating water for our tea.

"Well, I've come from Los Angeles in America to stay at monasteries," I start.

"But what is your journey? Why are you here?"

Few Americans are accustomed to such directness, and I certainly am like my countrymen. I could answer, "I am on my way to Puto, and wish only to stop here for a night." But this is, of course, not what he is asking.

I am a little embarrassed. He is patient, silent, expectant, as if I have brought a message for him from the fabled city of Kubla Khan.

"I came to China . . . to find . . . some sort of . . . a deeper insight . . . into my soul . . ."

"And have you found it?"

"Yes, well, yes . . . "

He isn't giving me a chance to ask him my favorite questions about the strongest desire or the greatest virtue. He wants *me* to talk.

"I would like to hear what you have found. I, too, am on a journey and perhaps your discoveries will help me."

At one and the same time, there is too much to tell him, and there is also nothing at all that I can say.

"Let me try . . . " I look down into my teacup as if the green tea of Ningbo will give me an answer—and it does. At least it gives me the beginning of an idea.

"I have discovered that the soul is not what I thought it was. Without thinking, I had been assuming that the soul is something special that needs a special fuel. I think that from the time I was a child I believed, in a simple, unthought-out way, that China was a unique place where there was a really big portion of soul. 'China' was always a magical word for me. Perhaps there was special 'soul food' in China that was missing in America. In America, there seems to be plenty of 'fast soul food' places, not just McDonald's in a literal sense, but fast fixes for the soul—painless sermons, undemanding values, short ways of reaching nirvana through drugs or alcohol, easy living, fast cars, big TVs—the whole panoply of a fabulous economy that eats into one's soul, but still seems like a good substitute for it. A devil's bargain.

"But I have learned that I was mistaken."

He listens attentively, with quiet eyes.

"Perhaps I wouldn't have known that I was mistaken had I not stood musing in your courtyard today. Probably I wouldn't have understood my mistake if you had not insisted on asking me about my journey.

"Now I see that China is no different than America. It is not a special place in the country of the blue.

"I do not mean that China is not as wonderful as I thought. It is every bit as wonderful. Lingyin, Guo Qing, the temple in which we are sitting at this moment—these are everything I thought they would be, the sites, the buildings, and most of all the people, each person in his own way—they are all special.

"No, what I discovered is that America is just like China.

I have to come to China to learn that I could have stayed home. But I would not have been able to see that if I had stayed at home.

"Now I think that there is the same fuel for the soul all over the world—everywhere, in everything. A nun back in the Hsi Lai Temple in Hacienda Heights said to me years ago, 'Buddha is everywhere.' I remembered what she said, but I never really knew what she meant, even though I thought I did.

"I can get deeper than she did even. 'Everything is everywhere' is yet more true. 'Jesus is everywhere' or 'Krishna is everywhere.' But that is not all. It's not just the great holy persons or religions that are 'everywhere.' 'Everything' is. Because everything that is, is holy.

"Look at this tea. When you asked me your question, in shame for how little I know I lowered my eyes to my teacup. And the tea gave me the answer.

"In China I have had tea with many people. With Peter Lin, and Master Ke Ming, with Chung Miu—there are too many names to tell you—and with a simple gardener and a happy nun, with fellow passengers who changed buses with me in Xidian, with nameless monks and erudite masters.

"Something warmer than the tea flowed down into my veins from all of these. I want to say something ridiculous, and it doesn't matter if it *is* ridiculous—that the tea is holy, and so are the people. The smiles and looks of fellowship we exchanged are holy.

"When I think this, then I remember how my Irish grandmother drank her tea—Lipton's—with milk and sugar, from a saucer. I got a taste of it from her teaspoon, and it brought us together.

"Of course, it's not tea. A peeled golden peach lifted to the sun is as true an offering. One grain of rice offers enough matter to last for a lifetime of contemplation.

"Having a neck massage in a low-backed hairdresser's chair is holy.

"Conrad Aiken and his wife, the painter Mary Aiken, who

took me in, are holy. When Mary told a friend, 'Jay is our son!', that was as holy as any grail.

"Dreams do come from the gods, even though I could also tell you how they arise physiologically and why they were valuable in evolution.

"My wife, whom I left behind in America in order to find a new spiritual life in China and bring it and myself back to her, already has the same grandness of soul that China possesses. I can bring what I have found back to her, but she has it already. Poems written to her are as good as sacred sutras. She weighs a hundred pounds, but she has the same quotient of spirit as a hundred-foot, ten-ton bronze statue of Guanyin.

"Now that I am thinking this way—now that your questions have opened up this path to me—I think that meditating in a waiting room in Shanghai squeezed between a farm wife and her husband, or sitting alone in the Japanese pavilion at Guo Qing, or teaching a class or riding in a shiny new Porsche, or shopping through the L. L. Bean catalog, are all holy, even if we don't recognize how sacred each is.

"Like the geese that I used to see from my window in Connecticut taking wing in the fall, all things are hurrying toward some sort of nirvana.

"So, now, winding through my journey, I think I have discovered something.

"The way that I have shared the lives of others, anonymous people, since I came to China has taught me a lesson about the holy oneness of all people. That's too grandiose a way to put it. I mean, we're all like kernels of rice in a big pot, getting cooked by the burner of the spirit world, until each piece begins to get mushy and stick to others. I'm not cooked enough yet, I know that. But as soon as you asked me about my journey and I looked into my teacup, I started to feel the cooking heat rise.

"I've been talking on and on because there's so much that your question brought out and also because I can tell you are not bored, you with your sympathetic smile.

"We're rice in the same pot. I shouldn't speak for you, but I will. Neither one of us has yet been fully cooked. We're still being knocked around by the bubbling in the pot. But the time will come when you and I and Ke Ming and Tian Shan, for all his troubles, will stick together. We're Long Jing tea, the finest, but we need an eternal second more of brewing.

"We're as holy now as we need to be, but that doesn't content us. How, with this vision of the world in flight, migrating from the winter of not-knowing to the warmth of the spiritual equator, how could we be content with ourselves in the present day?"

At this point I am like a windup clock that just wound down. An unexpected electric accumulation inside me kept the works turning. Now they cease. I have said all I can for now, though I know there is still more inside me. If I continue to talk, to get it all out, I might keep speaking until the last bell of doomsday and not stop even when the world ends.

We just sit. Noon has not yet arrived. The day is not yet half over. But if night had improbably fallen at twelve noon, we would both, I think, have pronounced this a satisfactory day and happily gone to bed.

I have not yet even had a moment to ask my abbot's name. He learned my name from Ke Ming's letter. But he knows my purpose without any testimonial. His name is irrelevant, and he has probably already forgotten mine.

He rises and pours a second offering into my empty cup. He fills his. We sit and drink in silence. He asked me a question and I answered it as best I could. I feel that we are both satisfied.

After a half hour he stands up, wrinkles his eyes at me, touches his palm to his heart and says: "I will think about your answer for many years. Thank you for it."

"I will think about how you listened to it."

He leaves. I wait alone, content.

In a few minutes a man in a brown robe appears and beckons me to follow him. He brings me to a room just big

enough to hold a bed. Wooden dowels are fitted into the wall for hanging clothes.

I realize the difference that being in a city temple makes when the time comes for night prayers. While Guo Qing is incalculably larger than the Ningbo temple, many more citizens assemble here in the evening. At Guo Qing over a hundred monks reside; here fewer than two dozen show up for evening chanting.

I fall in step with the abbot as we walk to the small temple for night prayers. I have learned his name from a monk and say to him: "Wuliang Chan, this morning when I arrived, the temple was empty of visitors. Now there are many people here."

"It is not just because we are squeezed into a city," he says, "but because in the city the peacefulness of mind is so easily lost. Many people come here to get back what they need to face the next day. We do our best."

"May I ask you a question?"

He grins at me with a twinkle of merriment. "So long as you do not demand as long an answer as you gave to my question earlier today," he replies.

"The name you have chosen seems to suggest that you are a great teacher of dharma. But you said almost nothing to the answer I gave you."

"Silence is dharma teaching as well," he answers. "Listening is dharma teaching too . . . Now we chant!"

We chant. After weeks at Guo Qing I am getting the hang of it. The next morning I do even better. There are a few families with special prayers at the morning ceremony.

I bring my bag down and linger near Wuliang Chan's reception room until he comes by: "Continue on your journey. Make more tea," he says.

I know what he means. Such an outburst as mine could very well seem like an end point, rather than a beginning. The rice needs more boiling, the tea more brewing.

CHAPTER 17

Another Beginning

❧ **LIKE QING WAI,** Wuliang Chan did not speak a word of wisdom—except that he speaks only wisdom. He is wise enough to ask me a question that I did not know I could answer. He is wise enough to listen. He is wise enough to agree that my journey remains unfinished.

On the more practical level, when I leave the temple, he gives me the very detailed instructions which I need to get to my next destination. He offers to go with me if I need him, but I am ready to go on to other teachers. I have to get downtown and then find, from Wuliang Chan's vivid word picture, a certain mall where the ticket office for steamships to Puto is located.

During my journey I try to go by foot, the way the old monks did, whenever possible. Doubtless this is a vain affectation, an archaic delusion even, an effort to pretend that modern industrialism has not permeated China, as I know it has. So I start walking, pulling my bag on its rollers ten blocks to the city center. There I turn left, walk over the bridge, and start to search for the shopping pavilion that my abbot described.

Never mind how I find it. It is not easy. But eventually I do find the steamship office. I purchase a ticket, and I am told where to sit until a shuttle for the dock arrives to take me there. What a relief it is simply to be taken care of. Finally, the shuttle comes, takes me, and deposits me at the right dock.

Thirty or forty people are already here in anticipation of the arrival of a small steamship. These travelers are talking and laughing and shouting with such vigor and verve they might easily be a hundred people from the volume of sound they produce. Among them, one young monk sits calmly, murmuring quietly as he touches each bead on his prayer bracelet.

Since he glances up at me with interest and does not seem at all foreboding or unwilling to talk, I sit down across from him. I ask the obvious question.

"Are you going to Puto?"

"Certainly." He smiles. He keeps saying his beads as we talk, but not with Tian Shan's compulsiveness. This lets me know, to my relief, that I am definitely at the right dock. I can't go wrong if I follow him. In China I follow many people.

"Where have you come from?" I ask.

To my surprise, he says: "From Wutai."

"But one of my best friends at Guo Qing lived at Wutai. Fo Yuan."

"I know him!" he says. "We were friends at Foguan Temple before he left."

"Now he is going to America at the invitation of the Buddhist Association there," I inform him. I have to laugh at myself, gossiping with a stranger about a mutual friend here in China. We monks get around, don't we?

"Ah," he replies noncommittally.

"And I—I almost went to Wutai," I tell him. "The Bureau of Religious Studies at Beijing was preparing to place me at Foguan Si until the plans fell through."

"How unfortunate!" he says with genuine emotion. "It is a wonderful place, a very sacred mountain."

"But you yourself have left it?" My remark contains an implicit question.

"Yes, I am going to study at Tiantong for three years. But first I will visit my cousin on Puto."

"And you will stay at Puji Temple?" I myself am going to seek admittance at Puji first.

"No. I will stay with my aunt and cousin. He works at the new temple of Guanyin. He carves statues of Buddhist deities from wood and sells them at the shrine near Purple Bamboo Grove. And you?"

"I have a letter to the abbot of Puji Si."

"You are a Buddhist monk?"

"No. But I am staying in monasteries during this summer."

"It is a remarkable, wonderful thing to do, " he decides.

I pause. I want to find out something about Wutai. "Perhaps I may be able to go to Wutai someday. If not on this trip, then on some subsequent one. It would be fine to be there. I'm told it is a special place of pilgrimage for the Mongolians."

"Yes, and it is very like Tibet there—a little Tibet. You will learn Chan Buddhism there. Yes, you must go."

"Could you write a letter of introduction for me?"

This is the way that I go from place to place. It sounds ridiculous to say that you never know when you might need a letter to Wutai, but the world is full of such strange turnings. Why pass up a good opportunity?

He writes an introduction for me in my notebook, ending with my dharma name.

"But surely," he adds, "when you return from Putoshan, you will make your way to Tiantong Chansi. I plan to make a long visit with my family on Puto. Perhaps you will make the same length of visit there, and I will see you back on the mainland. Tiantong was once a very great monastery, with more than three thousand monks living there. Nowadays we will almost have it to ourselves. The great wok, which once cooked for the multitude, is fallen into disuse. It is a simple place now. You will learn a lot there."

Letter of introduction

Eventually, the boat comes. His seat assignment is far from mine, and all passengers dutifully occupy their prescribed places.

This ship proves, indeed, to be "a slow boat to China," and I vow that for the return trip I will try to book the hydrofoil about which I have heard.

Three hours stretch before me. As the boat gets into a rhythm, beating seaward against the swells of the China Sea, I start to think about my talk with Wuliang Chan. Perhaps the metaphors of the rice pot and tea brewing that had tumbled out of me when I tried to consider his questions originated at Guo Qing, in my talks with the old cook—maybe they were a remembrance of my mother's rice pudding. Anyway, they were true to what I felt.

Puto will be my next cooking vessel. This island is devoted almost exclusively to Guanyin. At Guo Qing the masculine principle of wisdom is strongly stressed, but I gather from various conversations that on Puto a different emphasis—on a loving heart, a much more feminine view—is present. I came to China to dig deep, to experience all. Guanyin's island, I am hoping, will add another spice to the bubbling pot. I think about this until, to my surprise, three hours have already passed, and the steamship bumps into something and knocks me out of my lazy reveries. The "something" is the dock. We are already at Puto. A new uncovering begins.

CHAPTER **18**

The first of Buddhist Kingdoms

❧ **MANY BUDDHISTS COME** to this sacred mountain, not just from China, but especially from the countries and regions where the Chinese hold Puto in reverence —the Philippines, Thailand, Malaysia, Hong Kong, and Taiwan. All pilgrims who seek Guanyin's aid flock here. During the Cultural Revolution, nearly all the monasteries and nunneries on Puto were closed and their inhabitants scattered all over China. Many were "reeducated." Some were killed. Buildings were destroyed. But now the religious have all come back, rebuilding is going on everywhere, and Puto is more revered than ever. With the visitors, of course, money flows in, and so there is a lot of new building and restoration of the old structures. Instead of the practice in recent times of turning temples into civil offices or schools, schools and business buildings in Puto are being converted into Buddhist centers. History now spins in the opposite direction.

When I step off the dock, I know just what to do. In my notebook I have a simple map, hand-drawn by Xin Cai at Guo Qing. This points me from the dock to the left up the hill on the main road, past a row of fish restaurants. If I am

on the correct road, this will then open up to a big square of restaurants and one-story shops. From there I go to the right, between the new Hoi Tak Resort Hotel and a string of stores around a central market, and past the China Travel Service office and a bank. At the end of all this—if I am still on the right path—there I will be, at the gates of the largest monastery on the island, Puji Si. Let me try.

As I ascend the hill that rises from the harbor, two peasant women in blue quilted jackets are slowly struggling to push a two-wheeled cart piled high with watermelons up the steep incline. Without a word, I toss my bag into the front of the cart and step in between them, pushing with both hands. As soon as I do this, I realize from their astonished looks that if this is not a breach of courtesy it is certainly a revolution in custom. No Chinese man that I met would do this—except perhaps for Stuart Chow in America, or Fo Yuan at Guo Qing, who always fulfilled his duty to serve all living things.

I do it for pleasure, and I have to admit that when the women nearly stop in their tracks in their amazement, while I continue to push mightily, I am pleased at their stunned reaction. However, they recover instantly and accept the help that fate has sent them with the same equanimity that they would accept and absorb a broken wheel or some other misfortune. Doubtless they think: *It is our daily destiny to deliver watermelons from the dock up the hill to restaurants and stores. Well and good. Today there is a remarkably strange person who is making our load easier to transport. Let us accept his aid. Tomorrow morning, we will push another load, just as heavy, all by ourselves again.*

Maybe I am wrong in attributing this natural stoicism to them. But later, when I take my morning walks from Puji Si down to the old dock, I see them pushing their rickety cart of watermelons up the steep hill with resolution and no complaints every day. Perhaps in all the years of their labor, this is the only day a stranger will throw his bag into the cart and take a hand in the work. If so, that is what life sends—to them and to me.

An old man passing by who sees this unusual sight shouts *"Xinku!"* to the three of us"—Go for it!"

This isn't exactly the same as what I had told Wuliang Chan about everything being sacred, but it is the ordinary Chinese worker's version of the same idea. Work is simply—work. Work is defined by work. And life consists mostly of work. Occasionally, some special dispensation may descend from the heavens. Work is life. *"Xinku!"* Good job! Wear yourself out! Do your work! That is good enough.

I leave the women at the top of the hill, for they have stops to make all along the way and I want to hurry along. Every restaurant along my route displays the luck of its fishermen. In big red plastic pails, the catch of the day swims happily—seabass, small sharks, lobsters, crabs, puffers, sea slugs, and skates still survive in their reduced oceans and wait patiently to strike the fancy of fish-loving non-vegetarian visitors. Here, in Puto, Fo Yuan would have been obliged to live in perpetual anguish. Before the day is out, all of these marine creatures will be slaughtered for the gratification of diners. So far I have maintained a true vegetarian diet, but I am already aware that before I leave Puto I myself might be tempted to enjoy a fish dinner.

No one could get lost in Puto. The entire island is only four miles long by three miles wide. I follow all the signposts on my crude map, past the hotel and the central market, past the CTS and the bank, and Puji Si comes into view.

The heat is intense. If I had come to Puto to spend the day swimming at Hundred-Pace Beach, or simply to lie on its beautiful golden sand and contemplate the worn rocks, ceaseless combers, or blue islands in the distance, the temperature would have been perfect. Summertime days in Zhejiang and Fujian are very warm; the sun shines as it does nowhere else in China. Often a wall of water drops from the sky, but the rain itself is like a warm bath. By the time I arrive at Puji Temple, I am drenched with perspiration.

Trees tower over the temple walls. Massive rough trunks

thrust fifty feet into the air, unfolding into umbrellas of foliage that shade the walk a hundred feet before the gate is reached.

I step into the shade and take a welcome breath of cool air. As usual, in the environs of the monasteries that tourists frequent, souvenir stands and Pepsi vendors cluster about the path. Against the faded walls of the ancient buildings, they make a fine sight of vivid colors mixed with washed-out hues.

Only a few paces to my left a building is in the process of restoration. Through the open door I watch workmen coming and going. An old sign above the door signifies that this is a Buddhist school—that is, a training school for monks who aspire to be masters of dharma. This is something I have never seen, and even though it is dilapidated, I step inside to take a peek.

It is a horrible mess inside. Workmen are intent on shaping great clay statues, or in carving wooden figures. A woodcarver tells me that the school is being converted into a temple because there is such a need for tourists to see religious sites, so great is the press of tourists on Puto.

I walk back into the shade, past the souvenir stands to the gate of Puji. After paying my entrance fee, I ask the gatekeeper to watch my bag and I go to find the abbot.

Puji is a large temple, with many buildings and grounds covering more than thirty-thousand square meters. Inside the entrance, standing before the main temple, there are beautiful water gardens filled with lotus flowers and crisscrossed by marble walks. In the sun the marble gleams, the water sparkles.

I let my imagination paint a picture of Puji during the Cultural Revolution. The ponds are clogged with mud and debris, the marble is broken and stained. No lotus flowers, only a few rotting carp float on the surface of the water puddles. The paths are empty, the temple is closed. The censer is cold. A fiery-faced, high-school-age, self-appointed Red Guard fanatic scrawls obscenities on the walls: "Down with old gods, old thinking, old praying, and old temples."

Now, less than twenty years later, it is all changed. He who might once have been a Red Guard may run an elegant antique shop near the temple gate and support his aged parents in a nice senior citizens' home. The temple stands in newly painted and gilded glory. The paths and steps are swept clean. Busy monks hasten about the courtyard. The entrance to the main hall is clogged with visitors. They cluster around the great door, in awe of the magnificent Sakyamuni just within. There is no graffiti. The walls gleam in their vivid colors.

When I inquire at the office about the abbot and mention my name, I find, to my surprise, that I am expected. "We looked for you all day yesterday and the day before," the assistant says. "We wondered about you."

"How could this be? Did someone call from Guo Qing?"

"I think so, yes," he answers.

"Well, I was lost, but I was put on the right path," I say, too enigmatically to be understood. I am sure that Xin Cai is still seeing to it that I get to the right place, just as he had sent me to my allotted cushion on my first morning at Guo Qing.

"But now you are here. Abbot Xuan Zang is not available, but he has told us to give you a place whenever you arrive."

At Puji Si everything is restored. My room is neater and newer and equipped with air conditioning. But it is not just that the physical plant is spic-and-span. Everything is more *crisp*—not quite businesslike, for there is plenty of religious zeal among residents and visitors alike, but just more efficient, and in general a less reflective tone prevails than at the other temples which had taken me in. With all the tourists who crowd into the halls all day, my fellow monks are also much more busy. But, with no duties, I wander away from the temple frequently. After the morning chanting, usually I walk the two-thirds of a mile down to the old dock to watch the sun roar up over the tops of Puto Mountain. I often carry a brush painting box in my pocket. Sitting on a wall down by the water, I watch the remaining fishermen.

Most of them left the dock hours before dawn. Their boats are black dots on the gray-green water. A few have already returned with their catch. I sketch the harbor and the gates and stone structures. I watch the arrival of the Shanghai steamer and count those who disembark.

These are aimless, easy, summer days. I do my praying by walking and thinking and listening to the squawk of seabirds. I remember Wuliang Chan's admonition: "Dharma is silence." I try to listen. I am glad to get back to silence. Day after day I utter only a few words. I talk to few people. I listen to the distant mumble of others talking.

I do come to the ceremonies. I like to hear the chanting and night prayers. They are very much the same as at Guo Qing, with, of course, far more visitors. I sit at the end of a long bench when we eat. I am polite and pleasant. But now I have gotten inside myself and the silences are as vital to me as circulating and making acquaintances were at Guo Qing. Perhaps I discharged all I had meaningfully to say with Wuliang Chan.

I don't have to worry about whether others are annoyed at my lack of small talk. Nobody here is insulted. I like that. With some amusement I learn one day, from a talk going on not far from me, that some monks believe I am deaf and dumb.

"The poor fellow," one says, "he seems so serious and devoted."

"It is tragic that he is deaf and has not learned to speak."

"I believe he chants sometimes," another says. "Learned by rote."

They look at me with great commiseration. I smile at them.

This deaf and dumb stillness was doubtless part of what Wuliang Chan meant when he suggested that I brew more tea. I am being quiet, hardly moving, while the tea leaves of many weeks' experience unfold in the Puto heat and steep inside me.

While I was giving my long speech to Wuliang Chan, I felt for just an instant that I had almost arrived at the center of existence and its mysteries. The petals of the lotus of wisdom and compassion started to open. On Puto, I am going through the center. I couldn't have gotten where I am at Puto unless Wuliang Chan had asked me his question. It would have been impossible to go deeper if I had not let out, in a great flood, all the clogged grace I had stored up at Guo Qing.

What I had told Wuliang Chan was true. But now I get to a simpler truth, in just a few words: *I am here.* Existence doesn't have to be thought of as holy. It is just existence. I look about me and see everything as it is, in its greatest simplicity. The stone wall is rough. One ant, and then another, scurries over it, quickened by the sun's blaze, and disappears into some scrubby grass. The boats bob in the water. Everything is in motion, but it all stays the same, day after day. Rain falls. Tourists come. I no longer think about holiness. Holiness is what is, that is all.

At Puji temple I almost become one of the statues, I stay so still.

Sometimes I forget to eat, but I lose no weight. I breathe in food. Near the shore, a big fish breaks the surface. A bigger fish is chasing him. I am the bigger fish and I swallow him raw. In turn I am swallowed. So it goes. Everything becomes very still. Everything *is.*

The days go by unnoticed.

I walk a little way past the old dock, out toward where I know the new shrine to Guanyin is located. But I do not reach it. I intend to go nowhere. After a lifetime of traveling I am content to stay put all day, no more than a mile from Puji's gate. After decades of looking I see nothing, only the sun on the water, and, at night, the beautiful late July and early August moon rising over Puto's slope.

How many days have passed since I arrived? I am lost in time. As Xuan Zang's assistant said on the first day I arrived, I *am* here. Without intending to do so, he gave me a message.

Then, all at once, walking toward the shore early one morning, I come out of this silent world. I have gained what I needed. I want to have a big breakfast now. I want to know the time. I want to see the sights of Puto. Though I am different, I become my old self again, a modern man.

I head straight to the Hoi Tak Hotel, which advertises itself as "your perfect choice in the Buddhist paradise." I go to the coffee lounge, which claims to have "an elegant European ambiance." I like the claim, the commercial presumption, even if it is not quite true. I order and eat a big breakfast, with pancakes, syrup, and butter. I drink a glass of orange juice and a cup of black coffee. I order a second cup of coffee. I wish I could use the hotel sauna, reserved for guests, or play billiards for money in the game room.

All these things I had gotten out of me. Now I can take them back in without losing myself in them. When you lose all that you have, it is easy to get it back if you want it.

"What day is it?" I ask. I have been on Puto for two weeks and have not yet seen a single sight—except for Puji, which is on every tourist itinerary. Now, I want to see them all. I wipe the sticky syrup from my lips and march out of the hotel over to the China Travel Service office, which is just opening when I arrive.

"Please," I insist, "I want to hire a tour guide for a few days to take me to see Puto."

"That will be three days for a complete tour," the manager responds.

"Three days is fine, then."

"I'm not sure we have a suitable guide available. Let me see . . ."

He consults some papers. I want a guide badly. *If he truly has no one,* I think, *I'll go back to the hotel and find someone there, or hire someone off the street.*

"Well," he mutters in a distracted way, "Ms. Gu finished a party last night and slept over in our dormitory. But she is intending to go home today. She lives on the neighboring

island of Zhoushan. I *could* see if she will stay to be your tour guide. I only hope she has not already departed."

She is still here.

I am lucky because the days I spend with her become part of the magic of my China dreams. I came to China to find what the great and small monasteries have to offer. I didn't know what else to look for. But without meeting her, I could not have found all that I was seeking.

CHAPTER 19

Guanyin's Heart

❧ **AS I WRITE THIS** page I have but to look up from it and before my eyes are two things that remind me of Gu Jia Jing. One is a gold-colored plastic card, exactly the size of my Visa card, with a picture of Guanyin on the front and Thai writing, which I cannot read, on its back. Guanyin stands placidly at the center of a halo, her feet resting solidly on a giant lotus that itself is floating among the clouds. It is definitely a kind of credit card for heaven, or a visa of a different sort for immediate entry into the Pure Land. The other souvenir that Jia Jing gave me is a tape recording of the nuns at Ling Shi temple chanting the Heart sutra.

I have but to slide the tape into my battery-operated player to see and hear Ms. Gu again, and to be back on the island of Puto. I do just that, I start the tape. The chant begins, and I fall into a reverie of Puto—and Gu Jia Jing.

Although a graduate of the tourist college in Hangzhou, she still looks about thirteen. Her features, her way of moving as if she is walking on glass, the slightly astonished look that dances about the corners of her eyes, all convey the single idea of delicacy. But this is even truer of her inner char-

acter. She treats herself as if she were the finest, flimsiest piece of silk. She feels fragile to herself. Now and then, in a perfectly natural way, she touches her heart, just for a brief moment, with the tips of her fingers, as if to see if it is still beating. Never in my life have I met someone who is so sensitive to the changes in atmosphere. She often comments on the air. "Oh, I can feel it," she says. "It is a low pressure day. I feel the lack of oxygen in the air. I can hardly get a breath."

In the morning, when I meet her outside the gates of Puji, she usually says: "I have no energy today. There is not enough air."

Decidedly, this is not a pretense designed to get her out of the work of guiding compassionate clients. For even when the air is at its scarcest, she bravely marches along, climbing hills, scrambling over rocks, and, when necessary, treating herself as a rough piece of canvas rather than a silk scarf. As we go about, I learn that she has been in the hospital in Hangzhou for heart trouble of some vague sort, something— a muscle, a valve, an electric charge—that appears to be underdeveloped, and that makes her feel weak, fatigued, dazed. Yes, she has been afflicted for several years. The illness started when she was twenty, and ever since then she has been frequently in and out of hospitals. Now, four years later, she is better—a *little* better—but basically there is nothing to be done about this malady.

I always have the troubling feeling that she might simply *go*, like a soap bubble, at any time. One moment she would be Gu Jia Jing—the next moment airy nothingness, and there would be a gap in the cosmos where she had been. She is too fine ever to be a vulgar corpse.

"To be a tour guide," she says to me once, "is wonderful, because I meet people who come here, as you have, with the purest of intentions, to enter the paradise of the Pure Land. From the Philippines and Taiwan and Malaysia—yes, and now from America, for you are the first, the very first, Caucasian American that I have guided. But it is hard, very

hard, to be a tour guide. I must find something else to do, perhaps to be a primary school teacher, if I am to survive."

Eventually I think I understand what she really wants, and I say to her: "Gu Jia Jing, I think that what you really wish is to be a nun!"

She places her right hand over her heart and answers: "Oh, I do, I dream of that very, very much."

"Why not become one, then?"

She looks dimly astonished at that, as if it had never occurred to her that such a simple dream could be fulfilled.

"But I am not holy enough," she says. She starts talking in English now. "It will be many, many lives before I can realize that dream. I read everything I can about the sutras, but I do not understand them. My perception—is that the right word? Do I use it right?—my perception is so small."

And then she pauses, returns to Chinese, and comes back to the theme that recurs so often: "Besides, the life of a nun is hard, so hard, so very hard. I would fail at it."

No more than a few hours in her presence are needed for me to see that she regards herself as simply, unwaveringly, doomed. Was it the sudden shock of finding that her heart would not do? Or did the years in and out of hospitals, with never a cure at the end, wear down her hold on life? Did something happen to her in her early childhood that had impressed upon her the heaviest hand of fatality?

It is no accident, in any event, that she is so devoted to the Heart sutra—*that* will last even when her own heart gives out.

She is so accustomed to the idea that she will not endure, that she almost seems to be living in her next life already. This gives her all the more reason to be a devoted Buddhist, for of course Buddhism guarantees not just a second chance, but a millionth one. *Someday* she will be given a body that has a sound heart, and then she can be anything she wants, even a nun at Ling Shi.

"You are certainly a Buddhist," she says to me, "or you would not be here at Puto, for there is no reason whatsoever,

none at all, for anyone to come to Puto except to worship Buddha and learn dharma. Obviously, nothing is here except the Buddhist paradise."

"Well, no, I am not a Buddhist," I say each time we discuss this subject—for she keeps coming back to it. "I am simply here to admire Buddhism, to immerse myself in it, to experience it."

"Then," she always says with conviction, "then you *are* a Buddhist, for to admire Buddhism is to be a Buddhist."

"I *am* a Catholic," I say stubbornly.

But she is far more stubborn than I.

"Well, yes, of course. But you are becoming a Buddhist. You have gone farther along the path than you know."

I tell her that I am reading Edward Conze's *Buddhist Scriptures,* and I summarize some of the pieces I read. That completes her case.

"You understand so much! Yes, you are a true Buddhist— far more than I! I would cherish to learn from such a book, especially since, as you say, it is in English. I have never read a sutra in English, never a tale of Buddha in English. What a dream it would be, before I die, to have that chance!"

When I see her next I bring the book along. It is merely a Penguin paperback, worth about ten dollars, but it proves to be a treasure to her. As usual, she looks at first a little vacant and stunned.

"I will read it over and over, and think of you," she says. "Perhaps even in this life I will understand some of it."

I'm writing about Gu Jia Jing at such length, surely, because three rare days in Puto were spent with her, and so her image has merged and melted into my experience of that holy island. Her frailty, or in any event my own impression that at any moment she might vaporize and become pure spirit, mingles, too, with the picture of Guanyin on the card she gave me. Jia Jing also stands firmly on the earth, but like Guanyin she partly floats in the ether.

Such thoughts become consolidated and fixed on the day that she takes me to Ling Shi, the revered temple for female

monks. The day is like a gemstone that only gets its true meaning in the proper setting of our time together and the excursions we took as we rambled all over Puto Island.

While private cars are not allowed on the island, there is a very effective bus system. So far as possible, I tell her at the very first, I would like to avoid the modern conveyances, and walk, the way ancient pilgrims to this island had done. The prospect of this extremity of exertion seems likely to exhaust the small remainder of physical life left in Jia Jing, so I soon suggest a compromise. To travel to areas far distant from the dock, we will take a bus; but walk from place to place once we are at our destination.

Puto is one of the four famous Buddhist mountains. The whole island is a gigantic shrine. But like many other holy places in the world, Puto is now dotted with the impedimenta of tourism—souvenir stands, groceries, and eating places.

Like two nickelodeon figures on a rapidly unrolling scroll, Jia Jing and I walk through the Purple Bamboo Grove that seems as old as time itself. There, pressed into a stone, we find a footprint of Guanyin, made in who knows what distant eon. A moment later, we come out of the grove and I see before me a brand new monument in white marble, surmounted by a gigantic, shiny, brass statue of Guanyin about sixty feet high, towering above us, glistening in the sun. What does it matter that it is new? Everything on the island was new once. The oldest temple—whose name translates as "Unwilling to Leave Guanyin's Shrine"—was new in 916. Fayu Monastery was new in 1580. Purple Bamboo Temple was new in 1650. Someday this shiny new Guanyin will be a thousand years old and pilgrims will stand, as we are doing, amazed at the long shadow of time. The snowy marble monument and the brazen Guanyin will in time darken, and some day, in a twinkle of time, they will seem almost as old as all the other things on the island.

The oldest shrines on Puto, of course, are those made by the island itself. A creation of the seas, it is full of caves lifted

up from the waters ages ago. Every cave was transformed into a sacred spot by the earliest Buddhists who came here. Gu Jia Jing and I climb up and down rocks and squeeze our way through crevices that seem impossible to penetrate, in search of natural shrines.

We look down into a sea cave, called Buddha's Cave, at the waves crashing and swirling into it. Here, in ancient times, the image of Buddha would appear in the sea spray to devout pilgrims. We look and look, but no vision is given to us.

We climb down steps that were carved into the rock centuries ago to peek into Shan-cai Cave, where a remarkable series of carved panels tells the story of how Sensi Boy became a Buddha in his early twenties, so devoted was he to Sakyamuni from his earliest youth.

We squeeze into Dragon Mouth Cave, taking the legendary risk that the dragon will close his giant jaws on us if we are not truly faithful in spirit.

We climb a hill to try to see Guanyin's image in a cave sacred to her. From there we stroll to the Pavilion of Supreme Happiness, from whence, in ancient times, Guanyin could be seen striding across the waves.

We make a long, narrow circuit through immense rocks that lead us deep into the Western Heaven Cave, at the end of which we come out upon granite boulders that pilgrims long ago had seen as images of Guanyin preaching to turtles.

We descend into Mei Fu Cave. Here the earliest Buddhists discovered a pure spring flowing out of the rock. From the nun who has the spring in her charge we buy and drink two cups of water at one yuan each. With her usual sensitivity to atmosphere, Jia Jing declares the water to be full of oxygen and, therefore, a remedy for many ills.

We walk to Chou Jung Cave—the cave "facing toward the sun"—that is, the cave of the Eastern paradise—and we watch the sun rise out of the distant sea.

At dawn, we go down into a cave that has been inhabited for two thousand years to take a look at the Fairy's Well, a

round cistern into which waters flow from deep underground. Long before Buddhists arrived, Taoists treated this cave as a sacred place. Still, it is a surprise to find, in the darkness at the bottom of the cave, an actual, real life Taoist hunched over the Fairy's Well, trying to see an image. Is it the yin and yang that he yearns to perceive floating on the dark water? Or some sign of the incredible unity of opposites in the universe? He does not speak, though Jia Jung

Altar at Fayu Temple

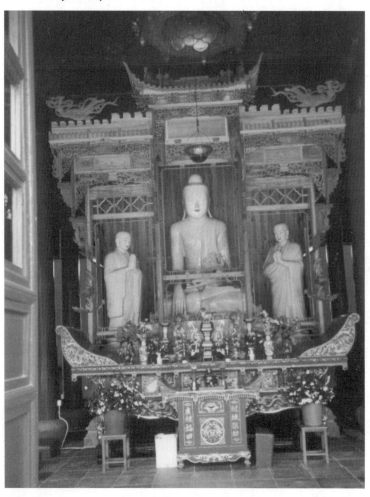

asks him politely what vision he seeks. He simply sits, wearing his traditional black four-sided cap, his white silk smock, black knickers, and sandals. Has he spent his life here? Will he die still gazing into the black hole of cosmic mystery?

These caves had made the building of temples unnecessary in the earliest times. Ancient fishermen probably weathered storms here. Later, Taoists came, and still later, Buddhists. Only when the caves were all filled did temples become necessary. From the point of view of Guo Qing, even the oldest thousand-year-old temples here at Puto are relatively "new." But the caves are as old as time itself.

Eventually, during one of the days I was seeing Jia Jing, I left Puji Si to stay at Fayu Temple, hardly more than four hundred years old—twice as old as the United States, but still a Johnny-come-lately here. To tell the truth, it is one of the most beautiful temples in China—rich, and therefore very well preserved; perfectly laid out, symmetrical, ordered, tranquil. Not far from Dragon Mouth Cave, Fayu is entered by a path that goes past the monumental Nine Dragon Wall, elaborately carved in deep gray granite. The wall—indeed the whole temple complex—was a gift made by the Emperor during the Qing dynasty.

Going about with Jia Jing, listening to her comments, I start to get some sense of the differences between the Tiantai Buddhism at Guo Qing and the spiritual convictions at the heart of this island.

At Fayu, during an evening talk with one of the masters there, I ask him, "Mao Jing, what do you consider to be the nature and source of enlightenment?"

He replies in a way that at first sounds like Ke Ming:

"The Lotus sutra teaches us that all the parts of the world are one. When we see that, then enlightenment follows; or, rather, that itself is the beginning of enlightenment, the knowledge that all is one. Then you see that you yourself are part of the oneness of all things. This occurs in a moment, and at that moment you are transformed by a direct insight into your own

identity, the ultimate reality. Any one thing—including you—is every thing. To know that is to be enlightened.'"

"I don't understand. It sounds like a circle. Which comes first? Do you become enlightened and so understand that all things are one, or do you understand that all things are one, and this brings enlightenment? Which comes first?" I ask.

"The idea of 'first' is no longer tenable in the state of enlightenment," he says. "One practices holiness not to attain enlightenment, but to achieve the insight that from all times, always, in your life you are enlightened. Remember the words of our great Japanese teacher, Nichiren Shoshu: 'When one attains the enlightenment of the Lotus sutra, even our own body, which was previously subject to birth and death, is unborn and unperishing. We do not become and we do not cease: we *are*. And the world is also transformed. The oxen, horses, and other animals in the land are all Buddhas, and the grass and trees, sun and moon are all part of the holy Buddhist community.'"

"And to achieve this takes . . . millions of lives?" I ask, not as a serious question, but as a reflection of Tiantai doctrine. I assume I already know the answer. This proves to be dangerous on Puto.

"Not at all. It may happen in a moment!"

That brings me up short. I am hearing a new doctrine. He continues: "The world has entered the final stage of dharma, and any one—you or I—can become a Buddha instantly. And when the person becomes a Buddha, his world becomes a Buddha land."

I am hearing the Pure Land doctrine, but I don't know it yet. I should have listened better on the previous night and in the early morning, and then I would have understood the monks at Fayu. They, too, chant *"Miao-fa lian hua jing,"* the words of the Lotus sutra. But their emphasis is on transformation and immediate entry into the Pure Land.

As I say, at first I assume that I am still hearing the Tiantai emphasis on wisdom, something on the order of Zhi Yi's teach-

ing in *The Great Calming and Insight*. But I soon find myself in strange waters at Fayu. I should have seen it plainly when Miao Jing concluded his teaching by advising me: "Never give way to doubt, but use all means to realize the faith and enlightenment that will enable you to become a Buddha in a single lifetime. *Miao-fa lian hua jing. Miao-fa lian hua jing.*"

It isn't until the next day that I begin to understand anything at all. And that occurs only because Gu Jia Jing takes me to the Ling Shi nunnery. There, everything becomes as clear as the pure spring at Mei-Fu cave.

"Since you have experienced dharma with Miao Jing and chanted Lotus and Heart sutras at Puji," Jia Jing says, "I can feel justified in taking you to Ling Shi."

But she herself does not know that on this very day a coterie of aged nuns has arrived from Taiwan to visit Ling Shi. They regard the founder of Ling Shi as the ancestor of their order, which had been swept to Taiwan with Chiang Kaishek. This is a big occasion, for it brings about a gathering of all the Pure Land believers in Puto. Some nuns walk over to Ling Shi from Yuelin. And there are also monks from the Hui Ji (Salvation) monastery, where the motto at the entrance reads: "We'll go to the banks of the Pure Land." Even some old retired monks hobbled over from Willow Branch for the occasion. When Jia Jing and I arrive, they are chanting the *daimoku*, the name of the Lotus sutra. We sit respectfully until they finish. Then, suddenly, the testifying begins.

Yes, "testifying"—the word used so frequently in the United States at evangelical revivals, when fervent born-again believers give testimonials to their suddenly achieved belief in sin and redemption. In the revivals on the American frontier, the believers would speak in vivid terms, sometimes in strange tongues, often twitching with the heebie- jeebies and rolling on the ground in frenzies, crying out, "Yes, Lord," "I'm coming, Lord," "I hear you, Lord." Mark Twain liked to satirize these revival meetings, and they must have been a wonderful sight to see.

But now I find myself at a genuine Chinese revival. At Ling Shi the antics reported from the American frontier are entirely absent. Calmness reigns. Most of the people who speak are old. Some are evidently sick or weak. But they testify. And so I learn something new. I learn, in my bones, the passion of Pure Land belief.

All who speak have in common a central faith in the Pure Land doctrine. That soon becomes clear. They are testifying to evidences that instantly upon death, death in this one life, each will become Buddha—or has *already* become Buddha, and will, dying, immediately achieve life in Amitabha's Pure Land. They are all future Buddhas, and Amitabha is each one. These testimonials are like the deathbed scenes of the faithful anywhere. The aged disciples are still in life, but preparing for death—which, of course, is preparing for another life, in the Pure Land.

Some speak about glimpses they have had of former lives. Some try to describe the ecstasy that comes from an indwelling sense that, although they are sick and in pain and dying, they are standing on the brink of Pure Land life. Some will probably still live on for years, but they are living their lives as if they are at the liminal nexus between life and death, looking for signs, foretastes of eternity. They talk of "limitless life," and speak openly of Buddhas, especially Amitabha. Later, I learn that "limitless life" is a direct quotation and an allusion to an important work, the Diamond sutra, on the contemplation of Buddhahood. Some tell of remarkable visions of colorless light. Or they mention omens and wonders experienced in their personal histories. One speaks of finding a relic—the Chinese call them *sheli*—in the cremated ashes of a recently deceased nun. She shows a little vaseline-colored bead in a glass box. Another tells of being visited in a vision by a dead relative who informs her radiantly of life in the Pure Land.

All this is being written down by one of the nuns in her twenties. She is clearly acting by mutual consent as the aman-

uensis of the group. Obviously, her report will be passed on to the younger faithful in the process of memorializing the Pure Land experiences of these ancient ones.

All at once I understand Gu Jia Jing. She gives the impression that she is barely alive in the flesh because that is exactly what she is hoping for and imagining. She is straining for a deathbed life even at the age of twenty-four. She hardly seems to breathe because she is forever drawing her last breath, until she can suddenly become Amitabha and breathe freely. She is not a nun in the sense that we use the word in the West, for she has taken no instruction and made no vows. But it is clear that she has chosen to be a Pure Land nun, at least in the spirit if not in fact.

She herself even speaks a little toward the end of the gathering at Ling Shi. She—looking beautiful and fresh and glorious among all the old and dying—tells a little conventional story about a queen who, imprisoned by her evil son, beseeches Sakyamuni to grant her a teaching that will ease her misery and lead her to a pure world free of torment. It is she—Queen Vaidehi—to whom Sakyamuni reveals the secret doctrine of the Pure Land, to which he promises the Queen she will assuredly go.

The story is old, old news to everyone there—excepting me, of course—but the antique nuns smile indulgently at the twice-told tale, and I think everyone likes it because they recognize that Jia Jing is not really close to death and can only participate by telling the old story about the origin of this belief. She has no Pure Land tale of her own except her wish to have one. All there share her wish.

Again, of course, all but me. Alas, I see the fervor and the beauty of their faith in transformation, and their yearning for the death that will bring it. But I am still attached to the beauties of the world, as much as to the spirit. I see what they have, but I am not to have it. Not exactly.

What I have is better. That is Gu Jia Jing. I have the memory of her that I can never lose. She has grace and kindness.

But she herself has also missed out on some vital ingredient, the love of life and a powerful resolution to live it to the full. In the midst of her beautiful life she is willing to pass away. My heart goes out to her, I yearn to gather her in, and care for her. I want to seize upon Jia Jing and hold her back from the abyss.

Do I need to say that in some special sense I fall head over heels in love with her? She becomes my Guanyin. Puto belongs to her. The song the sirens sing on this island is the Heart sutra. Any fool could see, of course, that my feelings for Jia Jing were all mingled with those for my wife, Helen, whom I missed keenly. Long ago, I came to understand the mysteries of the Blessed Virgin through Helen; now Jia Jing brought me to Guanyin. This frail woman with her failing heart and I rushed around Puto together for three days, and we never touched except for a final brisk handshake. For her I felt not the slightest tremor of sexuality, only a wish that I could save her, though I knew I couldn't, and I already mourned for her even as we rambled over hills and peeked into mystical caves.

Finally, I think: But the vitality of her fervent wish to be in the Pure Land, her holy devotion to a Buddha she felt so unworthy to know—aren't these wishes admirable, even if they involve a desire to die and be transformed into pure spirit? I have to accept her as she is, and to let her go on her own path, not mine or Helen's. Each of our paths is good, but they can intersect only briefly.

After Jia Jing and I spend three days together, she looks wan and worn. I really have exhausted her.

"Tomorrow I will rest," she insists at the end of the day.

I have no intention of disputing this.

"I will breathe slowly and calm my heart"—she touches it again with her fingers—"and the next day we will be able to go to some other special places. But, ah, not so special as Ling Shi, I'm afraid."

Jia Jing is also like the lotus. It unfolds its last petal, then fades away steadily and surely. But we will have an extra day if she survives.

She had been talking to me about the nearby islands that ring Puto. On some of these less-traveled islands, she said, are very old temples, never visited by tourists, and known only to local people. For me, this is tantamount to a challenge, and on her day of rest I decide to visit at least one of these remote places.

More comes of that than I expect.

CHAPTER 20

By the Ocean of Time

❧ **ANYONE WHO CLIMBS** up to the Pavilion of Supreme Happiness and looks over the vast expanse of the East China Sea beholds how punctuated it is by islands, little dots. Jia Jing herself pointed out to me the island where she was born and where she still lives with her parents. On it the government is building the big new international airport whose capacity for air traffic will soon inundate Puto with tourists, like a big tidal wave, and will sweep it away. Soon, Puto will be turned into a "Guanyin Land," complete with a roller coaster to the Pure Land. By then, I suppose, when the ancient Puto is gone, Jia Jing will be gone, too. But at this, almost last, moment, I am determined to visit the ancient world and preserve it in my memory.

Standing there, at the Pavilion of Supreme Happiness, it is easy to see that removal to the remote islands must be made by a fishing boat, for little boats, like insects, cover the stretches between islands, black specks on the yellow sea.

So, early the next morning, I take the bus from Fayu Temple. I walk past the line of fish restaurants that leads down toward the sea; past the "new" dock, where the big passen-

Puto harbor

ger boat from Shanghai ties up. Past Ci Yun, the old temple, I go under the arch that reads: "The First of Buddhist Kingdoms," and I arrive at the "old" dock.

The experiences of my life have taught me that if one acts like a fish to be caught, he will soon be hauled in. So, I start walking back and forth beside the fishing boats, expectant that a fisherman will call out to me: "Want a ride?" "Take you to the nearest island." "Where you like to go, mister?" and such like. Then I will let one talk me into a boat trip, as if that wasn't what I had in mind all along. I guess my basic idea is an American form of bargaining: let the eager Chinese fishermen think that I am merely strolling about, let them try to talk me into an excursion, and then play each one against the other and bargain for the lowest price. I am

ashamed to be acting this way, for I see that I myself am be-
having like a shallow, greedy product of the triumphs of the
soaring Dow, market Darwinism, and the cynical belief that
nothing matters except power and money, not even honor
and dignity. In my journey I wish to get away from all that,
but here I am embodying it. Fortunately, no one here coop-
erates with me.

There isn't one eager fisherman at the old dock. True, on
several boats men are preparing nets or baiting hooks on long
lines. But every one of them treats my presence with su-
preme indifference. No one calls out even a simple hello.

This reduces me to the level of a supplicant—a bad bar-
gaining position. But perhaps if I approach one and make
my desires known, a whole swarm of seafarers will fall upon
me, begging for my business, and compete with each other.

I approach one.

"Hello. Hello, there." Silence.

I feel foolish.

"Are . . . you going fishing?"

He looks up, but does not deem my profound inquiry to
merit an answer.

". . . I was wondering what the nearby islands are like."

Silence. Not even a glance.

". . . As a matter of fact, I was thinking of hiring someone
to take me to some of the interesting islands around here."

I think I detect a slight flicker of movement in response to
that.

". . .Well, perhaps you might be interested in taking me."

I say this as loud as I can so that the other fishermen will
hear. Perhaps they will join in and clamor to chauffeur me,
but there is no tidal wave of interest in my wish to go sight-
seeing. Only the fisherman I am talking to answers:

"This is a fishing boat."

"Yes, I see. But perhaps you have already completed your
fishing for today."

"No, I haven't."

"Perhaps, then, you might take me along as you fish, and then put me ashore at an interesting island where there are old temples or ruins—interesting sights. You know such places?"

Little do I realize then that I am forging a hook, baiting it, and then biting on it, all by myself.

"Of course . . . But you would have to pay me. It would take time from my fishing."

"Yes, certainly. And what would you charge?"

"To bring you to a very interesting island? One with temples and carved rocks and old pavilions?"

"Just such a place."

"Well, a hundred yuan," he says. That amounts to about twelve dollars.

"Fair enough. How soon can you be ready to go?"

"We can leave immediately."

No other fisherman has shown the slightest interest in our conversation, though several must have heard it. So much for bargaining.

"All right, then." He motions me to jump aboard.

"Shall I pay you now or later?"

"By all means, now," he says.

I pay him. He takes my bill with one hand and in the same motion starts his engine. We are on our way.

Most Chinese people like to talk, to question, to socialize. The taciturnity that is so often found in America and Europe appears only infrequently here. Even with monks and nuns, though by natural selection these may have been a bit more quiet and certainly more equitable and even-tempered than others, there is always more than mere calm—an inquisitiveness, a personal interest, a keen desire to make contact . . . I don't know exactly what it is, but it is always there. It makes for good talk. The Chinese are not interested in you for your money, as Hemingway says the French are. They do not care about your social class or, more importantly, your lack of it, as the English often do. They are not formally

friendly out of a deeply ingrained sense of decorum, as the Spaniards are. They are not interested in the purity of your accent, as the Brazilians are. No, they are most like the Italians: just interested in life. The spirit that sometimes hangs in the air in Italy is diffused all over China. Maybe it was born in China and brought back to Italy by Marco Polo. Maybe he brought it from Italy to China—I don't know.

My fishing boat captain, in any event, is the opposite of the typical Chinese: he is more like a New Englander, as silent and immovable as the granite hills of New England.

This is all right with me. The beauty of this day immerses me in a vast, unending natural world. A hundred yards from the dock, we leave civilization behind. If I want to look back, I can still see the old dock, the ship terminal, the big tourist steamer from Shanghai tied up at the dock, and beyond these the green hills of Puto, dotted with pavilions and temples. But I do not look back; these have disappeared utterly so far as I am concerned. I look ahead.

Before me lie island after island, and an endless sea. The sun comes out brilliantly from behind the usual haze. The fog lifts from the water. Every hundred yards that we sail reveals another island, then another. Emerging from the mist like great shaggy buffaloes on the American prairie, they just lumber into view, slowly, imperceptibly . . . then they are *there*. The water sparkles. The one sound of civilization that remains, the chugging of the outboard engine, melts into the scene. It has its own natural rhythm, and it fits right in.

The air above is filled with seabirds. They dive and splash. Suddenly my captain starts to toss bait or fish parts into the air. The birds spin and swoop and splash about us. Hardly a fish fragment escapes their quick beaks to fall into the sea. Here and there, near or far, a fat fish breaks the surface of the water and leaves a little foamy ring in the tiny waves. Sometimes an attentive bird dives through the ring.

What with the immense expanse of the East China Sea that just goes on and on and the islands always moving

silently into sight, the ecstatic disorder of the seabirds heeling and crying, and the chug-chug hum of the engine, I am soon drifting and dreaming, just as if I myself had swum into a liquid life where I can float and flow in any direction, instead of being merely a paying passenger on an old fishing boat with a silent steerer.

Little by little I forget where I am. I just am.

I start to recall boyhood times on the water, especially one time when I caught a four-foot shark, too dangerous to haul into the boat. This memory unfolds into a recollection of all the scary sea-adventure movies I had seen as a boy, filled with submarine monsters, giant clams, sharks, octopuses, fabulous squid.

These exciting thoughts awaken me to the present. The waters below us teem with fish, and where there is an abundance of fish, there are probably also predators: sharks, bigger ones than I had caught. I find myself looking at my feet that rest on the bottom of the boat. An inch or two of wood is all that stands between my soles and primeval monsters, and I feel the urge to pick up my feet. No use to peer into the water. It is impenetrable, filled with particles of yellow silt accumulating for millennia.

But the childhood fear does not last. I get back just to the present. I am on an excursion to an antique world. I begin to watch a big fishing boat throwing out nets in the distance, and I forget all about a shark's jaws thrashing and snapping at my boat.

I turn about to look at the captain, whose name I still do not know and which I never do learn, and he points to his left. In my reverie I hadn't noticed that we are actually approaching an island. But there it is, rising out of the sea, from a rubble of big sun-whitened boulders, into green hills.

"Here is where you want to go," he says passively, as if I had given him a definite address.

"And this is?"

"No name," he says. "No name I know. Good fishing around

the north side, though." He pauses. "No people here now. But long ago, yes."

"What's here?"

"Caves where Buddhists lived long ago. Ruins of a temple. No—one . . . two . . . three . . . temples. You'll see."

We are close now.

"Look here. There's a little path, maybe hard to find, but it starts just behind that big boulder that looks like a duck—see it?—may be a duck praying to Guanyin, eh?"

Another pause. The boat grates onto pebbles at the edge of the water.

"OK," he says. "I came here long time ago when I was a boy. You'll like. Good ruins. You'll see."

"And you?" I say, feeling apprehensive for the first time.

"I'll wait," he says impassively. "Maybe do a little fishing with a handline."

"You're sure you'll wait?"

"Sure. Easy to see this spot. I'll see you when you come back. Maybe an hour. Stand on the duck rock, see if you hear Guanyin preaching. I'll see you easy when you come there."

"All right." I move over to the front of the boat. "But maybe I won't take an hour."

"I'll see you, for sure."

I hop out, landing with my heels in the water, and then skip up on the rocks. When I turn around he is already backing the boat out.

It gives me an eerie feeling, to be all alone, despite his reassurances.

I find a barely visible path just where he said it would be, and at once my anxiety flips over into excitement. The path is badly overgrown with roots and vines, but in the dim past it had been marked by someone with a border of football-sized rocks on both sides. I follow these, like the reflectors that mark lines on the freeway. Every now and then I look back toward the sea and, sure enough, there is my fisher-

man, pulled up beside some boulders that thrust up from the water a hundred feet from shore. It looks like he is doing some fishing. Yes, he *is* fishing, for a fish splashes as it is pulled from the water, and it sparkles in the sunlight. Good. I could even yell to him from the shore, and he would certainly hear me.

Only a little bit farther up the hill the path flattens out onto a sandy plateau, at the end of which there is a cave, unmistakably a Buddhist's cave, with a crevice for an opening. On the lichened face of the grayish-green granite are ancient Chinese characters. Traces of red dye are still visible on the weathered rock. I haven't the slightest idea what the archaic characters mean, but on the opposite side of the crevice a big red heart is carved into the rock. Its meaning is unmistakable. The characters probably spell out the name of the Heart sutra.

I picture a solitary monk standing here in front of the cave, staring out toward the sea. Yes, there is Puto five or six miles away. On good days, when he chants the Heart sutra just right, with the requisite passion and conviction, does he finish his prayers just as the dawn breaks, and does he sometimes see a fleeting image of Guanyin rising out of the waves? I hope that he allows himself such a vision, even one time, before, all alone, one morning, he passes away in the midst of his prayers. The monk that I am making up goes directly to the Pure Land.

The person I am imagining is simply a representative of the many monks who must have lived here, one after another, for a couple of centuries.

I intend to go into the cave. As I approach the entrance I see just inside it a Happy Buddha carved into the rock. It is only about two feet high, but it must have taken a long time and immense patience to chip away the stone to make the figure.

Beyond this figure the cave opens up, but it is pitch black in there, and I can't see anything. My imagination starts to

work over the recollection that in China there are many poisonous serpents. Could snakes inhabit an island? The answer is yes, of course they could. I conclude that there is no reason to walk into a dark cave.

I turn away and soon locate the path as it continues further upward. At the top of the crest are the ruins of the temple buildings. They must have fallen down hundreds of years ago. Stone gates still stand and paved floors cover the ground. I can see exactly how small each temple had been—the largest is only twenty feet wide. Stone blocks, bricks, black roof tiles, and pulverized debris are scattered all about. I name the temples collectively "Looking Toward Puto to Find Guanyin Rising from the Sea." Then I sit on the remains of one of the stone gates. Dragons are carved into the dark gray rock. Good fortune. I had bought a roll and a bottle of mineral water at one of the little markets on Puto, and I consume them now.

At one time there must have been a spring near here, but there is no sign of one now. Perhaps long ago the spring was blocked off by a shifting of the rock. Without water, this beautiful little island would no longer be habitable. A modern geologist and engineer could doubtless get water flowing up here again—but there are no scientists handy. Why would anyone bother?

I walk around the ruins, picking up fragments, but I decide to leave everything as it is, taking only my plastic bottle with me, but leaving the crumbs I dropped to the busy ants that are already attacking the bits of bread where I had sat.

Time to go. To my amazement, I have already spent more than an hour on the island. From this promontory I cannot see the duck rock, or even the boulders where I had last seen my boat. I go back down the path pretty quickly, pausing for only a moment by the cave to say farewell to the monk's ghost, if there is one. In a short time I come out in the clear part of the path where I can see the landing place. Ten feet out from the shore I see my boat! Happy days! What a relief!

I wave to the fisherman, and he makes a slight gesture that acknowledges mine. Then I come down to the shore, grating on the sand and pebbles.

"Hello," I call out.

Another slight gesture. He is fiddling with the engine and looks up briefly.

"OK, I'm ready. Pull it in."

No reply.

"Well, I'd like to get going."

No reply.

"I'd like to go now."

He looks up at me—this time squarely, directly. "You'd like to return?"

"Yes. Pull in."

"To go back to Puto?"

"Yes, of course."

"About the return fare," he says flatly.

"The return fare?" I am feeling peevish, and it shows in my voice. The eerie feeling that I had had earlier when I found myself alone on the island comes back. I feel it go from my tailbone up my spine and conclude at the top of my head, burning the tips of my ears.

"Yes, of course."

"I already paid you."

"But that"—he pauses—"was to take you here. That is what you asked."

"Well, naturally, I intended to come back."

"Ah," he says, "but how could I be sure of that when I made my price?"

I see I am hooked, but I don't see how deeply the hook is set.

"All right," I say sulkily, "I'll give you another hundred. Just pull the boat in."

I have a crazy impulse to take a leap—if only I could run on the water—and jump into the boat. But that is physically impossible.

I just stand there stupidly, and hear him say:

"The return fare . . . is a bit higher, say a thousand yuan."

"A thousand!"

That was a hundred and twenty dollars, a year's wages for a monk, three month's salary for an average worker.

"A thousand is impossible."

"Very well, then," he says with no emotion. "You may wish to make this island your gate to the Pure Land."

He cranks the engine and speeds away! In seconds he has rounded the end of the island and disappears.

I am stunned. My legs are a bit wobbly, so that I have to walk over to a medium-sized boulder and sit down. I feel my heart beating—not to the tune of the Heart sutra, but in a panic. I look for other boats. They drift over the sea, but all too far away for me to be noticed. They are specks to me, and I would be nothing to the men in them. I have no matches. (Why did I give up smoking twenty years ago?) I cannot light a fire. There is no way for me to make a signal.

Then, my boat comes into sight again. And I—I am grateful to see the villain.

He pulls up to the exact spot he had occupied previously and floats there easily. But he looks at me intently.

"You have had time to think about it," he says. "Best for you to pay the fare of eleven hundred."

"But you said a thousand," I complain.

"Well, yes, but I wasted fuel driving off to let you think in peace. At least a hundred. Every time I ride away I waste a hundred. Perhaps I should go away for a while again."

I get the picture. Any fool would have.

"All right, I'll pay the thousand."

"Eleven hundred."

"Yes, come and pick me up."

"But the fare first."

All I want to do is to get back to Puto again where I will be safe. So I plan to say, "Fine, but I'll have to go back to the island to get the money. You can come with me." Of course,

I conspire to turn this thief over to the security guard down by the dock. But the fisherman is far ahead of me.

"I see you wear a nice American money belt," he says. "It seems rather thick."

He is right. He sees everything. He probably even knows that it is from Willis & Geiger and he has already figured out how many hundred dollar bills I have folded into it.

"A nice American one hundred dollar bill and four hundred yuan will do just perfectly," he says.

He tosses me a jar with a screw top lid. "Put it in there, and toss it back."

I am so beaten that I mechanically catch the jar, sit down, take my belt off, slide out a hundred dollar bill, and put the indicated amount in the jar, screwing the lid on.

The moment the jar leaves my hand, I want to pull it back. What if he takes the money and leaves? But I can only watch the arc of the jar in the air. It splashes a foot from the boat. He reaches out an oar, sweeps the jar to him, and without even looking at it, drops it into his soiled jacket on the floor of the boat.

A second later his boat grates again on the shore. I feel a strong surge of relief, and jump into the boat without delay.

He says nothing more than he had on the way out. He is impassive. As for me, I might as well admit that I sulk noticeably all during the return trip, which goes straight to Puto. As we swing past the gate of the ancient dock, I see the motto again, "The First of Buddhist Kingdoms."

And then I start to think of the monk, the exemplary monk that I had invented back on the unnamed island. He had spent his life there, in that lonely place, living in a cave, and later his followers built temples. None had complained at any time, not even once. They gave their lives, while I had let my heart become bitter for having spent a mere few moments marooned in solitary fashion there, and losing nothing but money. My heart starts to soften toward the fisherman whom I wanted to kill and feed to the fishes only

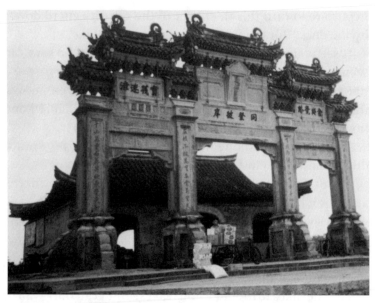

Gate at ancient dock: "The First of Buddhist Kingdoms," Puto

a short time ago. Perhaps the eleven hundred yuan I gave to him would be the only big score that he would make in all his weary days. His existence, like the monk's, involves a lifetime of poverty and grinding work for mere survival. Momentarily we will pull into the fisherman's dock, and I will walk up the hill and take a bus to Fayu, where I have a comfortable bed, while he will return to his difficult life.

Surely my empathy does not go far enough to incline me to want to make any more contributions to his newfound, temporary affluence, but my bitterness melts away, and when we do pull into the dock, I reach out my hand to him, smile, and say, "Thanks."

He looks at my hand as if it were a four-day-old mackerel, but he takes it for a second, suspiciously. I shake his, warmly.

I have four thoughts as I walk back, up the hill.

The first is that I have actually gotten what I wanted: I went back in time, all alone, and communed with the old ones who had lived and died there. I was stranded, as they were.

The second is that it will be very fine to see Gu Jia Jing tomorrow.

The third is that on the outward-bound voyage I had been remembering catching a shark as a boy and watching deep-sea movies. But at that very moment the fisherman was a shark tightening the circle about me.

The fourth is that now I can turn him in. The large sum of money will be found on him. He will be beaten to a pulp by the police and the other fishermen, whom his thieving has disgraced. But I no longer want to see him injured.

All over the world, even at this very moment, I think, sharks like this fisherman are doing what is in the nature of the shark to do. Even around the Heavenly Paradise of Puto, sharks patrol the waters, waiting for prey. Yet, except for a chunk of eleven hundred yuan that had been bitten off me, I am intact. The sun is still shining. The waters glisten. The boats plow through the fertile sea.

Then, as I pass a little string of fish restaurants, a teenage girl in a miniskirt, doubtless the daughter of a restaurant owner, comes up next to me before I notice her, and asks politely: "Wouldn't you like to eat now? We have a beautiful lobster and some clams, and a nice, a very nice bass fish."

Yes, she is a shark, too, but a charming one, ready to pull me under into her Dad's restaurant. And I am a shark, too, for I intend to feast on these poor sea creatures.

I chuckle silently in my head over the ironies that come too fast and are too numerous for me to count. But, after all, it is getting toward lunchtime. Now that she mentions it, a fat lobster, a luscious steamed lobster, would be exactly the right thing.

"Which restaurant is yours?"

She smiles happily. Success with the first customer of the day.

"Here it is."

She was right. It is a nice lobster, and I eat every morsel, smacking my lips and clicking my teeth with joy.

CHAPTER 21

The Lotus Closes

❀ THE NEXT DAY Jia Jing takes me, as she had promised, to Willow Branch and Yuelin—or "Happiness"—nunnery, where there is a beautiful white jade—or marble?—statue of Sakyamuni. We speak of the Pure Land again. An old nun of Yuelin who had been at the Pure Land gathering two days before is very happy to see us, and she tells us:

"Afterward, I had a dream or vision that I saw a gigantic lotus flower unfolding, and on each petal as it opened there stood a nun who had passed on to the Pure Land. Some of them I even recognized as famous devotees, such as Yang Jie. Others were nuns I knew here in Yuelin before they died. And—this is truly wondrous—some of the petals that opened last held people who were at our meeting, still alive. This is a sure prediction that these people we saw will soon live in the Pure Land."

She pauses. Her eyes are sparkling with tears of happiness. Jia Jing's eyes fill with tears. I also feel tears of exaltation welling up in me. Then she says what she wanted most of all to tell us: "I too, I believe, will appear in that same

flower, as another petal unfolds. Perhaps, dear Jia Jing, you will see me there."

When we finish our morning tour, Jia Jing brightens heroically.

"I have done all I can do for you," she whispers. "You have seen a great deal. You are a lucky person, a friend of Amithaba's. I am lucky, too. Had it not been for you, I would not have had the unforgettable experience of being at Ling Shi that great day. Your great fortune brought me there. Thank you."

She fishes in her little bag.

"And now, before we part, I have two presents for you. Here is a beautiful picture of Guanyin standing in the Pure Land on a lotus flower. May it remind you of the time we shared. And here is a tape of nuns chanting the Heart sutra. I will read the wonderful book you have given me and think of you. Someday, when our petals unfold, we will greet each other, two loving friends in the Pure Land. What a day of joy that will be."

I take the card and tape gratefully. There is nothing to say. *Listening is dharma, too*. Those words of Wuliang Chan's echo in me.

"I can do no more. Our tours are over. This afternoon I will go back to my home island for a long rest. You will leave soon. We will not see each other again in this world. Goodbye." She smiles, shakes my hand firmly, turns crisply, and walks toward the China Travel Service dorms, never once looking back, although I watch her until she disappears into the alley. I brushed her hand only for a second, but she has touched my heart forever.

That afternoon, back in a secluded pavilion at Fayu monastery, I spend a glorious time drifting in the imperial glow of the past few days. Jia Jing is often in my thoughts. So is the fisherman. So different from each other, together they give me a simple feeling for the world as it is, and will always be.

I pack my bag. I am ready to go back to the mainland.

I can no longer remember what I had been seeking in traveling to the sacred Putoshan. But the reality of finding Jia Jing and the fisherman is more than any pilgrim in China could wish, even in his dreams.

CHAPTER 22

freedom

✤ **"NEVER SEE HER** again. Never see her again"—I wake myself, crying out, on the morning I am to depart Fayu Si and leave Puto forever. A moment before, in sleep, Jia Jing and I were in a small motorboat on a vast sea. Suddenly, she simply, easily, slipped over the side, flowing into the water as if she herself were water, disappearing. Not even a bubble, only an almost invisible circle is left, and the slight swell rolls even it away. She is gone.

In the dark of the morning, in the big temple with my fellow monks, I chant the Heart sutra and Guanyin's name. I know that, among those monks and visitors gathered with me at Fayu, some are Pure Land disciples. I join with them, whoever they are, and say Gu Jia Jing's name, along with Amitabha's, in my prayers.

Leaving Puto. This magical, mountainous isle has contributed something new to my journey—sights, as well as insights, an experience with Pure Land Buddhism that is like the yin to the Tiantai sect's yang. Now I make sense of the arrangement of the statues in almost all temples. At the entrance Sakyamuni greets us. At the opposite door Guanyin

presides. They are back to back. Guanyin is the other side of Sakyamuni. The Tiantai and Pure Land versions of Buddhism are not just theories—I feel in my heart how they are truly attached and shape the lives of people. One made Qing Wai what he is; the other Jia Jing.

For a moment I feel sad to leave Puto. But as I pass through the monastery gates, this feeling disappears. As soon as I board the hydrofoil my spirits brighten. I don't want to stay. I want to go on. Am I sliding too shallowly over the surface of things and not thinking very deeply about them? This is true. But perhaps, after all, it is not such a shallow truth. My eyes are fixed upon the present and future, not upon the past. Should I hold with more commitment to what is past, like a good Confucian, or should I let myself swing, like a traditionless American, towards what is always coming? Well, I tell myself, God placed my eyes in my head to see forward—I should not thwart the cosmic purpose by always looking behind me. But the God who arranged my physiognomy also gave me a memory. I want to have both—the Chinese and the American way of seeing, unalterable history and the ever new; the Buddhist sense that the world will never end, and the Catholic conviction that the world will come to a dramatic conclusion in a second coming. More and more I find, as I go on into China, that I want to have it all—and I can. The more I become Chinese, the more American I am. Each new entry into Buddhist mysteries makes me more a Catholic. Every time I yearn to hold on to the past, I learn to drive forward. History propels me into the future. In China I accept my past as I had never been able to do in America. All my old hurts are turning into new graces. I want to be renewed in China *and* return to my own country. Even more deeply, I want to *make* a country that encompasses China and America, the best of all things. I create my own "Chinamerica." I open the gates to the celestial city of my soul and wait for the world to migrate to me.

So I sail on toward an unseen shore with a backward glance at the island as it disappears into a cloak of fog.

As the hydrofoil speeds on, I ask myself the question that I had sometimes asked others: "How long till I become Buddha?"

My master at Quo Qing answers: "Millions of lives!"

My master at Fayu Si says: "Right now!"

Both say: "Buddha is everywhere." "Buddha is in you." "You are Buddha."

I have no desire to choose among them. There is no answer anymore, no answer needed.

Surely it would be incredible luck to have the chance to spend millions of lives striving after perfection, albeit with many failures and innumerable setbacks. What a relief it is from the "one chance" at heaven that Christians believe in, to have an endless multitude of chances at your disposal—as many as you need, until you at last achieve the celestial goal. What good fortune to live a Buddhist lottery in which, sooner or later, everyone wins, and no one is left out. Patience and forgiveness and an incredible sense of endless opportunity are here in abundance.

But the Pure Land vision—immediate transformation in one blinding flash—is like being born again into a whole new dimension. We spend billions on space exploration and think it marvelous to get a probe to another planet. But these pale in comparison to the instantaneous leap from life to eternity, and at no cost to the taxpayer. Space travel, indeed!—from earth to heaven in a second.

I decide to believe in both, the eternally longed-for heaven and the immediate, transcendent leap to it.

The hydrofoil pulls into the dock. It is the end of the first week of August. I am headed toward Tiantong, one of the greatest of all monasteries in Southern China. No one has told me how to get there. Around the dock are a few private taxis. These are expensive, but do I have an alternative? The hydrofoil dock is located in a place of splendid isolation. Perhaps the temple is ten or twelve miles. Besides, I have no

idea which way I would walk, even if I were not carrying a piece of luggage.

A little bargaining with a taxi driver and we arrive at a price. After my experience with the fisherman I am overly cautious, repeating the price several times, writing it down, and finally counting out the bills, showing them to the driver, getting his nod, and placing them conspicuously on the seat. I keep my rollaboard on the seat next to me, not locked in the trunk, to be sure I will not face an exorbitant luggage fee to unlock the trunk.

Ah, I think, a few moments ago I was thinking about how to get to heaven. Now, already, I am focussed upon the mere question of how to get to Tiantong Chansi, as if that is the only destination that counts. And I am worrying about money and counting out yuan. So quickly do we descend from the heavenly mountain to lower altitudes and attitudes. Will I never learn how to stay on the heights?

Probably not. Such is life that nothing is entirely foreign to it. I guess I am learning that. The Puroshan lotus is closed. But I am also free to go on.

I see clearly, as the taxi bumps along over rough roads, I was wrong, very wrong, about the distances. Tiantong is far more than ten miles away. The ride takes almost an hour. I begin to feel that with my gross underestimation I had cheated the driver. Certainly, my precautions had been un-necessary. My guilt is unnecessary, too. Finally, we drive through a long road with thickly walled with trees on each side, and we emerge before the great gate of Tiantong Chansi. The driver gladly takes the agreed-upon fee and leaves me standing alone outside the gate.

How many times in life must I stand outside gates, won-dering if I will be admitted, before all gates fall before me, and there are no more barriers between me and my desires, when the desire and its enactment are one? The answer, I see, is the same one to which my meditations on the boat led: the fulfillment of desire may take almost endless striv-

ing, or else occur at once. Is readiness all?

Tiantong Chansi lies majestically in the foothills of heavily forested high mountains. What I learned earlier concerning the location of Fengguang and Guo Qing can be said in superlatives about Tiantong. The perfect monastery must be secluded, in the mountains, ringed with trees, fecund with ripe nature. This is Tiantong, more than any other place I know. Perhaps only Wutai could measure up, should I ever travel there.

Tiantong Temple is surrounded by high walls, like a fortress. This place is so remote, and so few people come here, there is not even a gatekeeper, and no one to collect a fee. After entering the gate, I find myself in a cobbled courtyard above which ancient trees rise to great heights. Stones and inscribed tablets are all about. Slightly to my left, a broad, crudely paved path leads up into the mountain heights. Centuries ago, everything was settled just as it is now. The courtyard was constructed to give travelers an immediate sense of having reached the end of one journey; and the path leading upward and disappearing into a mass of trees suggests the beginning of another, now in sacred precincts.

I am just in that same position, having completed my pilgrimage to Puto but not yet arriving at my new destination, in the middle of a journey.

I am standing in the courtyard when a middle-aged woman comes up to me. She is polite and friendly. She pulls a cloth cover off a wire cage. Inside is a squirrel. The cage is so tiny and the squirrel is so big that the poor creature can hardly move a muscle in it.

I know what she wants.

"How much?"

She smiles graciously, as if she is about to make me a remarkable deal, one I couldn't resist.

"Fifteen yuan."

It is a good deal.

I even have enough coins to pay that price, and I think foolishly, but fleetingly, that a squirrel for $1.80 is a much better buy than three little fish for the $1.20 paid by Fo Yuan.

"All right," I say, "but we have to release him (is it a him?) where you can't catch him back."

"Of course."

We walk over to the base of a gigantic osmanthus tree. A metal tag proclaims it to be three hundred years old. She opens the cage door. The squirrel hesitates for a moment and then shoots out onto the roots and almost flies up the trunk until, in a second, he is lost in the foliage. Does the woman have an accomplice hiding in the dense green above, into whose waiting cage the trained squirrel will run? Was this the mammalian version of the fish paradise? Will this squirrel be recycled over and over again?

The thought is amusing—and it doesn't take me long to realize that I am not entirely wrong in my suspicions.

The woman smiles with satisfaction at the release of the squirrel, as if the release (and not the money) pleases her greatly. Then she reaches around her back and produces another cage. In it is a twin of the squirrel that has just been released!

How did she keep him hidden? I suppose she must have had the cage tied under her tunic to the sash around her waist.

"Wouldn't you like another," she politely inquires, "so long as we are still standing at the foot of this fine old tree? This one can, if you wish, join the other."

She is a pleasant woman, finely rehearsed in this business of releasing squirrels. I hesitate. When she sees that I am wavering, she continues her sales pitch, but she overreaches herself.

"In fact," she says, "I have twenty or thirty of the little fellows. I raise them for the pleasure of religious folk such as yourself. And they breed quickly. I can give you a good buy on the whole lot. A hundred and sixty yuan. Wait. Say a hundred and fifty."

For a mere twenty dollars I might earn an eternal reward and take a big shortcut to nirvana. But, like Fo Yuan, I leave part of the imprisoned world to be redeemed by others. I have learned that we are all in this together.

This time my spirit is all right. I believe that what I did is enough. Only God can liberate the whole world, but I have done a godly thing. I did as well as Fo Yuan had done, and I had not even gotten really angry as he had.

I bow to the woman and leave her. We each got some satisfaction out of the exchange. I start up the solitary path.

My bag refuses to roll over the cobbles, and so I put it on my shoulder and climb the tree-lined path up the mountain to the temple itself. Once there, I go right to the easily identified reception hall and ask for Xiu Xiang (meaning "Peaceful"), to whom I have letters of introduction from more than one of my friends. Will I find, in him, a new friend here?

Old Questions with New Answers

❦ **IN A MOMENT** Xiu Xiang comes out to greet me. He is a master, a teacher of dharma here, not the abbot. He barely looks at my letters before welcoming me warmly —the invariable, immediate acceptance which is one of the sweetest of all the characteristics of religious Buddhists.

"So, you have just arrived from Puto," he starts. "A wonderful place, a holy place, indeed. Our temple, which we will share with you as long as you wish to stay, has its own special features, as you will see. "Perhaps, since it is still early in the day, we can have a little conversation," he says.

This is the sort of moment for which I always hold my standard questions in reserve. In Ningbo city, Wuliang Chan had not given me time to administer my quiz before he questioned me. I am not anxious yet to have Xiu Xiang inquire into my journey. And so I hurry to get out the first of my questions:

"I have asked this question of others, but I would very much like to know what you believe to be the hardest desire to overcome."

Like almost all those of whom I asked this question, he has his answer ready, for it is a central personal question for

any Buddhist. He gives it slowly, thoughtfully.

"The hardest desire to overcome is the wish to rise above the people.

"Sakyamuni had been Prince Siddhartha. His father petted and pampered him, not allowing him to mix with the people. He was not allowed to know how people suffered—through old age, or sickness, or want of material necessities.

"At last, by chance, Prince Siddhartha discovered that suffering exists. He realized that he had been kept from the very knowledge that he needed to possess if he truly aspired to become holy, a *real* prince. This knowledge told him that he was not above the people. He, too, would age. He, too, would feel pain and not know what to do with it.

"He determined, then, to leave his privileged place and descend to the people, experiencing what they experience. He saw age, disease, imprisonment, persecution, poverty, mental sickness, starvation, loneliness. He experienced all these himself. He insisted on experiencing all of the ills of the world more fully than anyone before him had done.

"Then, finally, he knew that having absorbed all the experiences of suffering people, especially of the poor, he could concentrate these in one burning focus. This was the time he sat under the Bo tree, determined that he would not rise until all of his experiences fused together in one flame of enlightenment. When this occurred, he became Buddha. We must all do the same.

"We do not know fully how to interpret the story of Buddha. Here is how I interpret it. I think that Prince Siddhartha represents many lives—perhaps many thousand lives—of people who exist on the level of complete unknowing. Many are the people who live in ignorance. Many are those who do not know the experience of the people, and who hold themselves above the poor. 'Siddhartha' represents a woeful state of the soul.

"The Siddhartha soul is locked in a tower of ignorance. It knows nothing of the anguish of existence. It is like a baby.

It is fed, it is diapered, it is nourished and nurtured by others. A baby thinks itself a prince, arrogantly unaware of the needs of anyone else.

"After eons, it dawns upon this baby soul, this aristocratic soul, that there are indeed others in existence, with claims equal to his own upon pity, justice, and sympathy. At this point, the baby grows into a child who lives in the world, suffers, changes, and ages. The child soul is still confused. When it was a baby, it knew exactly how the world was made—to please the baby. But once it descends from the tower, it does not experience pleasure anywhere, only pain. How can the childish soul get freed from the confusion that besets it?

"The man who sat down under the Bo tree gives the answer. He must rest, freeing himself from the whirling world of confusion. Then he must find the central, unmoving pivot on which the world whirls and whirrs. He must close his eyes to the movement and give attention wholly to the unmoved. Probably this part of the story of Sakyamuni also represents many, many lives—not just a short time under a real tree, but mankind's centuries under the shade of ignorance.

"If we can do as Siddhartha did in growing up, we too will become like Sakyamuni and rise up as a Buddha. If we cannot do so, we will never become a person, but grow old with age and spiritual stupidity. The winds will blow us away like dry leaves and scatter us across the cosmos.

"Look at the representations of Sakyamuni, especially those by the original sages in India. He is a young man, muscular, fit, vigorous, ready in strength to take on the demons of the world.

"We too must be in good shape.

"That is what we monks are trying for—to get in shape, to follow a rigorous athletic regimen and become truly healthy. Of course, look around at the monks here. I am not referring to athletic bodies, obviously. My own body, as you see, is poor enough. I am referring to a well-exercised soul.

"We withdraw from the world. We follow the path of the Buddha from his Siddhartha soul to the child soul, and hope to sit under the Bo tree of this temple and make our way, after thousands of lives, to full enlightenment.

"But that is where our problem comes in that you asked about. In withdrawing from the world in the hope of transcending ignorance, we are constantly in danger of arrogance, as if we are different from, or superior to, the people.

"We want to withdraw, as Buddha did, but we must never forget the suffering of the world. Otherwise, we will become the truly ignorant Siddhartha soul again, instead of the Sakyamuni soul.

"Our greatest desire is to escape from samsara into enlightenment, but that is the source of our greatest dilemma. We must go beyond the people, but never abandon them in their need.

Xiu Xiang and author at Tiantong

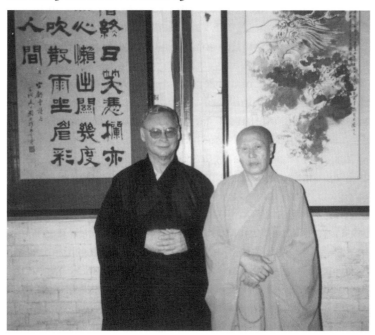

"The people are Buddha, just as we are. We are all on the same path."

The way I am reporting this speech makes it sound as if it took a matter of minutes to deliver. But a very long time elapses before Xiu Xiang actually comes to his conclusion. He speaks these words very slowly, often repeating them, and always checks with me to be sure I understand him. He allows for interruptions, natural breaks.

While he talks, we drink tea, we go outside and walk around the garden, we relax into long silences. We proceed slowly, as if we have many lives to talk these things through.

During all this time I say nothing, not a word. When I think he is finished, I remark: "I have never heard the story of Sakyamuni explained in just this way. It is a very profound interpretation."

"Excuse me," he answers. "Your comment reveals a danger for you. Obviously, you are a Western man of intelligence. Perhaps, if you answered your own question, you would conclude that the desire that for you is the hardest to conquer is the desire to be intelligent, to understand quickly."

"But isn't wisdom the goal? Isn't that what you are driving at?"

"See, you *have* misunderstood me. Wisdom is certainly the goal, and certainly not the goal. Our aim is to achieve knowledge of suffering, to achieve wisdom, if you will. And then to be wise enough not to be smart."

Yes, as Wuliang Chan said, I should brew more tea.

I see that he is urging me not to say anything more, but to reflect, perhaps for a long while.

Another monk is called to show me to a room. The building I am in is so ancient that I think: It looks as if it is ready to collapse, but if it has not done so by now, it will probably hold up for another century. The room itself is bare, unpainted, with wooden walls that have aged to silver. Sunlight struggles through the dust-stained windows, but some previous occupant has wiped clean a little circle on the pane,

and a round shaft of light shines right through it and makes a golden circle on the wall in back of my bed. Completely dilapidated, it is just the room I want.

I go about the usual business of all temples, content to chant and read and be still.

The next time I meet with Xiu Xiang I also get to ask my other standard question: What is the greatest virtue to possess?

In contrast to his long reply to my query about samsara, he goes right to the point and is brief.

"The greatest virtue is to give relief to the poor."

This is quite a surprise. This assertion differs so much from the Tiantai and Pure Land branches of Buddhism that I venture another question to determine whether I have understood him (or he me) correctly. I ask, "What, then, is the most important goal—to reach nirvana or to lead a moral life?"

His answer remains perfectly consistent: "To lead a moral life, and to preach morality." He then adds, "Nirvana will come after eons of leading a moral life."

This talk with Xiu Xiang tells me at once what a different sort of monk I am talking to. For Ke Ming and Qing Wai, monks lead the people by achieving wisdom; in Xiu Xiang's vision, monks lead the people by giving them support and comfort, and by offering to them their own examples of abstinence and moral virtue. I ask Xiu Xiang what sutra he believes is the greatest, rather sure it would not be the Lotus or the Heart sutra. At first, he gives the usual answer that all scriptures are equally great, but as a kind of footnote he adds that the Ground sutra has the greatest use for him.

I begin to understand that wisdom is great, the greatest virtue. But to relieve the poor is just as "great" a virtue. In the end, there are only virtues, no hierarchies. *Both* are "the greatest." There is no ranking of virtue.

Xiu Xiang continues:

"I have already told you that the most important stage of growth toward wisdom is the experience of the suffering of people. To grow rich in wisdom you have to grow very poor

in possessions. In order to leave suffering behind, we must join with the poor, so that we can all go to nirvana together. I think that until the whole world can enter nirvana, no one can go there. And we monks must go there last, refusing to enter until we have brought everyone else in."

During the week or so that I spend at Tiantong, I have many discussions of this sort with Xiu Xiang.

One day he asks me: "Jay, why did you come to China in the first place?"

It is exactly the sort of question I do not want to hear. An acute person, he knows just what to ask. I have been struggling with this question myself. The trouble is, the question has too many answers. I try to make only a start, and eventually my answers take several days. Truthfully, he is not satisfied with any of my answers, and I find that my explanations ring hollow for me, too.

"My fascination with China started when I was a child."

I tell him all about my boyhood, and about my cousin Joan who was born in China and lived there with my uncle and aunt, Aunt Florence, my mother's sister.

"I was jealous of Joan, I guess. I wanted to have what she had. China was a toy that I wanted to possess."

Later, I tell him that I was in China two years before as a tourist, sailing the Yangtze gorges.

"Then you can't be looking for another tour now. You had already been to China as a tourist," he says. "You have already visited all the major sites. Why did you come back this second time? There is more to your desire than any sort of tourist visit could satisfy."

I acknowledge at once that he is right. China is more than a site to visit. Then I try to tell him that China has always held a special mystery for me. But I know I am staying on the surface, not truly answering his question, even as I say: "As I grew up, China more and more meant a place that is exotic and perhaps holds a special secret. I came to China to solve that mystery."

"But you could have studied Buddhism in the United States," he objects. "You could have gone, as you told me you have done, to the Hsi Lai temple."

Certainly this is true. A day later I try again.

"I came to China this time to find whatever it is that I would discover if I could get out of the channel I had dug in my life."

"Yes, we all do that. But perhaps those channels, if we dig them deeply enough, unearth deep wellsprings right where we are."

He is right. I am learning the truth of what he says right here, in talking to him. I try again, and I start to get it right.

"I have discovered that I am touched and refreshed by facing, at one and the same time, the very, very old, and the unprecedented new. These are both very deeply in my soul. And by being an American in China, not an American or a Chinese person only, I can try to see all sides. I have realized that I cannot escape my desires, but that even the most mundane and banal desire can reach out to the heavens and become sacred.

"I have learned that everything can be loved. I thought that when I came to China I could stow my love safely at home. But I have found a new depth of love and holiness here in China to bring back home."

I take a paper out of my portfolio.

"Look here, even this wretched brush painting that I did yesterday while I sat in the forest high up in our mountain— even this painting, which is a complete failure in any artistic sense, satisfies me. I can accept it without really judging it.

"I learned in Puto that whatever happens, simply happens. I'm not saying, like Candide, 'Whatever is, is *right.*' Just that it *is.*

"But I keep learning new things. They seem to fit together. What I am saying to you is a provisional pause on the path of learning. And to you, Xiu Xiang, it probably seems shallow.

"Last week, I learned something from you that I hadn't

previously understood—I mean understood by really *feeling* it—how important it is to be at one with the poor, the hungering swell of humanity. I know that an American is supposed to be brought up on the idea that we accept the 'huddled masses yearning to breathe free, the wretched refuse' of the rest of the world. But the truth is that we have lost this idea in America. I didn't know I was coming to China to learn how to be among the poor, poor farmers, poor fishermen, poor monks—those with a salary of a hundred dollars a year. But that is what I came to learn and absorb, without intending to, in preparation for seeing you, and relearning the life of Sakyamuni.

"Now I know that if you keep looking, you keep finding. Maybe that is it. I came to China to continue looking. When you have to face new scenes and unforeseen circumstances, you have to *look* much more closely than you do at home. This journey has been a discovery. I couldn't have achieved the same by merely staying put at home. Perhaps our American essayist Thoreau could learn by staying put. But I wish that I could seize him by the lapels and say, 'Henry, go to China! There's more to find out about yourself than even you can discover in Concord. Get on the first Clipper ship you can, and report back in a year with a new *Walden!*'

"Here I am, well advanced in my life, and learning that it is just beginning.

"From here I'll fly to Xiamen. Now I know that there is something more for me to learn there. I've come to China to realize that the future is continuously unfolding, and to take whatever it brings.

"I'll have to report back to you in a year, then perhaps every ten years, to tell you the newest answer to your question, for I think that it will take me a long time to find out even a small part of the answer. I'll only find it out little by little.

"But this is the best answer I can give you now."

Without intending to, I matched his long speech with my own almost interminable talk.

But few of my days at Tiantong are spent in talking. I roam the old paths in the forests and step across the mountains. Often, I leave the temple immediately after early chanting and breakfast, skip lunch, and spend the whole day walking aimlessly in the hills. I find old, barely visible, paths where monks must have walked in the early part of the century. I sit on rocks and think—about nothing at all. With me, I bring a brush and ink stick for painting. In a small plastic bottle I carry water. With these few implements I can grind the ink stick on any declivity in a boulder so as to make ink. I draw the trees and the hills and the wisps of fog on sheets of rice paper which I have folded up in my pocket. Sometimes I use twigs or pine needles instead of the brush, and I smash dirt into the water to make brown ink, and little blue and red berries to make other colors. I put the paper aside, too, and paint stones and smooth-barked trees and old brown leaves, brittle as ancient parchment paper or pattra leaves. Tiantong lets you do that—leave civilization almost entirely behind. I rest on ancient boulders, some of them carved with mystical characters or elaborate calligraphy. I draw pictures, I write poems, I chase squirrels. I study ants and their ways. I become Tiantong's cataloguer of sudden showers and sunny skies. I number the trees and make the acquaintance of the birds. I surprise harmless green and black snakes warming themselves on flat rocks. I turn stones over and find the crawling mysteries beneath them.

I carry a red collapsing plastic cup with me and dip it into fresh springs that seep out of the limestone mountain. One day, I am suddenly surrounded by a cloud of tiny, beautiful iridescent butterflies, whirling and dancing. One gets stuck in my hair and falls down my collar. Just as I am tilting my cup up to my lips, another winged creature flies into the water. Without pausing I drink it down, and I feel the live butterfly, like a winged god inside me, beating in every vessel of my body.

The quiet days are full. The silences speak loudly to me, in poems, in thoughts, in images and symbols.

In the solitude of this mountain forest, a piece of knowledge is given to me about how to climb a mountain.

Xiu Xiang talks to me whenever I want to listen. But now, the birds and wind and even the rocks and the snakes, with their tiny darting tongues, and the squirrels speak to me, and I spend many a convivial hour in the mountains.

Of course, I am expected to be back in the temple every day by dusk. If I stay out all of a warm summer night and sleep on pine boughs, someone will worry about me and go to the trouble of walking out to look for me. So I come back before dusk each night in order to give no one an extra burden. Besides, I am hungry by evening, I might as well admit that, and I also like the night-work. Nature is good—but so is the fellowship of man that Xiu Xiang preaches.

The kitchen at Tiantong

I try to tell Xiu Xiang about this one day, though I'm afraid I fail to explain it any better than I am doing now.

"I've found out something else, Xiu Xiang, something underneath the need to love the people in all their tribulations. I've discovered that . . . well, that there isn't really any loneliness, or, better still, no aloneness. You can't be alone. When I go out into the forest here, it's crowded with life. I like the way it teems. It talks to me. Yesterday I had a conversation with an earthworm. I intend to seek him out again."

He says slowly: "These forests are very, very old. They are so old that they had no beginning. I know what you mean. Everything hereabouts has acquired a soul. Everything is Buddha here."

CHAPTER **24**

An Attack, and a Repulse

❧ SO MUCH LUSCIOUS and inexhaustible
life exists at Tiantong that I almost decide not to go on to Xi-
amen. When the time arrives for me to return to the United
States, I can fly right from nearby Ningbo to Shanghai to
catch my Japan Airlines flight.

But, I tell myself, if I had intended to go to Xiamen, then
it must be that in Xiamen some new lesson is waiting for me
to come to it. To be sure, I have already been filled like a cup
to the brim with lessons. But I am ready to allow my reach
to exceed my grasp. Why not?

Xiu Xiang offers to have me driven to the Ningbo airport
in the temple's van. Why, when I myself had spent such a
happy separation from the world here, would I oblige any-
one to leave it? So I ask the monk charged with communi-
cating with the city to arrange a taxi for the next morning.

By this time I am over the shyness that had restrained me
with Ke Ming when I departed from Guo Qing at the very
outset of my trip. As soon as chanting is done and breakfast
slurped, I draw Xiu Xiang into a pavilion with me. Other
monks join us and we talk until a young man in ordinary

clothes is guided to our pergola by another monk. This is the taxi driver.

I know that in trying to recount the talks that Xiu Xiang and I had, I give the impression that we disturbed the universe with chatter. But our talk was so quiet and calm, it was almost silent; maybe we did, in fact, communicate with our thoughts.

The difference is immediately apparent before we are with the taxi driver for a minute. He is an inveterate talker. He is very young, younger than his years. Xiu Xiang would have termed him a baby soul.

Before I can even say good-bye to Xiu Xiang, this young man starts to ask about the monastery. He wants to know why the monks are living a secluded—he means "useless"—life in the mountains of Tiantong.

"I'm just driving a taxi for the summer," he says. "I'm a student."

He regards this as an elite position.

He asks Xiu Xiang: "Is this your job? You work for the government, right? How much you get paid? It's a pretty easy life. But there's a lot happening outside here."

"Well, yes," Xiu Xiang answers, "the salary of a monk does come from the Bureau of Religious Affairs, but we *work* for the enlightenment of the people."

"The government organizes things for the welfare of the people."

Xiu Xiang doesn't see eye to eye with the doctrines that the young man learned in his city schools. He starts to explain these differences to him, talking seriously and sincerely. But the driver becomes impatient with the strange speech he is hearing and starts to fidget. He builds up such a head of steam that he blows his top and challenges the monks: "Don't Buddhists know that science has proved that 'god' is dead and you are talking nonsense?" We can hear him scornfully speak the name of God with quotation marks and in lower case. Everyone knows where *he* is coming from.

"That's just your communist textbooks talking," Xiu Xiang says gently. Another monk chimes in: "Have you ever thought for yourself? Do you have a Mao recording inside your head that speaks for you while you move your lips?"

The student is stunned. Probably he has been told in school that when an educated communist disciple speaks up authoritatively, he will silence all opposition. To be attacked and actually held in contempt by those whom he regards as stupid monks must be an unprecedented experience for him. He just sits with his mouth open for a few moments. And then he tries again—but rather more meekly this time.

"You don't understand. You have never read Darwin and Marx," he tells them.

"For myself," Xiu Xiang answers, "I looked into them at one time, when I was a very young man. I believe that if you will consult an English edition of Darwin—not your expurgated Beijing-approved text—you will find that Darwin declares his firm belief in God over and over again in the text."

The young man makes no reply.

"But," Xiu Xiang continues, "I found little of interest in Darwin and nothing in Marx and Engels. They reached no higher than a low level of consciousness. And I haven't read them at all for years. When you graduate from high school and go to college—"

"I HAVE graduated from high school," the young communist insists, a little panicked. "I HAVE! I am a junior in college!"

"Ah, I see," says Xiu Xiang. "Please forgive me, I did not mean to hurt your feelings, and I see I have done so. My only excuse is that you seem so young."

Actually, Xiu Xiang's comments about Darwin take me by surprise, since we had never touched on any but sacred matters. I was not prepared to learn he had read Darwin. I wonder if he might have been a college teacher until the Cultural Revolution, and then, after enduring years on a rural farm, become a monk and master when the Gang of Four were overthrown.

I say, "We'd better go down to the car."

The student is quite ready to go.

For a time, as we drive, he broods quietly over the rough treatment he got. But it is not in his nature to sulk, and every mile we get away from the monastery he brightens more.

I am sitting beside him in the car.

"You can call me Charlie, Charlie Chen!" he offers in English.

"I can't call you Charlie Chen," I inform him. "It makes me think of old movies about Charlie Chan, the great detective. All of these are now regarded in the U.S. as hopelessly politically incorrect."

I am joking with him, of course. If he wants me to call him Charlie Chen, I will certainly do so, but I want to see what he will say.

I soon learn that Charlie is very well informed about America, and especially American movies. He knows the movies I refer to. He is a modern young man. His English is excellent.

"Ah, so," he returns brightly in English. "Yes, 'Number One Son,' 'Solvy Crime,' etcetera, etcetera. Velly racist, Charlie Chan. But I like those movies, doncha know? Charlie Chan very smart detective, catchy all bad boys, eh?"

I can't help liking him, or at least wanting to like him, he is trying so hard to be an American, to know everything. That also makes me want to tease him and make fun of him, because he himself is so full of good spirits.

"Okay, we've got plenty of time," he continues in English. "I checked. Your plane leaves this afternoon, not his morning. Change of schedule. Let's do lunch. There's nothing out here in the sticks. We'll dive into a great dish downtown."

It is a long drive, and we talk about many things. I learn that he is far from content to remain stationed in Ningbo any long time.

"I'm arranging to go to some university, Texas University or University of California, maybe Yale."

"And you'll study—?"

"Economics, certainly. I want to come back and be a big operator in Shanghai. That city has a swell future. Or maybe I'll stay in the good old US of A and work in the commodity exchange in Chicago. A smart China boy could pull off some pretty fair deals there."

"You're a member of the Party here?"

"Sure. But in America I'll be a Democrat. That's okay. Nobody in China is really a communist anymore. We've got Hong Kong, and we've got capitalism. Let the city officials be communists, the rest of us will be businessmen. Good deal!"

As we pull into the center of Ningbo, he inquires: "What's for lunch? You've been in Tiantong too long. You're not a Buddhist, right? You eat meat?" He doesn't even pause. "Yes, all Americans eat meat, Texas steaks, hot dogs, hamburgers. So, we'll go to McDonald's for a real lunch."

"McDonald's?"

"Ronald McDonald, the Big Mac, Chicken McNuggets, Double Cheeseburger. The Golden Arches are the right stuff."

"Well, I've never eaten in McDonald's," I say. It is a lie, to be sure, but I really don't want to be spirited off to McDonald's.

"You don't eat meat?"

"Yes, I do, but I don't eat in McDonald's. We can go someplace else."

"I see what you mean. Okay, it's too greasy. What about KFC, then? It's better. In Northern China, like Beijing, they enjoy McDonald's better, they like the wheat buns and seared meat. But here in the South, we like KFC better, good chicken."

"No KFC either, I don't eat it," I insist. Certainly, that was not true either, but I simply couldn't help teasing this superficially Americanized, communist Chinese boy.

"All Americans eat KFC," he pleads. "All Americans like it. Colonel Sanders' original recipe or barbecue flavor, take your choice."

"What I'd like, what I'd really like," I decide, "is to go to

an old-fashioned noodle and dumpling restaurant."

"Okay, okay, we can do that." He doesn't like it, but at least we have arrived at a clear objective. "There's only old people there, no music, no rock and roll, no American posters. But I get it," he brightens, "you want the good old taste, the original recipe of old China, just like the good old days, right?"

"Yes, take me to the oldest, most decrepit, run-down place you can."

"I know just the place. My grandmother eats there."He makes an abrupt turn across three lanes of traffic. "Yes, the exact place, a real hole-in-the-wall."

The section we arrive at, in the very heart of Ningbo, looks like nothing so much as the New York Chinatown of my youth—or the Los Angeles or San Francisco or Vancouver Chinatowns—big red and green wooden gates, crowded stores, fancy gilded decorations on the buildings. I had always believed these American Chinatowns to have been sort of movie sets, but now I realize that even as a child I had been seeing one version of genuine Chinese architecture, an imitation of an imitation of what old China might have been or at least should have been. This place in Ningbo was probably being built in the 1870s or '80s, at the same time as the identical Chinatowns in America.

We soon make our way past the souvenir shops to the Meng Liang Lou, a noodle shop so authentically ancient that the Los Angeles Board of Health would have closed it down without a moment's hesitation.

The noodles are fine, with quite a bit more spice than I had had in my rice at Guo Qing or Puto. I don't have any meat, and I am very satisfied.

Only one particular detail breaks the spell. Next to me on a bench at the long table is a typical version of one sort of Chinese family—an old pair, a grandmother and grandfather, along with a four- or five-year-old grandchild. Without a doubt, the little girl's parents are both at work in the business district of thriving Ningbo. So these grandparents, like

many, many others in China, have to baby-sit their grand-daughter all day.

The old folks are happily digging with their chopsticks into bowls of noodles in broth, just as their grandparents had done, and theirs, all the way back to the Ming dynasty. But for the little girl, the old China is completely lost. She sits down. In front of her she places a little red and white card-board box on which smiles the happy, almost Chinese, face of Colonel Sanders. Delicately she opens her little treasure, spears a chicken nugget with a plastic fork, dips her morsel into a little tub of Texas Bar-B-Que sauce, and eats happily.

By the time she is seventeen she will be a complete American. She will travel to the U.S. to attend Cal Tech. She will surely go to computer fairs. She will belong to a scientific society. She will never eat the Colonel's nuggets anymore, but only rice vermicelli and tofu. She will jog, swim, and bike daily and stay exquisitely slim. By twenty-five she will become an executive at Microsoft. Twenty years later her daughter will go to Yale, grow breasts, get zits, major in Chinese- American studies, and spend a year abroad at Ningbo, where she will begin to study Mandarin and attend an introductory class in the Ningboese dialect of Wu. In Ningbo, too, this daughter will meet her ancient grandparents for the first time—that same young couple who at this moment are out working in an office somewhere—and they will tell her all about the "old" China of the late 1990s, when her mother was a little girl.

As Charlie Chen and I walk back through Chinatown-in-China toward the car, he pulls at my sleeve and says: "Listen!" as if a very important announcement is being made.

I hear many sounds. When is China ever quiet?

"What?"

"To the music. You hear it?"

"Yes. What is it?" I really do not know. I am not teasing him this time.

"The music from *The Titanic,* the most popular song in China."

I know he means the movie. I haven't seen the film, and don't want to see it.

"Celine," he prompts me.

"Celine?"

"Yes, Celine is singing on the CD. You know Celine!"

"I thought Celine was a dead French author."

"Everybody knows the song." He sings a few bars in a tinny, high voice. "That's Celine! Celine Dion!" he concludes emphatically.

"I never heard it," I tell him.

"Never heard it! That's impossible. All Americans know it. Most popular song in America. Big hit in China. You hear it when you see the movie. I saw it on the Big Screen in Shanghai, costing pretty big bucks."

"I've never seen the movie."

"That's impossible!" This is becoming a favorite phrase for him to direct toward me. "All Americans have seen *The Titanic.*"

"I'm sorry."

Actually I *am* feeling a little sorry for him. He is getting exasperated, and he can't conceal it.

"You do not eat the American food all Americans eat. You do not go to see the greatest American movies. You know nothing about American music. Are you from America? Maybe you come from New Zealand? I don't know what to make of you. Do you only like noodles and vegetables and temples and the murmurings of monks? Where do you come from?"

"From California," I say quickly. It puts him back in his old groove, as if I had pushed a button.

"California. Hollywood, home of the movies. Disneyland. Universal Studios, Beverly Hills, Graumann's Chinese Theatre, O. J. Simpson."

I want to ease his mind, and so I tell him little lies again, only this time to calm him down, to soothe his perplexity.

"Certainly. I go to Disneyland all the time. And Knott's Berry Farm," I see him insert this new item in his mental catalog.

"And I see the movie stars on Hollywood Boulevard. I shop on Rodeo Drive. You can see O. J. Simpson playing golf all over Southern California." Once I get started making up things to please him, I find it easy to go on. "And Las Vegas, Caesar's Palace, Palm Springs, the Hollywood Bowl, Bruce Springsteen, 'Born in America—'."

"Yes, I know that old song, once very popular in China," he interjects. I can see by his smile that he is happy again, and so I stop.

We finally do arrive at the airport.

Charlie moans: "That monk bothered me. I doubt if he ever read Marx or Darwin. They're just stupid monks who can't do anything else. What do they talk about? What can you say about Buddha? I wish I could have heard them chanting. They just murmur. Most of them don't go to school, they can't even read, they don't even know what they are saying. *Hum, hum, hum, hum, murmur, murmur, murmur.* They're not educated, just stupid monks."

I see that he is still hurt by Xiu Xiang's dismissal. But he is getting his equilibrium back.

Charlie is certainly wrong about Xiu Xiang. Isolated as he is in the lonely hills extending for miles all around the temple, Xiu Xiang is a spiritual master and evinces a deep concern for the poverty of the average Chinese person; much more concern, I should say, than the young communist, Charlie Chen, ever feels.

Charlie is a modern sponge, but I like him because he takes everything in with such enthusiasm. With a few lucky breaks, he will become a shipping magnate at Ningbo. Perhaps someday I'll come here again, and he will meet me in a big chauffeur-driven Rolls Royce limousine. Maybe, even, Xiu Xiang's sincere remarks on the needs of the poor will also stick in Charlie's mind and he will become a famous philanthropist in this area, but attribute it all to his modern training.

At the airport I thank him, shake his hand, and slip a hundred-dred yuan bill into it.

"You know, we are not allowed to receive tips. You have paid the agreed-upon fee." But he holds onto the bill anyway.

"It's not a tip, just for friendship."

"All right, then," he says. "I'm 'king of the world.' Thank you very much."

He is gone.

I am on my own again, on my way to Xiamen, to find whatever awaits me there.

CHAPTER 25

You Can Calm Your Heart Here

❧ **ANYONE WHO GOES** to Xiamen with even the slightest interest in temples will soon find himself in Nanputuo.

I went to Xiamen to spend the last part of my Chinese journey at this famous temple. The city of Xiamen itself, I thought, would be of little interest to me. However, it turned out that in this city I was to find a great deal.

Old-timers know Xiamen as Amoy, which became wealthy in the nineteenth century when its fine harbor drew international trade to it. Gulangyu Island, just a short ferry ride across the bay from the Lujiang Hotel, at the end of Zhongshan Lu, is still bulging with Western-style houses. One nationality of European architectural style crowds in only a few feet from a completely different style, as if Europe has suffered a great explosion and houses from Germany, France, Spain, and Italy have all landed helter-skelter beside each other on the shores of this island. Today, this island is a museum of decay. By contrast, the city itself is a busy free trade port, even more full of new buildings and money than Ningbo.

Nanputuo Si was there more than five hundred years before the city was. Even now, Nanputuo stands apart from old Amoy and modern Xiamen in a quiet setting of its own. When it was founded in the Tang dynasty, it was a grand affair, but it is much grander now.

My taxi from the new airport leaves me at the gate of Nanputuo and I pay my entrance fee. I find I am hungry. I hurry to the big Puzhaolou vegetarian restaurant. Nanputuo is so steadily visited by tourists that a recent abbot built this very large restaurant to accommodate bus tours. Bountiful meals, such as monks never eat, are served here, so that tourists can feel they have eaten "with" the monks. These tourists are almost all Chinese. Busloads of them come daily from Taiwan to visit the sites from which their ancestors fled poverty and upheaval centuries ago. There is also a big new air-conditioned dormitory where tourists can stay overnight on special tours. Ironically, the Chinese tourists are going to stay in the foreigners' building, at a high price, while I will live with the monks for whatever I wish to donate.

So Puzhaolou is the vestibule through which wealth continually flows into Nanputuo. During the time I am at the temple, tourists come steadily. They eat, they pray, and then they give gifts in remembrance of ancestors, or for their own health or luck, but mostly for their families, whose lineage goes back as far as anyone can remember. Many dead ancestors, the opening up of China to the Taiwanese, the rapid accumulation of new money in Taiwan, the proximity of Taiwan to Xiamen—these all lead to bulging coffers in Nanputuo.

Certainly, the temple was given a thoroughgoing restoration no more than ten years ago. Somebody else might say that the bright red and green paint and the abundance of gold leaf and gilding give the temple a garish gaudiness. But that is only in comparison to the many less important, faded and worn, old temples with only pennies to maintain them. It looks fine to me. It looks just like it did when it was first completed. It glows in its own glory.

Nanputuo is the way a temple is meant to look—splendid in the sun, shimmering in the moonlight. Before it is a big lotus pond. In the middle of August, when I arrive here, the flowers are in full bloom, and there are many of them. All about the grounds are freshly painted buildings—dormitories, bell towers, a big Buddhist school, ten small temples and pavilions. And among these are ponds, gardens, little groves, walkways, secluded spots, benches, springs, a parking place for tour buses—and all swept and polished and clear and clean.

In the evening, when few tourists remain at the temple and Puzhaolou is locked up, Nanputuo gleams in the dying light with a calm assertion that beneath its modern veneer it is truly venerable with age. It had looked like this once, when it was built over a thousand years ago, and it looks like this still, always old and ever new.

During my days at Nanputuo, while the air is superheated by the day's brilliance, I soon form the habit of visiting certain favorite places on the temple grounds. In one of these, a spring flows out of the hillside, over a granite boulder on which a heart shape is carved and painted red. Through the crystal spring the heart shows clearly and an inscription translates as: "You can cleanse your heart here." I sit on the low wall that contains the pond into which the water flows and *do* feel the calm of a purified heart. In the mornings, after the chanting and breakfast, I usually start my day at this spring. Then, with a calmed heart, I bring my peacefulness to my other favorite places. To the left of the temple entrance a Bodhi tree has been planted. This is the famous Bo tree under which Siddhartha sat until he became the Buddha. I sit there with my heart calmed almost as long as Buddha sat under his Bo tree. But, sorry to say, I achieve no more than a tranquil mind. I do not become a Buddha.

But I am content with that, for had I been transformed, as Sakyamuni was, what would happen to the rest of my life at home? Not nirvana, but my life in America is what I have, and I confess myself content.

After several days of rain have mostly kept me inside my room at the temple, I decide to go to Xiamen's Wanshi botanical garden. The grounds are completely drenched. Suddenly the sun comes out brilliantly. Each water bead on the fresh leaves sparkles like a green sapphire.

Everything seems overgrown. The air is thick enough to swim in. We are marine creatures. Plants could grow in this liquid ether. The little moon bridges are submerged. I walk on water.

I think that if I lay down even for a few minutes creepers would encircle me, honeysuckle, grape, and calamus leaves would hold me close, seizing me about the middle, love-vine clasping me. I enter this moist world, and all its unfolding blossoms take me in.

Another day I go over to see the decaying remnants of the European colony and the Koxinga Museum on Gulangyu Island—but I find something much better than these tourist sites. I locate Baigungyan Si, the most beautiful temple in China for nuns. At one time the most elegant and wealthy Chinese women would come here on retreats to return to the inner life before resuming the life of pleasure. They left many treasures here. Nowadays, the nuns display the wonderful articles left in the temple.

Excitedly, the nuns lead me to an upstairs room to show me a new statue of Guanyin bodhisattva that has just been completed and installed in a special room all of its own. Here, at Sunlight Rock Temple, these nuns have a special devotion to Guanyin, and they regard this statue as an incredible gift. The nun who lifts the cloth that keeps the sunlight from touching the statue does so with reverence, and even though she has undoubtedly seen the statue several times before, she emits a little cry of ecstasy when she pulls the cover off and the statue leaps beautifully into view.

The features are delicate and individualized. She looks like a young girl, just in the midst of her teenage years, not the ritualized Guanyin face that I usually see. Every part of the

statue—the twenty arms, body, fingers, even the items held by Guanyin—is carved with meticulous care, but also with amazing vitality. The way the cloth is slowly withdrawn from this beautiful girlish yet powerful statue is, for me, incredibly erotic, as if she, Guanyin, is naked when this garment falls from her shoulders.

Guanyin bodhisattva with a thousand arms lavishes upon me many gifts. In her hands I find an arrow, a cup, a lotus blossom. She offers herself. I yearn to be taken in by those delicate arms. At first sexual, my feelings soon start to change. It is grace and love and piety and kindness to all living things that I see she is offering, not a mere embrace.

After the nun decides that Guanyin should be exposed no longer to the daylight, so precious is the statue, she throws the cover over the statue and beckons me to follow her.

She brings me to An Loche, the abbess of the nunnery. An Loche has been informed that a foreigner is at the temple, and she has the inevitable tea ready to serve. Only here, at Sunlight Rock, the tea is poured not from a rough earthenware pot. It comes steaming out of a handmade Georgian sterling silver tea set and is poured into Limoges cups, accompanied by lemon slices and sugar cubes, served with tongs.

An Loche is the wisest woman in Asia. Certainly, she gives me the best answer of anyone when I ask her about the hardest desire to overcome. For all their wisdom, from Ke Ming to Xiu Xiang, they did not see what she sees.

"When any desire remains hard, all are hard," she says. "When any one is easy, they are all easy. The same with virtue. If one is easy, the rest will be easy."

I will never need to ask this question again. It is the complete answer. Until all desires are resolved, negative desire will always seek and find an outlet.

By this time I understand that my question is really about myself: What is my own attachment to desire?

That night, back in Nanputuo, I think: Soon I will be leaving this temple and China itself. I am satisfied. I have gotten

all I need for a lifetime, and much more than I expected.

But the most meaningful experience I have in Xiamen is yet to come. It occurs without intention or premeditation or expectation. Quite by accident, if there is an accident, a young woman who is very different from both Gu Jia Jing and Charlie Chen or anyone else I met opens another door to my inner life. This is the last treasure I will gather on my journey.

CHAPTER **26**

Sudden Enlightenment: A Woman, Of Course!

✿ **I MET XIAN XIAOPENG** at Nanputuo one morning when she was leading a Taiwanese tour group around the temple. She had graduated from Xiamen University only a few weeks earlier. An English major, she began to work for the China International Tourist Service, partly to earn some money and partly in the hope that big American or British or Australian tour groups would come by on whom she could practice her English.

I am sitting near the rock-to-cleanse-the-heart-with. While her Taiwanese group throws coins at the red heart with frightful abandon and lots of laughter, she steps over to me and says rather shyly, in English: "You are European, or perhaps an American?"

"Yes. An American."

"I am a major in English," she says, "but I am trying hard to speak like an American, not a British person."

She rambles on, occasionally glancing at her tourists to see when they will complete the battering of their coins against the boulder. "I am waiting to see if I am to be admitted to the master's program in linguistics. I have had American teach-

ers at the University, you know. We have an excellent program. Professor Dr. Weatherby brought in a bat and a ball and three gloves, and we even played baseball. I felt like a Boston Red Sox. I'm so happy to see an American. Excuse me, my name is Xian Xiaopeng, like our political leader."

As she pauses, I tell her my name, in a kind of parenthesis between her headlong rush of words. She keeps on like a freight train. She is full of good spirits; life is expanding before her limitlessly, it seems. She is prepared to grasp each moment and to wring all its juices from it before it flies on. She has a lovely round Southern Chinese face which lends itself to a vast range of pleasant expressions, and they all pass before me.

Most of her tour group are now standing about, pockets emptied of coins, and so she has to go.

"Please let me meet you and take you somewhere, anywhere you would like, in this, my native city," she says. "I have no groups tomorrow. I'll come here at ten o'clock— would that be all right—?"

I nod.

"—and then we can wander about and talk American English. If I may, could I bring my copy of *Absalom, Absalom* and listen to how it would sound if you read some of it with the proper Mississippi accent?—and—"

I keep nodding.

"—and I'll take you someplace interesting that is not on the tourist itinerary . . . let me see. Yes, to the mosque in Xiamen. Yes, very interesting—"

I have no chance to reply, except to smile, before she turns away, saying as she is turning: "Ten o'clock. Ten o'-clock here."

Xian Xiaopeng knows what she wants. What else can I do but honor her wishes? I leave my robes at the temple and go as a tourist. We do go to the mosque. She says that it had been built at the beginning of the eleventh century, a mere two hundred years after Nanputuo, and I am ready to believe

this because some parts of it are obviously very old—and especially amazing. Having spent so much time by now in temples that are purely Chinese architecturally, or amid new business constructions that are purely steel and glass and marble modern, it brings me up short to suddenly come upon a building in China that was once completely Islamic in style. That is plain to see, even through the alterations of later, mostly Chinese-style, restorations. The minaret has become a pagoda.

"This," Xian says with pride in her city, "is where the Silk Road really begins. As you see, our port here is one of the best in the world. During the Song and Yuan dynasties"— she is full of the details of her recent training in the China International Travel Service program—"a vigorous trade was established with the eastern world, which soon extended all the way from Xiamen into the spicy Middle East."

Sure enough, the spicy Middle East is still alive in Xiamen. The mosque is locked; we never see the inside. But on the streets, men and a few women in Muslim dress mix oddly with the Chinese population. Behind the open doors of a shop, bags and cans of Middle Eastern foods are arranged on shelves. On the corner, a descendent of the Uigurs is lighting charcoal in a barbecue grill, and just a few doors down the street a restaurant already emits the scents of Eastern spices.

It seems incredible, but it is true, that Muslims who had come to Xiamen from Turkestan a thousand years ago had, generation after generation, held to their faith and their foods. The little population here dress exactly as their compatriots who had stayed in Persia or Iraq dress today. The men wear dark suits, shirts open at the neck, with cracked, dusty slip-on shoes. The women wear black robes and head coverings. Poor they are, but they probably tolerate poverty as well as their forebears had. Doubtless there are also Muslim merchants here who do a prosperous trade, sending Chinese silks and lacquers and pearls from the Xiamen shoals back to destinations from Turkestan to Mongolia. For a mil-

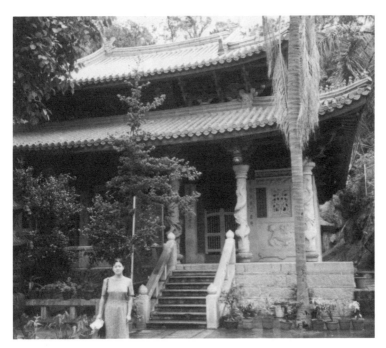

Nanputuo Temple

lennium, all has remained constant in this little backwater
of two or three streets near the edge of this Chinese city.

We each eat two sticks of shish kabob and drink Coca-
Colas. This is fine. But it is not the best part of my day with
Xian Xiaopeng.

"Now, I promised my grandmother that I would visit her
today, on my day off," she tells me, "and since you are inter-
ested in temples, you must come to see her with me. She
lives at Tiger Brook Temple."

The temple is very, very rundown. Only a few extremely
old women live in it. It is unkempt and disorderly in every
way. Here is a place to which no foreign visitor has ever
come. Officially, the CITS does not know of its existence. It
is not listed in any tour book. I guess I might as well come
right out with the obvious fact: it is a temple where ancient
nuns come to die. So far as I can see, there is not a trace here

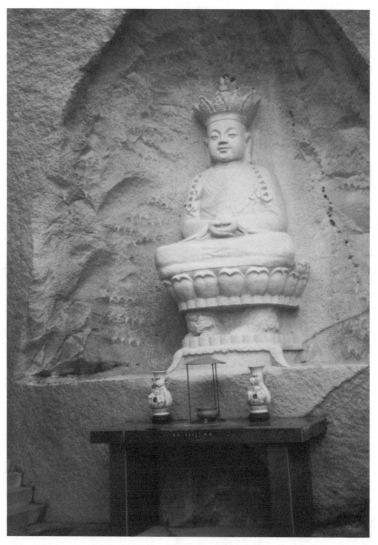

Tiger Brook Temple

of Pure Land thinking. It is just a little community of seven or eight nuns, who can no longer do anything except care for each other.

Everything I have written above is true, but I see that I have portrayed Tiger Brook as a sad place, and it is far from that. It

is, to be sure, a place for death, but outwardly there is no dwelling on death. Far from it. The smiles and the little exclamations of pleasure that the old nuns give out when they see Xian mounting the stairs, and the genuine interest and joy that they express when they see that she has a foreigner—an American—in tow, draws me into the warm orbit of the little group in the nicest way. They rush to embrace Xian and to find a chair for me—to see that I am comfortable, and to clear a place for me to rest my hands on the cluttered table.

Xian's grandmother is awakened from her light sleep by the hustle and bustle that our arrival occasions. The door to her tiny room creaks open, and out she steps. Almost as small as an elf, she immediately draws Xian to her. Beside her, the girl is as big and robust as a panda, and when they hug, the miniature woman practically disappears in the folds of Xian's loose dress.

"So you are here from America?" she asks me.

On the way, Xian had told me that her grandmother was eighty-six. But when she speaks, her directness and firmness of voice contrast starkly with her evident age.

"Yes, from California."

"Well, America is a great place," she replies. "I know all about America. Sun Yat-sen"—she uses the Chinese name, of course—"married a good American-educated wife. So did Chiang Kai-shek—his wife was a much better woman than he was a man. America. Sacco and Vanzetti and Big Bill Haywood, and Edgar Snow. I heard John Dewey speak at Nanking Normal School"—she gives the old American pronunciation of "Nanking"—"when I was a little girl in boarding school."

As she talks, she leads us into her own room. Xian brings along an extra chair for me. As we enter the space, hardly more than a six-by-eight cubicle with a window at the farthest end, my eyes fall on something I had never again expected to see. In one corner is a Singer sewing machine with a foot-operated elevator pedal beneath it to make power. It

is exactly like the machine that my grandmother once owned. When my father left us, and my grandmother moved into our railroad flat on Menahan Street, she brought a few precious items besides her meager welfare check. The only one of any real value was her foot-operated Singer sewing machine. It sat in our kitchen for nine years, until she died and my mother gave it away to a Long Island cousin who converted it into a decorative table.

My grandmother, Elizabeth Burnell, had worked in a shirt factory when she was a girl in the 1890s. After making thousands of shirts, she could turn one out in very short order. So, whenever we had an extra quarter or fifty cents that could be expended on a little remnant of material, she would tape measure me quickly, murmur how fast I was growing, and produce a shirt for me. That we had to select from remnants meant that I would often be wearing lavender shirts with orange stripes or some other strange combination, but any shirt was better than no shirt. I loved her for it.

Now here I am again, in the presence of an old grandmother and a Singer sewing machine. I know that she will not make a shirt for me. But I feel tears start in my eyes.

"Ah, you sew," I say stupidly.

"Yes, I worked in a shirtwaist factory in Nanjing for a few years to get the workers organized, or at least to raise their proletarian consciousness. Do you see, I have an American machine? I can still make shirts."

I stay away from that subject.

There is a nice picture of Mao Zedong above her bureau.

"So you were a communist?"

"Yes, of course."

"And now a nun?"

"Not precisely. You sound like a Kuomintang official interrogating me. Please continue." She is joking archly.

"I gather that you *were* interrogated by the Kuomintang. I'll play an official investigator. So, you say you are not precisely a nun?"

"Perhaps I am here to organize the nuns. Maybe we aim at getting better conditions in nirvana, a shorter sentence, fewer than a million lives."

"You couldn't have stayed in Nanjing all during the war? You weren't there when the Japanese captured the southern capital?"

"It wasn't the Japanese who drove us out. The Nationalist authorities hunted down Red units like mine. Any communist who was caught was shot without delay, in the back of the head, and left in a field. The few of us who still survived in May, 1931, decided to slip out of the city one by one and reassemble near Nanchang, in Jiangxi Province. There, if we needed to do so, we could flee into the mountains and lose our pursuers—at first the Nationalists, but soon enough the Japanese invaders. We were guerillas year in and year out, until the triumph of the Revolution. Then I came to Xiamen with my little boy—Xian's father—and worked with the city authorities to develop workers' housing. Now this is a rich capitalist city."

"But why are you living in a Buddhist temple? Oddly enough, I see a picture of the Buddha on your wall, right next to Chairman Mao."

"Of course. I am also a Buddhist. And we have a nice little community of women here."

"A communist *and* a Buddhist? What about 'religion is the opiate of the masses'?"

"Oh, that is a silly German thing. It doesn't apply to China. My heroes are Buddha, Sun Yat-sen, Mao Zedong, and Deng Xiaopeng. I believe that all were both communists and Buddhists. Don't you think so?"

"I'll have to think about that."

Then I come out with what I really want. "Would you let Xian take a photo of us next to your pictures?"

She stands up pertly. I stand next to her and Xian shoots the photo. I want to keep a memory of this incongruous Hall of Fame—and of her.

With Xian's grandmother and Mao

We talk on, and eventually she sends Xian to get some green tea, a small brown clay Yixing teapot, and the tiniest possible teacups. We have four pourings of tea. And then it is time to go.

As I make my way from the room saying my thanks and good-byes, I veer a bit out of the way in order to run my finger across the wooden top of the Singer machine. Even the grain feels the same as I remembered it.

I hope that gesture will go unseen, but she misses nothing.

"Yes, it's a fine piece of work. It could last many lifetimes," she says.

All she misses is that I am thinking of my grandmother, not of the machine. And I hope that she will not offer to make me a shirt—say, out of a remnant of a Red Guard banner.

She doesn't, thank God, and we leave. But long, long into the night, I think about this guerilla fighter, whose face now

mixes and will, I guess, forever mix with my own grandmother's, who had been born in 1875 in New York, when the Irish themselves were still a downtrodden and revolutionary group. But I am not thinking about politics and revolution, I am thinking about the passion and endurance of these two women, whose lives had been as hard as their loves had been great.

I cleanse and calm my heart in Xiamen. And then, in the last days of August, I start for home. Only part of an afternoon and one night in Shanghai remain until I will leave China. But I am not yet ready to leave my China Dreams.

Ascent to Home

❀ SHANGHAI! IT IS like an old home, but it is not really home. Every sight is familiar. After months of constantly passing from one new sight to another, here, happily, there is nothing new to see. I have already seen the glorious waterfront, walked by the shops on Nanjing Lu, toured Sun Yat-sen's residence, viewed Yu Garden—fragrant with blossoms in full summer—taken an elevator to the rooftop of the Peace Hotel, and gazed at the treasures in the Bowuguan, Shanghai's great new museum. I can afford to miss another glimpse of the white jade Buddha at Yufo temple, dwarfed by the "White Jade Condominiums" towering above it. My thoughts are almost all on tomorrow's flight.

Wistfully, and almost with regret in advance, I order the airport taxi to swing by the ancient Longhua Temple, the finest in the city. One last look, one final temple. The monks are chanting a special ceremony for the lunar month. But I am no longer one of them. I stand at the entrance to the main temple, watching and listening. The door is open, but I do not enter.

I tell my taxi driver: "The Yangtze New World Hotel, please."

He makes a polite offer to spend the day with me and show me "the most interesting and rare" sights of his city for only two hundred and fifty yuan. I am sorry to disappoint him, for it cannot be every day that he has the most estimable fortune to find a "rich" American opening the door to his cab. But after saying good-bye to Longhua Gu Si, the only attraction I want to visit is my hotel. He believes that I am wrong, very wrong, to reject the splendid opportunity he is offering me to see his city. I swear that he is right, but still I wish to reach my hotel as soon as possible.

He makes one more try: "I will take you to all the best shopping places in Shanghai so that you can buy the finest of Chinese goods to take to all your friends in America."

It is obvious to him that, being an American, I must want to shop. I say a firm "no."

Chinese, who know how to survive, do not easily accept defeat—but at this final refutation of his last hopes, he yields. I admit to him that I have disgraced the tourist's code, but I don't care.

I unpack and repack. I lay out my clothes for the next day. I make some minimal reparation for my refusal to support the tourist economy by strolling through the shops in the lobby and buying a yellow silk tie with a yang and yin symbol on it. On the room television I watch an old episode of "Charlie's Angels." I have been with many Chinese angels. I am getting ready to go home.

In the evening, I decide to take a walk around the hotel. The streets are still crowded. I follow the crowds and cross under one of the big concrete elevated freeways that run like ribbons through Shanghai, and arrive outside the Shanghai Mart, a shopping complex just around the corner from a big Westin hotel. I do not go in but stand and take in the scene.

Night falls swiftly, the streetlights come up—neon lights, clear and hard as a box of precious gemstones spread out on a glossy black velvet pad. Behind the tall buildings, the sky is still lambent, radiant with the blue and gold and green

reflections of the sun setting behind filtering layers of the city's air pollution. It is hard on the lungs but a wonder for the eyes.

Shanghai! The opium dens are gone. The People's Republic has put an end to gambling. Drunken sailors are no longer "shanghaied" or picked up at the long bar in the Dongfeng Fandian. The Reds have relentlessly cleaned up Shanghai's vice, and have turned the city into the Peoria of the East China Sea. It has become a purely commercial city of thirteen million, where busy Japanese, Taiwanese, and Americans flit from one high-rise or hotel to another, making deals. It is hardly a Chinese city anymore. Not a shred of the old exotic romance flutters in the town, only the modern industrial romance of the triumph of steel and neon.

The hotels rise up higher and higher. Anything lower than twenty stories is a cottage. All day long the clatter of construction vies with the rattle of American CDs, blasted out of every other doorway. Michael Jackson's voice is all around me: "It's after midnight. Something evil's lurking in the dark."

But I sense no residue of the old evil here, only the indomitable capacity of technology to ruthlessly fill up empty spaces. Every vacant lot is a target for a high-rise. Every instant of silence offers another opportunity for some machine to amplify sound beyond the human ear's capacity to endure it.

My journey has certainly not been about Shanghai, any more than it is about Guo Qing or Ningbo or any of the other places I found myself. The story, of course, is about the tides and turmoils of my inner life. Wherever I stopped in China, a new spot in my heart's geography was marked on the map of my soul. There is so much of me that is not yet charted. Many unglimpsed places still remain even as I am leaving. China is not "strange" because of the new scenes or scents or people I encounter here. It is so because it brings forth the exotic secrets and previously unencountered spots of my own strange being.

In the last account, I have been getting an education in myself—in my own multiplicities and also in my simple

faiths; in my depths—and, yes, decidedly, in my shallows. True, on the surface I have been learning about different strains of Buddhism, the history of China, and the modern scene here. But behind these, I learned to find myself. Thoreau asks, Why travel abroad until you have explored the longitudes and latitudes of your own being? But I find here that my new experiences lead directly to the foreign territories of my own self.

After all the times I have asked others about the hardest desire to give up and the greatest virtue, I come upon the answer for myself as I walk back to my hotel. I guess I had to ask a lot of questions to find my own answers.

My own most powerful virtue has always been expressed in my desire to see, to investigate, to learn more, to examine and to seek out. The world waits to be looked into, penetrated, opened to grasping inspection.

The hardest desire for me to give up is just that same thing—the desire to look, to experience, to take one more step into the abyss of mystery. And it *can* be an abyss. Any virtue, I see, can turn into a horrific vice. Evil does look out of sunlight.

Everything contains its opposite. You can have the whole world even if you have nothing. In China, I had worn a plain robe, eaten sparingly, and slept in quarters of the barest kind. Some of my best times were spent in quiet, or in sincere talk, or in listening to the heartfelt prayers of others. A talk with a tree can bring as fine a vision as an expensive journey to consult the wisest man in the farthest reaches of the universe.

Can I *want* to plunge deep into the spiritual life and yet be without desire? No doubt I often failed to be a good monk. But, after all, on my first day in Guo Qing I learned that Ke Ming himself still experienced desires, and that gave me a little lesson in not desiring perfection of myself. Perhaps the yearning to be perfect is the most dangerous desire. Learn to live millions of times before perfection begins.

As I said, this book about desires could only be written by going to China. Desires are like summer swarms of mosquitoes

in Southern China—but there is no desire repellant to ward them off, no electric mosquito killer. Desires breed everywhere. In the long run only a little boundary exists between the "dark" desire of possession, materially or sexually, and the "illumined" desire to achieve wisdom. Curiosity can lead to enlightenment, but also to disaster. Still, enlightenment may come by way of danger, too. This is a puzzle, but I do not want to solve it, only to watch the dances of desire, often fulfilling, but sometimes distressing. I conclude only that desires are inseparably woven into the mottled tapestry of life.

When the virtue of looking thrusts inside the self or extends outward to the lives or anguishes of others, it can stop there, it can be calm there. It doesn't have to plunge dangerously into the abyss of possession or the bordellos of desire.

Back in my hotel room, I set my alarm clock and also leave a wake-up call. I am not going to take any more chances. Nothing in the world will keep me from making my flight.

I think I am exhausted and will fall asleep immediately. But as soon as the room is dark I am wide awake. I realize that I am trying unconsciously to make my final China day last as long as possible.

I know that for a long time yet I will continue to discover what I have learned in China. But as I lie in bed awake, reflecting, mulling over all that I have experienced, when I think I have learned all I could for now, one final fragment of enlightenment spreads its halo about me. The last lesson comes in three words: *I am alive.* Whatever else I have discovered, this is what I have uncovered—the glory of being alive. Life—holy, loved, shared—life is the central secret. To define life takes a whole dictionary. But at this moment, I don't have to define it, I don't need any other words. It is enough to feel alive. This is life, simply being alive. In China I have preserved and expanded life. I have come halfway around the world to learn that I am alive and that life is the nirvana it seeks. I have come halfway around the world to go home.

Whatever I had wanted to learn by going to China, I have learned. What I have found is what I wanted to find.

The next morning I board my long Japan Airlines flight. I settle into my seat and take out my green notebook. It is filled with scattered notes, sketches, poems, doodles, Martin Yan's recipe for stripped bass Hangzhou style, undecipherable scrawls, and even a drawing of Confucius.

Master Kung

My green notebook is like a bone pit, in which parts of ancient animals and relics of buried men are preserved. It consists of what had struck my imagination and stayed there long enough for me to fill the blank pages with these things.

I remember back to the train station in Shanghai and my first night in Guo Qing. I remember when I followed the three nuns through the dark halls in order to find my way back to my own bedroom.

I think of Ke Ming with great affection. It is two months since I have seen him. How is he now? I wish him well. I smile, thinking of Chung Miu's smile. I page through my notes and revisit them all, right to Xian and her grandmother.

I hear Ke Ming say: "You have Buddha in your heart. Take it back to America."

I come to the end of my notes. A few pages at the back of my notebook are still blank.

I drift in thoughts. I dream. I drink a ginger ale. I eat a salmon fillet. A movie comes on and I fall into a long, uneasy sleep.

I dream that I have my notebook open on my tray.

Dreaming, I write on the first blank page in my notebook: "I am sitting in the waiting room of the main railway station in Shanghai, along with a thousand other people."

My Boeing 777 climbs to its cruising altitude of thirty-five thousand feet, high above the limitless sea. We are higher than any mountain on earth. A good place for me to begin my own ascent. As I sit still, I am climbing and flying home.

Afterwords to the Reader

❧ *Journey to Heavenly Mountain* is the story of a journey into the heart and soul of man, and, in particular, of one man—myself. Desire, in all its mysterious and complicated forms, is my major theme. I have dwelt on the desire to know God and sacred things, the yearning for illuminated insight, and the wish to achieve virtue and calmness of spirit. I have not forgotten that darker desires—for material plenty, for possession or control over others, and for merely sensual pleasures—can lead one away from simple goodness. But I have also been mindful that even darker desires can lead one back to the holiness of the world. This triple sword of desire gives complexity to choice and depth to experience. Seeking has been my preoccupation in this book. Journeying was the form my seeking took. My goal was to tell about the richness and varieties of inner experience, along with the potential for growth in wisdom and empathy, which life among the Buddhists offers.

This much will be clear to all readers of my book. There is one matter, however, on which added comment may be helpful to the reader. *Journey to Heavenly Mountain* concerns

an American in China and also, more deeply, portrays the way that the spirit of China seeped into an American. A special, intimate connection has long existed between the mind of the West and what Sturgis Bigelow nicely called "the soul of the East." America and China have always responded vigorously to each other because they have so much in common at their center—a profound capacity for hope; a stubborn faith in the future; and an implicit, though seldom expressed, belief in the ultimate goodness and sagacity of the human enterprise.

Though our governments seem to be at odds with each other at the present time, China and America are steadily moving toward each other. Just as the last century was certainly the American century, the next hundred years, I believe, will be the joint "China-America," or, as I call it, the "Chinamerica," century. The historic and transcendent task of these two countries is to lead the world into this new millennium—not just economically, but spiritually and psychologically as well.

To my mind, this mutual destiny of China and America contrasts strongly with the plight of Europe. Thomas Mann's *The Magic Mountain*, a novel which perfectly summarized the condition of Europe in the twentieth century, represents Europe through the metaphors of sickness, disease, and death. Mann centered his book on a group of European patients at a Swiss sanitarium on Mount Davos, his magic mountain. The leading figure of the book, Mann writes, has an "inborn attraction to death," and believes that healthfulness can be achieved "only through the encounter with disease." Contrariwise, Americans have always sunnily believed that the route to wholeness is through health. Similarly, the patient, sane conviction of Chinese Buddhists that eventually every soul will be enlightened, even if this might require millions of lives, coincides with American optimism. Americans are merely more hasty. True enough, both China and America have had a surfeit of the experience of the dis-

mal failures of life, but neither has been crushed by this. The national characters of Americans and Chinese dispose neither people to put much stock in the Hegelian paradoxes that still linger in Mann's text. Mann is unalterably convinced that "one must go through the deep experience of sickness and death to arrive at a higher sanity and health; in just the same way that one must have a knowledge of sin in order to find redemption." Less circuitously, Americans and Chinese prefer to arrive at health through taking the path of health; to achieve redemption they try to practice virtue. They seem to be convinced, as Aristotle was, that evil is the absence of good, not the path to it, and that sickness is the disappearance of health, not the means of achieving it.

The reader who remembers Mann's novel and glances at the chapter titles shared by *The Magic Mountain* and *Journey to Heavenly Mountain* will understand my book as a response to Mann's. *Journey to Heavenly Mountain* is suffused with enchantment, but it is not enchained by the enchantments of illness. As an American book, it is closer to Thomas Merton's *The Seven Storey Mountain* than to Mann's novel. It is closer to the great Buddhist monk poets than to the German master novelist. My book asserts with a clear voice and an impassioned heart that the twenty-first century world that will unfold through the leadership of Americans and Chinese is to be healthy at its core and conclusion, despite the manifold vicissitudes we will encounter in the next hundred years.

My book involves a journey to a world far older than Europe, by a native of a world much newer. Ultimately, it is a thrust into the new millennium and the healthful heart and soul and spirit that have long endured in China and can also prevail in America as this new century unfolds.

Acknowledgements

❧ The graces and goodness showered upon me in China continued during the preparation of this book, and so I have many people to thank.

Myron Simon was present at every stage of my experience and the composition of this book. At the very beginning, when I was seeking admission to Chinese monasteries, he led me to the historian of modern China, Ping-ti Ho, who introduced me to Ying and Stuart Chow. Ying sent me to Ke Ming; and he and the others named in my book, along with numerous anonymous monks, passed me happily from one to the other on my journey.

Alfred Balitzer and Caroline Avery provided me inspiration and support through the Durfee Foundation.

Orm Øverland of Norway, Sheng-Tai Chang of Shanghai and Long Beach, George Leonard of Beijing and San Francisco, and Roger Ames of Hawai'i read my book as it developed, and each helped to make it better. Myron Simon read every version.

Cindi Guimond, John Wright, Owen Laster, Carol Houck

Smith, and Nan Talese each gave me special encouragement at times when I needed it most.

Geraldine Uyeunten gave me unstinting, gracious, and perfect help at the final stages of the preparation and submission of this book, completing the work started by Richard Drake and Linda Tuthill. Dasya Zuccarello, publisher of Hohm Press, gave this book his unqualified support. I was extraordinarily fortunate to have Nancy Lewis copyedit this book; she has a keen eye, a subtle touch, and an empathetic heart. My daughter, Laura Ann Friedlander, gave me her aid and counsel at the final stages of preparing this book.

Regina Sara Ryan, my editor, the best of editors, accepted this book with the most generous enthusiasm and guided it expertly to publication so that the reader now holding it in his or her hands can close the circle which opened with my journey to Guo Qing. Without Regina Sara Ryan, my book would not be as good as it is, and perhaps would not have come into existence at all.

The last words are, as always, for my beloved Helen. She is the first and the last for me. She confers upon me a special, angelic grace that always sustains me and, at the times when I can fully accept it, exalts me. She is what I have now, in this life, instead of heaven.

Additional Titles of Interest
HOHM PRESS

SIT: Zen Teachings of Master Taisen Deshimaru
Edited by Philippe Coupey

Like spending a month in retreat with a great Zen master. SIT addresses the practice of meditation for both beginners and long-time students of Zen. Deshimaru's powerful and insightful approach is particularly suited to those who desire an experience of the rigorous Soto tradition in a form that is accessible to Westerners.

"To understand oneself is to understand the universe."

—Master Taisen Deshimaru

Paper, 375 pages, 18 photographs, $19.95
ISBN: 0-934252-61-0

HALFWAY UP THE MOUNTAIN
The Error of Premature Claims to Enlightenment
By Mariana Caplan
Foreword by Fleet Maull

Dozens of first-hand interviews with students, respected spiritual teachers and masters, together with broad research are synthesized here to assist readers in avoiding the pitfalls of the spiritual path. Topics include: mistaking mystical experience for enlightenment; ego inflation, power and corruption among spiritual leaders; the question of the need for a teacher; disillusionment on the path . . . and much more.

"Caplan's illuminating book . . . urges seekers to pay the price of traveling the hard road to true enlightenment."

—Publisher's Weekly

Paper, 600 pages, $21.95
SBN: 0-934252-91-2

**See our order form on page 249 or
visit our website at www.hohmpress.com**

THE ART OF DYING
By RedHawk

RedHawk's poetry cuts close to the bone whether he is telling humorous tales or indicting the status-quo throughout the culture. Touching upon themes of life and death, power, devotion and adoration, these ninety new poems reveal the poet's deep concern for all of life, and particularly for the needs of women, children and the earth

"An eye-opener; spiritual, native, populist. RedHawk's is a powerful, wise, and down-home voice."

—Gary Snyder

Paper, 120 pages, $12.00
ISBN: 0-934252-93-9

THE JUMP INTO LIFE: Moving Beyond Fear
By Arnaud Desjardins
Foreword by Richard Moss, M.D.

"Say Yes to life," the author continually invites in this welcome guidebook to the spiritual path. For anyone who has ever felt oppressed by the life-negative seriousness of religion, this book is a timely antidote. In language that translates the complex to the obvious, Desjardins applies his simple teaching of happiness and gratitude to a broad range of weighty topics, including sexuality and intimate relationships, structuring an "inner life," the relief of suffering, and overcoming fear.

Paper, 278 pages, $12.95
ISBN: 0-934252-42-4

**See our order form on page 249 or
visit our website at www.hohmpress.com**

THE ALCHEMY OF TRANSFORMATION
By Lee Lozowick
Foreword by Claudio Naranjo, M.D.

A concise and straightforward overview of the principles of spiritual life as developed and taught by Lee Lozowick for the past twenty years. Subjects of use to seekers and serious students of any spiritual tradition include a radical, elegant and irreverent approach to the possibility of change from ego-centeredness to God-centeredness—the ultimate human transformation.

Paper, 192 pages, $14.95
ISBN: 0-934252-62-9

THE SHADOW ON THE PATH
Clearing the Psychological Blocks to Spiritual Development
by V.J. Fedorschak
Foreword by Claudio Naranjo, M.D.

Tracing the development of the human psychological shadow from Freud to the present, this readable analysis presents five contemporary approaches to spiritual psychotherapy for those who find themselves needing help on the spiritual path. Offers insight into the phenomenon of denial and projection.

Topics include: the shadow in the work of notable therapists; the principles of inner spiritual development in the major world religions; examples of the disowned shadow in contemporary religious movements; and case studies of clients in spiritual groups who have worked with their shadow issues.

Paper, 300 pages, $17.95
ISBN: 0-934252-81-5

**See our order form on page 249 or
visit our website at www.hohmpress.com**

WESTERN SADHUS
AND SANNYASINS IN INDIA
By Marcus Allsop

This book contains interviews and stories about a unique group of Westerners who have lived in India for twenty years or more. Now known as sadhus and sannyasins (traditional Indian holy men or women), they have renounced the materialistic values of their native culture in favor of a life of austerity and spiritual practice. Their exact numbers are unknown—since many of them have chosen a life of anonymity. Marcus Allsop's pilgrimage takes him from Mt. Arunachala in southern India to the source of the Ganges in the foothills of the Himalayas. He stops at age-old shrines and majestic temples, and shares the powerful insights into Indian spiritual culture that he gains along the way.

Paper, 232 pages, 24 photographs, $14.95
ISBN: 0-934252-50-5

THE YOGA TRADITION: Its History,
Literature, Philosophy And Practice
by Georg Feuerstein, Ph.D.
Foreword by Ken Wilber

A complete overview of the great Yogic traditions of: Raja-Yoga, Hatha-Yoga, Jnana-Yoga, Bhakti-Yoga, Karma-Yoga, Tantra-Yoga, Kundalini-Yoga, Mantra-Yoga and many other lesser known forms. Includes translations of over twenty famous Yoga treatises, like the *Yoga-Sutra of Patanjali,* and a first-time translation of the *Goraksha Paddhati,* an ancient Hatha Yoga text. Covers all aspects of Hindu, Buddhist, Jaina and Sikh Yoga. A necessary resource for all students and scholars of Yoga.

Paper, 520 pages, over 200 illustrations, $29.95
ISBN: 1-890772-18-6

**See our order form on page 249 or
visit our website at www.hohmpress.com**

PRYING DANGEROUSLY: Radical Reliance on God

By Regina Sara Ryan

Praying Dangerously re-enlivens an age-old tradition of prayer as an expression of radical reliance on God, or non-compromising surrender to Life as it is. This approach expands the possibilities of prayer, elevating it beyond ordinary pleas for help, comfort, security and prosperity. *Praying Dangerously* invites a renewal of the inner life, by increasing one's desire to burn away superficial, safe notions of God, holiness, satisfaction and peace.

"A brave book for brave people . . ."

—David Steindl-Rast, O.S.B.,
author *Gratefulness, the Heart of Prayer*

". . . wise, fierce, challenging . . ."

—Andrew Harvey,
author of *The Essential Mysitcs*

Paper, 240 pages, $14.95
ISBN: 1-890772-06-2

TAO TE CHING FOR THE WEST

By Richard Degen

A new rendition of the revered classic, *Tao Te Ching*, this sensitive version offers a contemporary application of Eastern wisdom to the problems created by modern Western living. It presents a way of life characterized by harmony and integrity; a way that bypasses the happiness-depleting traps that people of all ages have set for themselves and others.

Paper, 120 pages, $9.95
ISBN: 0-934252-92-0

Visit our website at www.hohmpress.com

HOHM PRESS

Name _____ Phone _____

Address or P.O. Box_____ _____

City _____ State _____ Zip _____

QTY	TITLE	PRICE	TOTAL
	Journey to Heavenly Mountain	$16.95	
	SIT	$19.95	
	Halfway Up the Mountain	$21.95	
	The Art of Dying	$12.00	
	The Alchemy of Transformation	$14.95	
	The Jump Into Life	$12.95	
	The Shadow on the Path	$17.95	
	Western Sadhus and Sannysasins in India	$14.95	
	The Yoga Tradition	$29.95	
	Praying Dangerously	$14.95	
	Tao Te Ching for the West	$ 9.95	

Surface Shipping Charges *Subtotal*

1st book or CD $5.00
Each additional item $1.00 *Shipping*

Method of Shipping TOTAL
_____ Surface U.S. Mail (Priority)
_____ 2nd-Day Air Mail (Mail +$5.00)
_____ FedEx Ground (Mail +$3.00)
_____ Next-Day Air Mail (Mail +$15.00)

Method of Payment
_____ Check or M.O.—Payable to Hohm Press
_____ Call 800.381.2700 to place a credit card order
_____ Call 928.717.1779 to fax a credit card order

Credit Card Information
Card # _____ Exp. Date _____

**Visit our
website to
view our
complete
catalog!**